H_2O

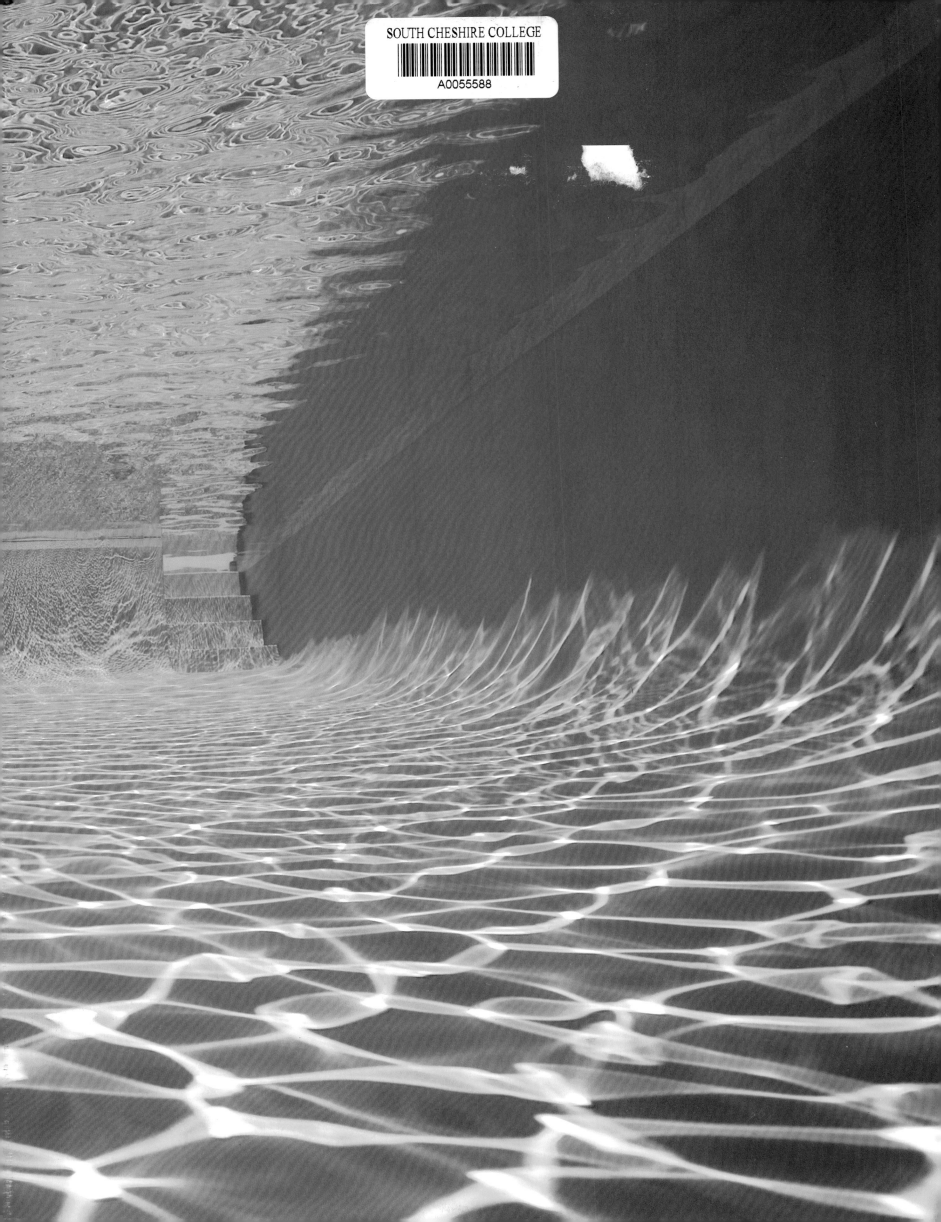

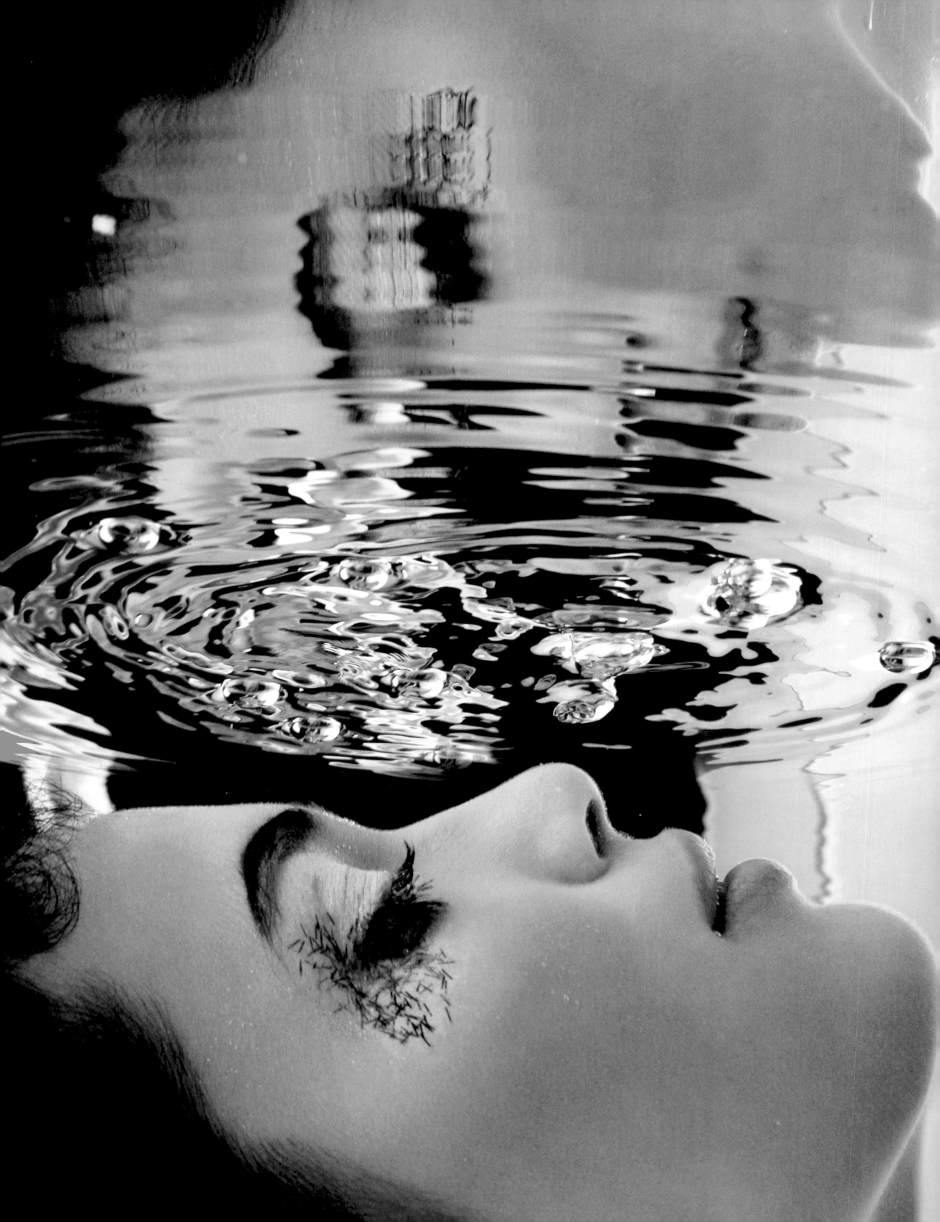

H₂O

Photography

HOWARD SCHATZ

Project Director/Senior Editor

BEVERLY J. ORNSTEIN

Introduction and Text

OWEN EDWARDS

A Bulfinch Press Book

New York Boston London

HOWARD SCHATZ and BEVERLY J. ORNSTEIN

Other books

In Character: Actors Acting, 2006

Botanica, 2005

Athlete, 2002

Rare Creatures, 2002

Nude Body Nude, 2000

Body Knots, 2000

The Virtuoso by Ken Carbone, with photographs by Howard Schatz, 1999

Pool Light, 1998

Passion & Line, 1997

The Princess of the Spring and the Queen of the Sea, 1996

Body Type: An Intimate Alphabet, 1996

Newborn, 1996

Water Dance, 1995, 1996

Homeless: Portraits of Americans in Hard Times, 1993

Seeing Red: The Rapture of Redheads, 1993

Gifted Woman, 1992

Photographs and design copyright © 2007 by Howard Schatz and Beverly J. Ornstein
Introduction and text © 2007 by Owen Edwards

Hachette Book Group USA
237 Park Avenue, New York, NY 10017
Visit our Web site at www.HachetteBookGroupUSA.com

First Edition: November 2007
Bulfinch Press is an imprint and trademark of Little, Brown and Company (Inc.)

Library of Congress Cataloging-in-Publication Data
Schatz, Howard
H2O / photography, Howard Schatz ; project director/series editor, Bevery J. Ornstein ;
introduction and text, Owen Edwards. — 1st ed.
p. cm.
ISBN 0-316-11775-7 / 978-0-316-11775-3
1. Underwater photography. 2. Schatz, Howard. I. Ornstein, Beverly J. II. Edwards, Owen. III. Title.

TR800.S28 2007
778.7'3 — dc22 2007062007

Book design by Howard Schatz

Printed in Singapore

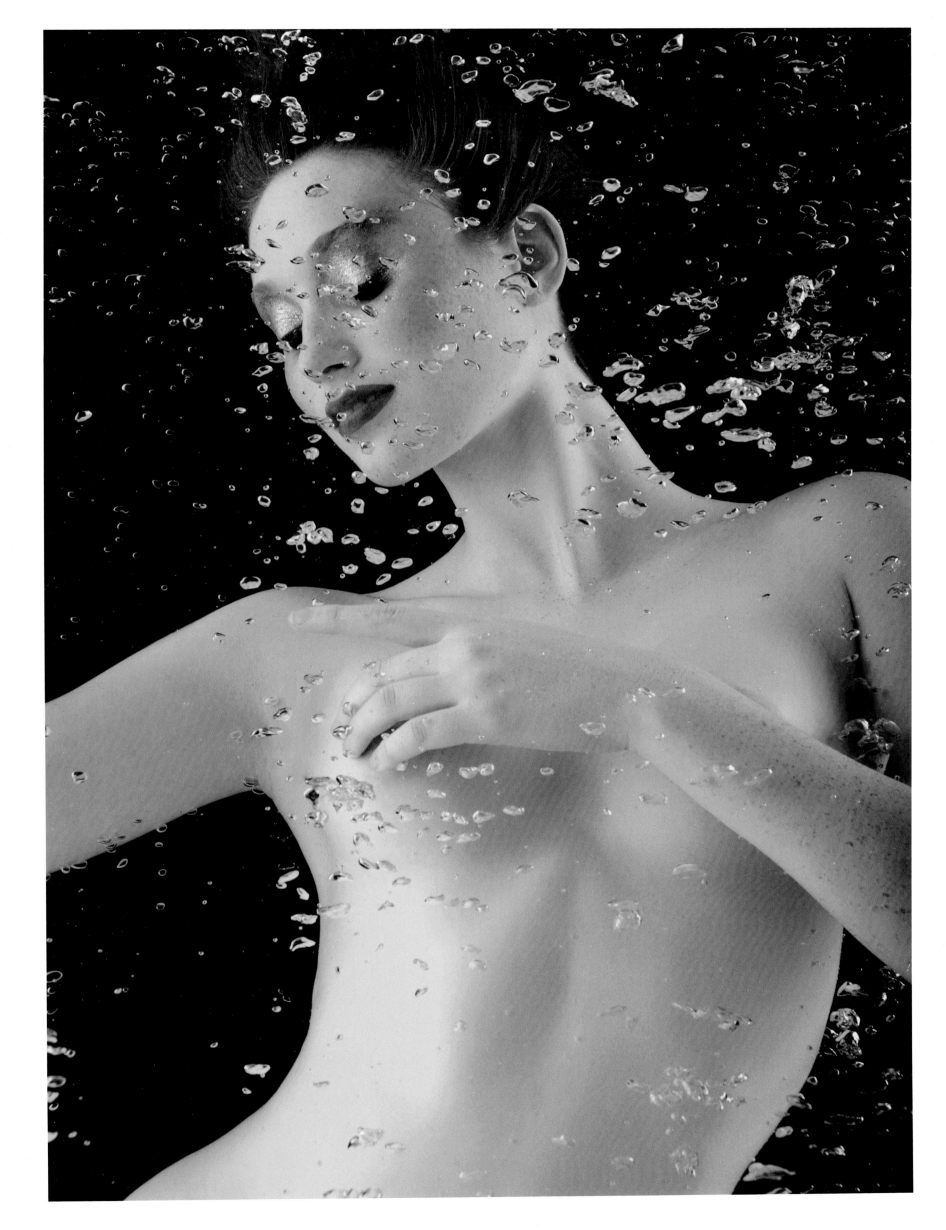

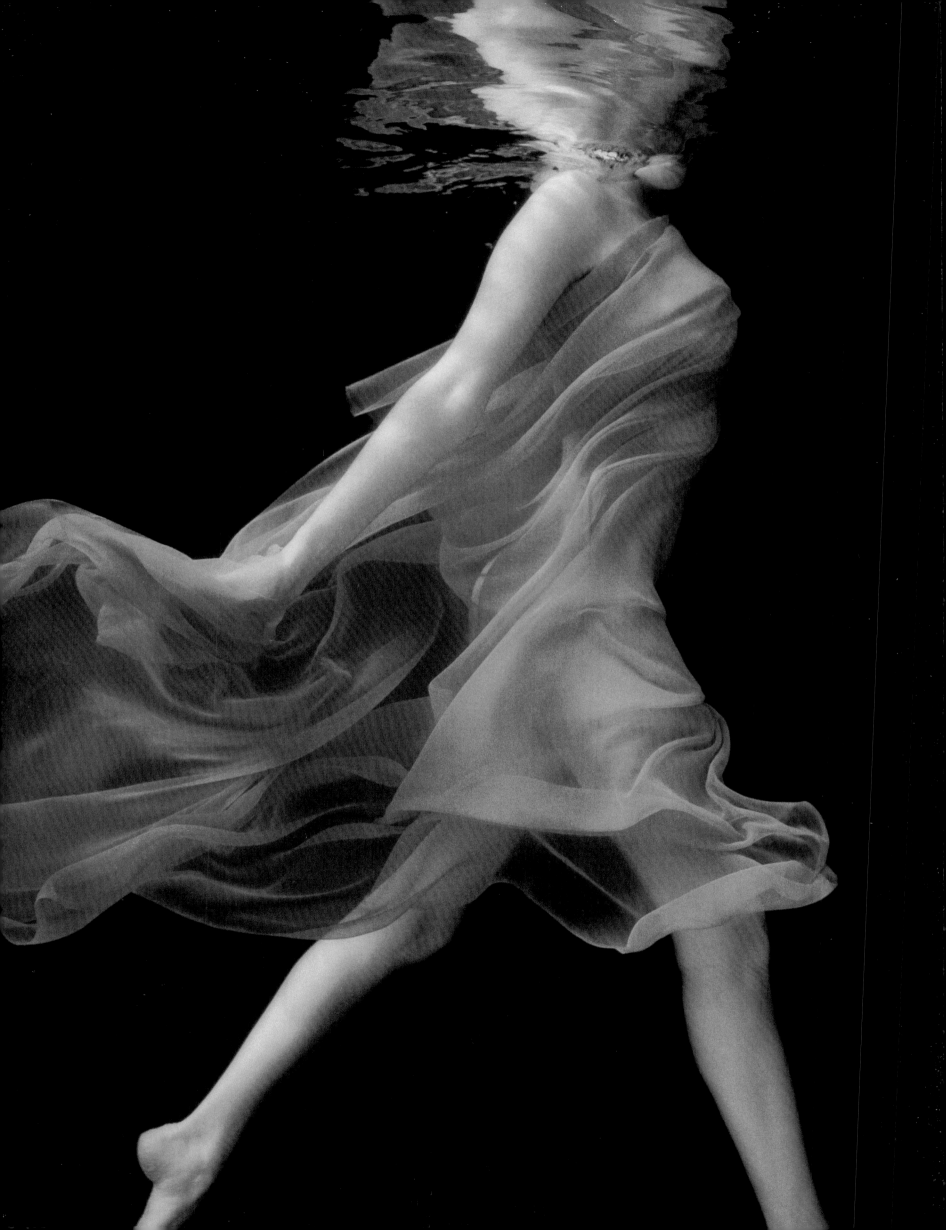

Fluid Dynamics

The title of this book – H_2O – is the terse and elegant symbol of what may be the happiest accident since the big bang, and a miracle pretty much beyond comprehension. Imagine: two atoms of one gas just happen to encounter one atom of another gas to create an entirely different substance, so implausible, so unlike the insubstantiality of air or the gritty reality of earth, that beyond its simple chemical formula, it seems to defy understanding.

It should be no surprise that the ancients understood this magical stuff to be one of the four elements that, with earth, air, and fire, composed everything. Or that in only the second verse of the Book of Genesis, God is said to create "the deep" before there is a firmament or even light. From what scientists tell us of the creation of life, water was the substance without which life, at least life as we know it, could not have happened. Countless meteors might have plummeted into a dry and desolate earth, but all that sound and fiery fury would have signified nothing had not water given their insensate organic compounds a chance to combine in strange and serendipitous ways. Whether one believes in reason or randomness, the intentional or the incidental, the mystery of water cannot be denied. Churches may offer basins of holy water, but, in fact, all water is holy.

H_2O has become for Howard Schatz what the air of the studio, the streets, or the great outdoors is for other photographers. He has so thoroughly adapted it to his artistic purposes that he and his subjects might be thought of as a new species of amphibians, living their lives on land but revealing their creativity beneath that infinitesimal membrane separating dry from wet. For the past fifteen years, Schatz has made water so much his own element, his own submerged pictorial world, that his work beneath the dappled surface of his swimming-pool sets must be considered both entirely new and delightfully definitive.

Over the years, other photographers have taken a dive, of course; at least a few have emerged with memorable images. Brett Weston, Toni Frissell, and Larry Sultan are some of the better-known camera artists who have made aquatic photographs in private and public swimming pools, with results that range from ethereal to intentionally comical. And legions of nature photographers have strapped on scuba gear to bring back visions of fish and fauna from a world filled with beauty, terror, and, literally, unfathomable mysteries. For these photographers, water is an environment to be experimented with or explored. Schatz has done something very different. Whereas others have used water as a part of their pictures, he has, more often than not, taken water out of the picture, rendering it invisible while keeping it in his artistic equation and making it the unseen partner to his subjects. It is the quality of water, not the water itself, that Schatz

finds so alluring. As with some sorcerer's transformative elixir, he can use this unseen substance to evict that bane of earthbound humanity – gravity – giving his remarkable troupe of naiads, Rhine maidens, and aqua-men the grail of weightless grace, the ineffable lightness of being. Water presents the photographer with unique problems, problems for which Schatz has developed exceptionally elegant solutions.

The ability of the camera to stop time is unique in art. Though painters and sculptors can create the illusion of action suspended, we know it's an illusion, since the artist works over a far longer period than the moment he preserves. The camera, on the other hand, makes a picture almost instantaneously, and over the years photographers have found it irresistible to show people and animals as if in flight. Cartier-Bresson's fat Parisian trying to leap a puddle (the impending splash, which we will never see, adds to our pleasure), Philippe Halsman's Duke and Duchess of Windsor surprisingly if reluctantly jumping a few inches off the floor, Richard Avedon's exuberant models as missiles, are all examples of what might be

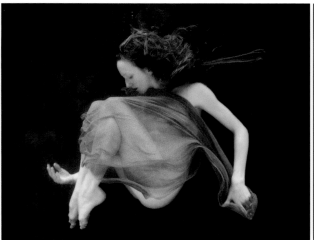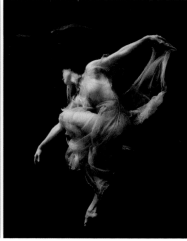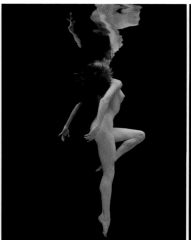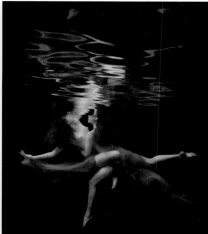

called the decisive-moment school, midair division. But despite the legerdemain of the freeze-frame, we know that the moment is just that – an instant caught and held for just a split second – not gravity defied but the observer duped.

Schatz doesn't give us time stopped; instead, he creates a new, uncanny continuum. His pictures, some-how simultaneously energetic and languid, do not imply the tension of split-second levitation but rather the kind of blissful, supernatural flight that normally takes place only in the shimmering territory of our dreams. As he has said, "I'm not freezing action, I'm finding moments in a dream." These bodies, unbound by the killjoy realities of Mr. Newton's immutable laws, give us a singular artist's view of – to borrow a term from engineering – fluid dynamics.

Photography, perhaps more than most arts, is a constant tug-of-war between Harmony and Invention. Harmony asks that what has worked in the past be allowed to go on working without interference. Invention, fidgety and easily bored, wants to move on, reveling in trial and unfazed by error. Schatz is a prime example of these two forces in near perfect balance. His education was in science, and before he became a photographer, he worked in a profession where the unexpected is not welcome. As an artist, Schatz courts accidents and depends on an aesthetic version of the law of unintended consequences to provide new ways of seeing. "I'm inventing all the time," he says. The best inventors know that more ideas fail than succeed (hence, the daily rigor of trial and error), and artists know that failures and accidents are what move vision forward. Unlike what young artists and writers imagine, a muse rarely sweeps grace-fully into the room but usually enters, if at all, with a lurching stumble.

Schatz's remarkable partnership with water thus began not with a revelatory bang but with happenstance

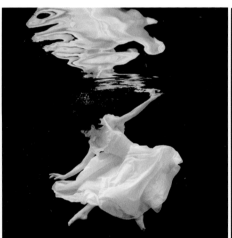 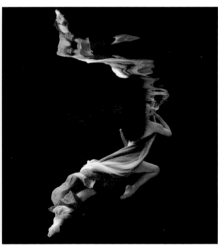 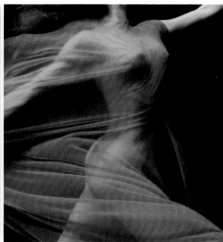 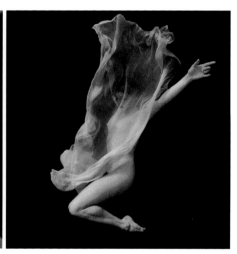

and some initial missteps (or, rather, missplashes). By 1994 he had already established a reputation as an insightful portraitist, with three books – *Gifted Woman*, *Seeing Red: The Rapture of Redheads*, and *Homeless: Portraits of Americans in Hard Times*. Because he was beginning to feel the effects of many years of hard-played handball and pickup basketball, he began to replace these sports with a daily swim in a private pool. But the fitness swimmer had the curious eye of a photographer. "One only needs to put on a pair of swim goggles and look underwater to discover the strange and beautiful world of light, bubbles, and reflections," Schatz says. He hadn't logged many laps before he was thinking about making photographs underwater.

Water Dance

I had met Howard socially, so he knew of my longtime interest in photography. One day he called and asked me to come to the pool with my teenage son to "try out an idea." The idea, it turned out, was to make a series of triptychs of people – first, standing fully dressed against a white wall; then, still in the same clothes, looking as nonchalant as possible, immersed in the pool; and finally, standing sopping wet out of the pool. His working title for the series was Vanity, Terror, and Humiliation. My son and I were a test, and I will admit that nonchalance was not accomplished.

On seeing the results of this and similar dunkings, Schatz knew immediately this was a one-joke concept with no staying power. He had many more ideas for how to use water in a new way, and more tryouts

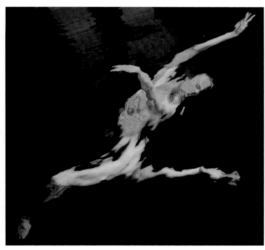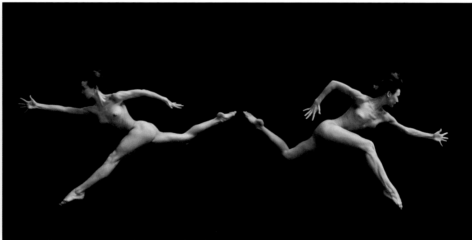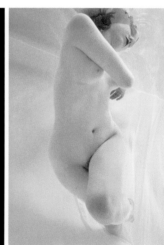

took place. Nothing worked as he felt it should. But through what he calls "mistakes and useless forays," Schatz was learning to manage water. With the deliberate methodology of a scientist, he analyzed the chemistry of pool water, studied books on underwater nature photography, spoke with experts who regularly dive with cameras, and haunted equipment stores to increase his technical proficiency. After six months, he had solved, one by one, most of the problems that water presented: light, color, clarity, temperature, buoyancy, even the way to attain the same pH as human tears so that his subjects' eyes wouldn't be irritated.

What he had not solved was what to do with his newfound ability to make a pool the perfect place for picture-taking. He had done scores of tests, used countless feet of film and a small army of subjects, but had not yet made that one photograph that provided an "Aha!" moment. Still, if it's true that luck favors the well prepared, Schatz was poised for some luck. When the pool was crystal clear, when he could make an image of a person with normal skin tones, when he had figured out how to place strobes safely outside the pool area and still control light, when "the water didn't burn the eyes and freeze the bones,"

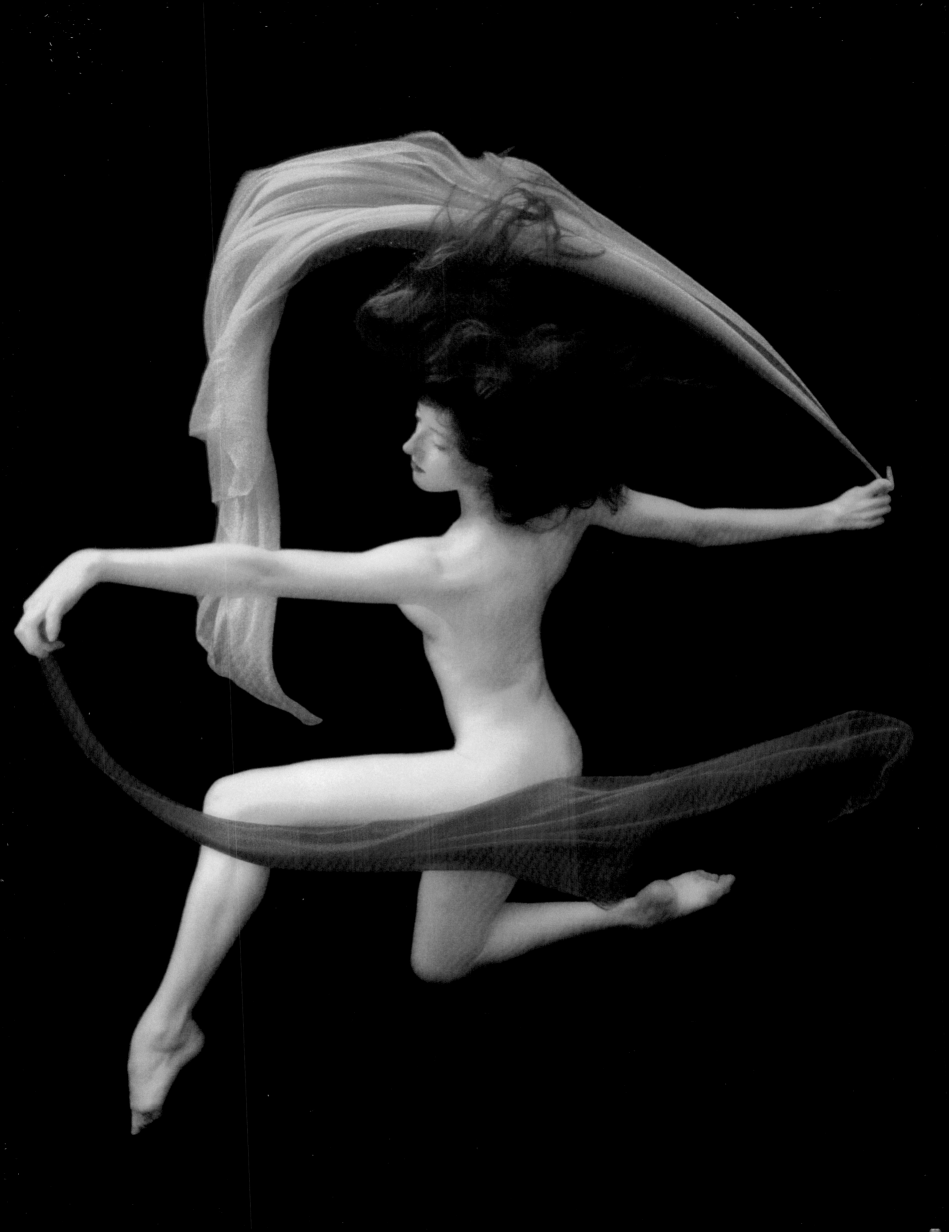

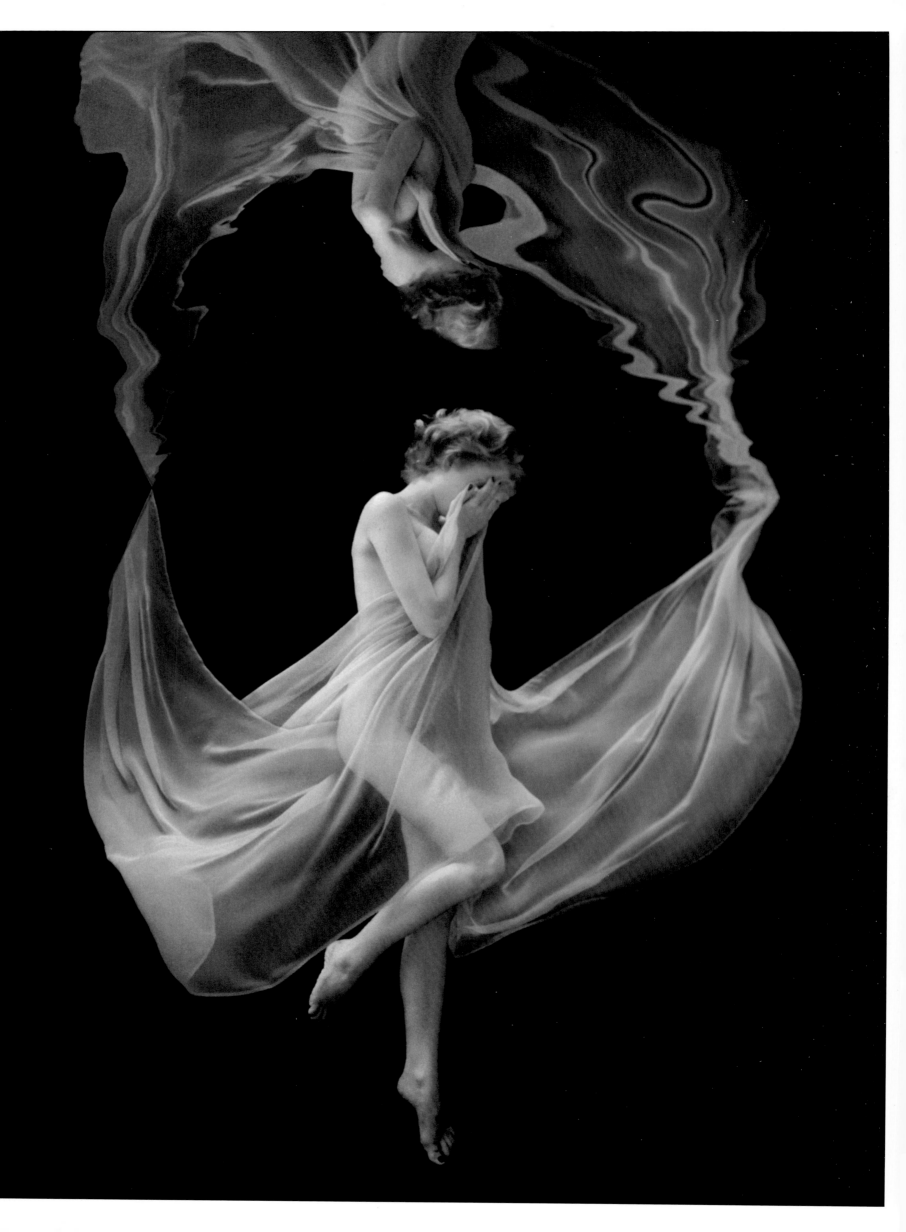

he picked up the telephone and called Katita Waldo, a lithe prima ballerina with the San Francisco Ballet who had appeared on the cover of *Seeing Red: The Rapture of Redheads*. "Katita, can you swim?"

"Sure," the dancer answered matter-of-factly. And from that moment on, the shimmering fugues of harmony and invention to be found in the pages of this book were set in motion.

There are times in art when model and muse merge; after a few hours in the pool with the ballerina, Schatz had his revelation and his inspiration. He realized that dancers were exactly the right subjects for this medium. They had near perfect control of their bodies, they could react instantly and accurately to direction, and, when set free of gravity, they would respond with amazing grace and a kind of delighted gratitude.

The pas de deux of photographer and dancer yielded extraordinary results (and signaled an end to the pool as a pool, and the beginning of the pool as stage and studio). Other dancers from the ballet became

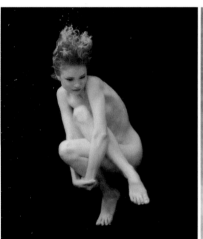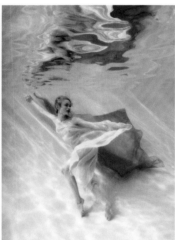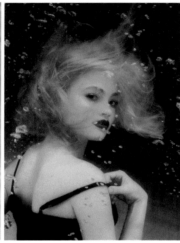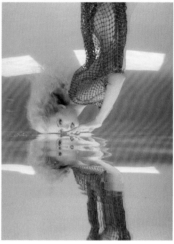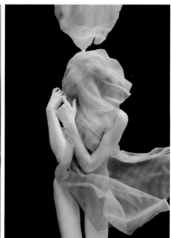

part of the underwater repertory company. Hours, days, and months of work followed, with dancers learning how to express energy in a world without gravity, a strange new counterpoint to their illusion of weightlessness onstage, and with Schatz refining the techniques necessary to direct choreography effectively while treading water. After about eighteen months of Schatz's making new images, several of the pool photographs were published in the annual photography showcase published by *Graphis*. B. Martin Pedersen, the publisher of *Graphis*, called one day to ask, "Do you have any more of these images?" And so, in 1995, *Water Dance*, Schatz's first book of underwater imagery, was published.

Pool Light

Having found his theme, Schatz began to explore what has become a flood tide of variations, all the while adding to his troupe of willing and pool-friendly dancers, and to his self-imposed challenges. Unlike the bumblebee, which ought to know that it isn't properly designed to fly, Schatz was well aware, after half a year of exploratory work, that what he wanted to accomplish was going to be difficult: nothing less than perfectly composed pictures that brought the buoyancy of outer space to the intimacy of inner space.

Every day's underwater sessions revealed something new, or something that needed further experimentation, and sometimes led him only to an evolutionary dead end. How did this fabric look in the water, as opposed to that one? What colors were best, and what lighting matched what moods? How much

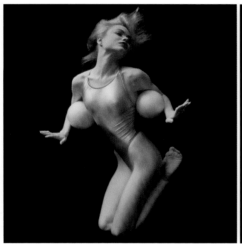 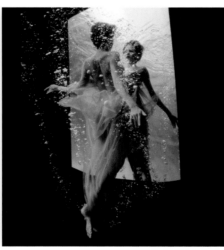 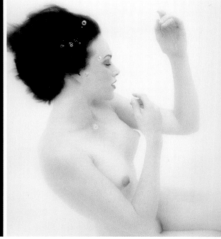 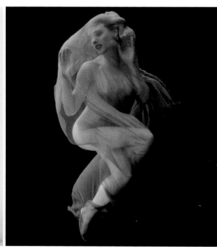

should water be allowed to transform the tone of a dancer's skin? When should the natural give way to the supernatural? As the work went on, Schatz began to counteract his own previous effort to make water invisible by making it part of the picture, with ripples bending light, or scrims of bubbles surrounding swimmers, and especially with alluring reflections in the mirrored "ceiling" of the pool surface. This undulating mirror has let Schatz create two pictures in one: a realistic image and a more figurative rendering that is somewhat abstract and random. The reflections range from simple distortions (as in a fun-house mirror) to the hyperenergetic whorls and eddies of Pollock or de Kooning. Each discovery, every energizing accident, led to another series of experiments, and these new images were the genesis of Schatz's second underwater book, *Pool Light*.

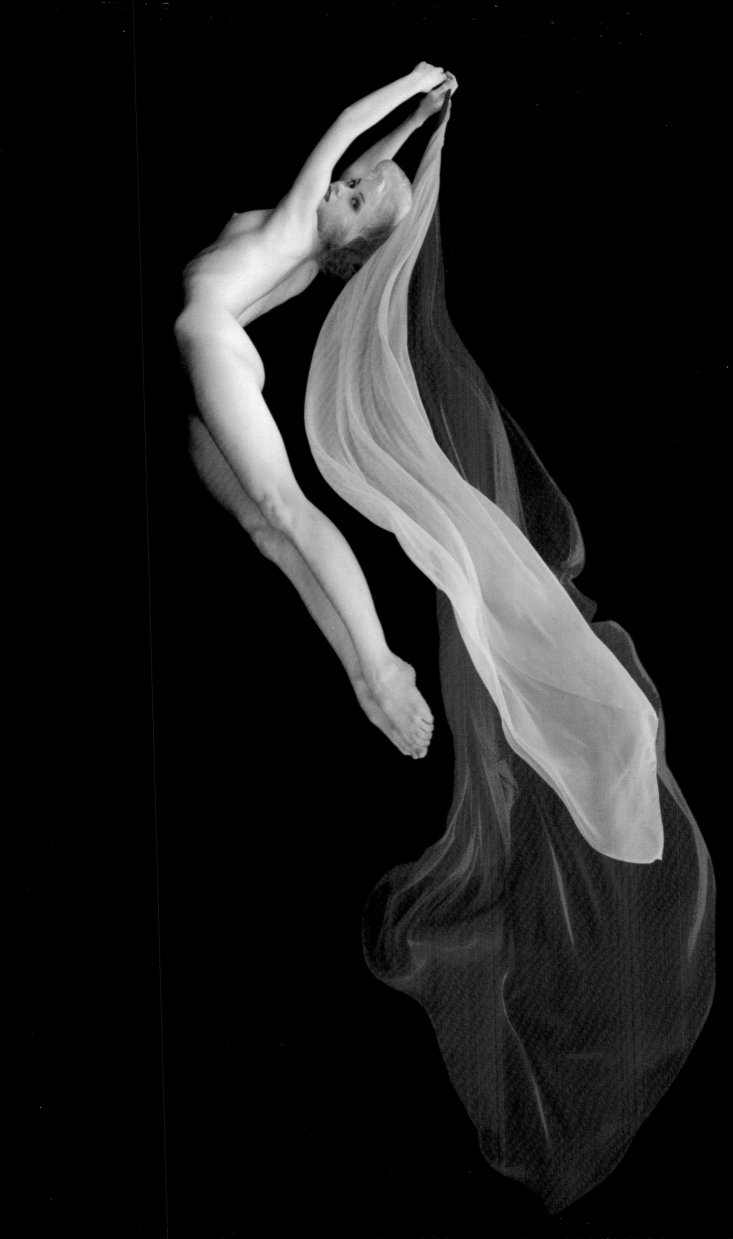

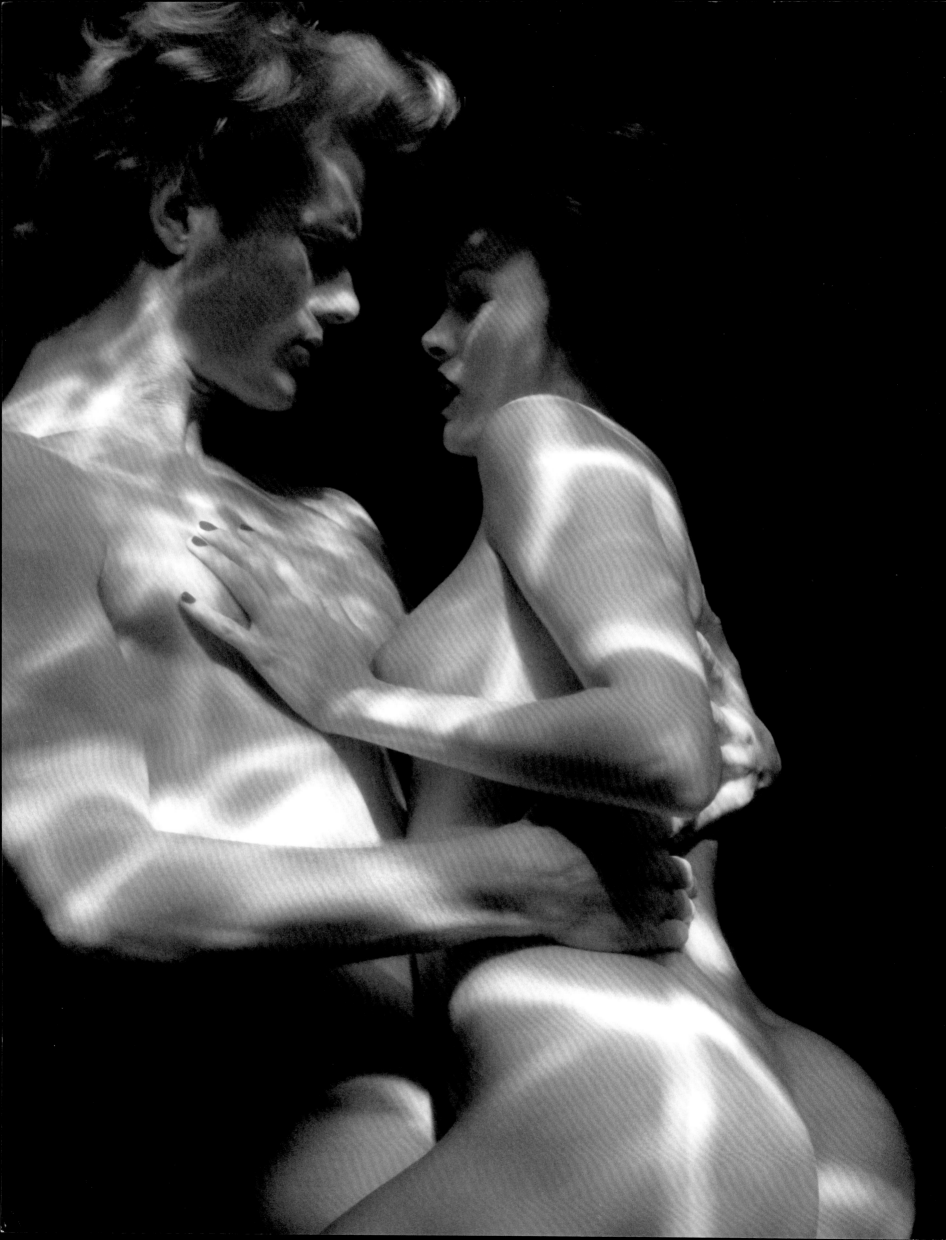

Nude Body Nude

As Schatz learned to exert more and more control over the elements in his pictures, the reflections provided the pleasure of accidents and surprises that impelled him from photograph to photograph. Though he could affect how close a dancer came to the mirroring surface, or whether there were any reflections at all, the final form of these visual echoes was the work of the spontaneous creativity of water itself. As his pursuit of the human form continued, in the water and out, Schatz embarked on an intensive study of nudes, which was published in the book *Nude Body Nude*, incorporating some of his ongoing underwater explorations.

Schatz's work became better known, and he was commissioned to bring his underwater mastery to fashion editorial and advertising campaigns. Inevitably, these assignments brought about a move from California

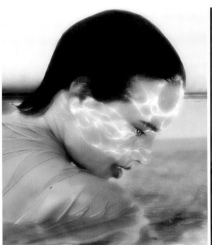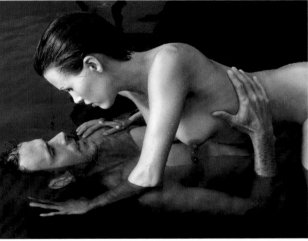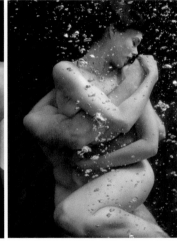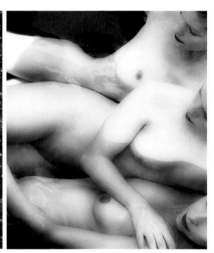

to New York City. Fashion work required a change from dancers to professional models, a species that could be considered freaks of nature. It's a mysterious fact that models, who may not be beautiful in person, are transfigured by the camera, while the looks of a woman who turns heads walking into a room may not survive the coolly objective appraisal of the lens.

What mattered to Schatz was not just how well the models photographed but whether they could look beautiful underwater. This drastically narrowed the field. To be fair, a young girl who is striking enough to interest top model agencies won't have given any thought to how long she can hold her breath or how relaxed she can look when emptying her lungs to sink to the bottom of an eight-foot pool. So, a new challenge loomed. "Very few fashion models can do this work," Schatz says. "In casting over a thousand models during the past ten years, I've found only a small number capable of doing this. It has to do with comfort, and for some reason few (with the exception of dancers) are totally comfortable underwater." Mercifully for both the photographer and his prospective models, Schatz can usually tell very quickly if a woman is to the moisture born.

At a California casting session in 1994, early on in the search for models who could give him the combination of photogenic looks and amphibian poise, after testing more than thirty women without success, he found himself in the water with a lissome blonde named Shawnee Free Jones, a young woman who had grown up in Fiji and lacked only gills to be Schatz's dream of aquatic perfection. "She went underwater, smiled, turned gracefully to face the camera, drifted down, and played…all beautifully."

Water Dance had not brought an end to Schatz's fascination with the sublime effect of water on bodies and materials, yet one can't help wonder if his interest might have ebbed had it not been for the revelation that it actually was possible to find models as beautiful in a pool as on a runway. Jones appears, ethereally appealing, on the cover of *Pool Light*, the book that resulted from the sessions that began that day, and although there are other marvelous models in the book, including Julie Montgomery and Tabitha Garza, Jones is clearly the photographer's second great inspiration. "I didn't have to teach her anything," Schatz

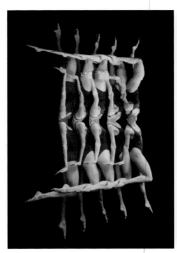 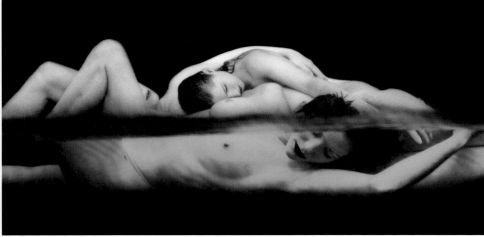 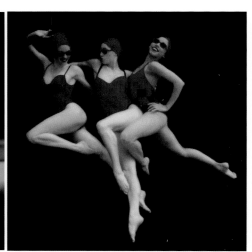

says. "All the lessons of hyperventilating, releasing some of the air in her lungs, opening her eyes, relaxing her face…all were unnecessary. I only had to say a word or give a subtle suggestion, and a world of surprises unfolded in front of my lens."

In downtown Manhattan, Schatz's SoHo studio work in fashion editorial and advertising took up more and more time. While working on print and television ad campaigns and creating books on athletes, actors, dancers, and flowers, he continued to fly back to California to produce pool pictures. After seven years of this routine, he and Beverly Ornstein, his wife and creative partner, designed and built a pool north of New York City, expressly for making photographs. However busy with assignments they may be in the city studio, every Monday is devoted to work in the pool, with a steady cavalcade of assistants, stylists, costume designers, and, of course, models and dancers making the pilgrimage from Manhattan. Indefatigably, passionately, some might say obsessively, Schatz pushes the form that is essentially his invention, using his rich palette of innovations, techniques, and directorial skill — before, during, and after the clicking of the

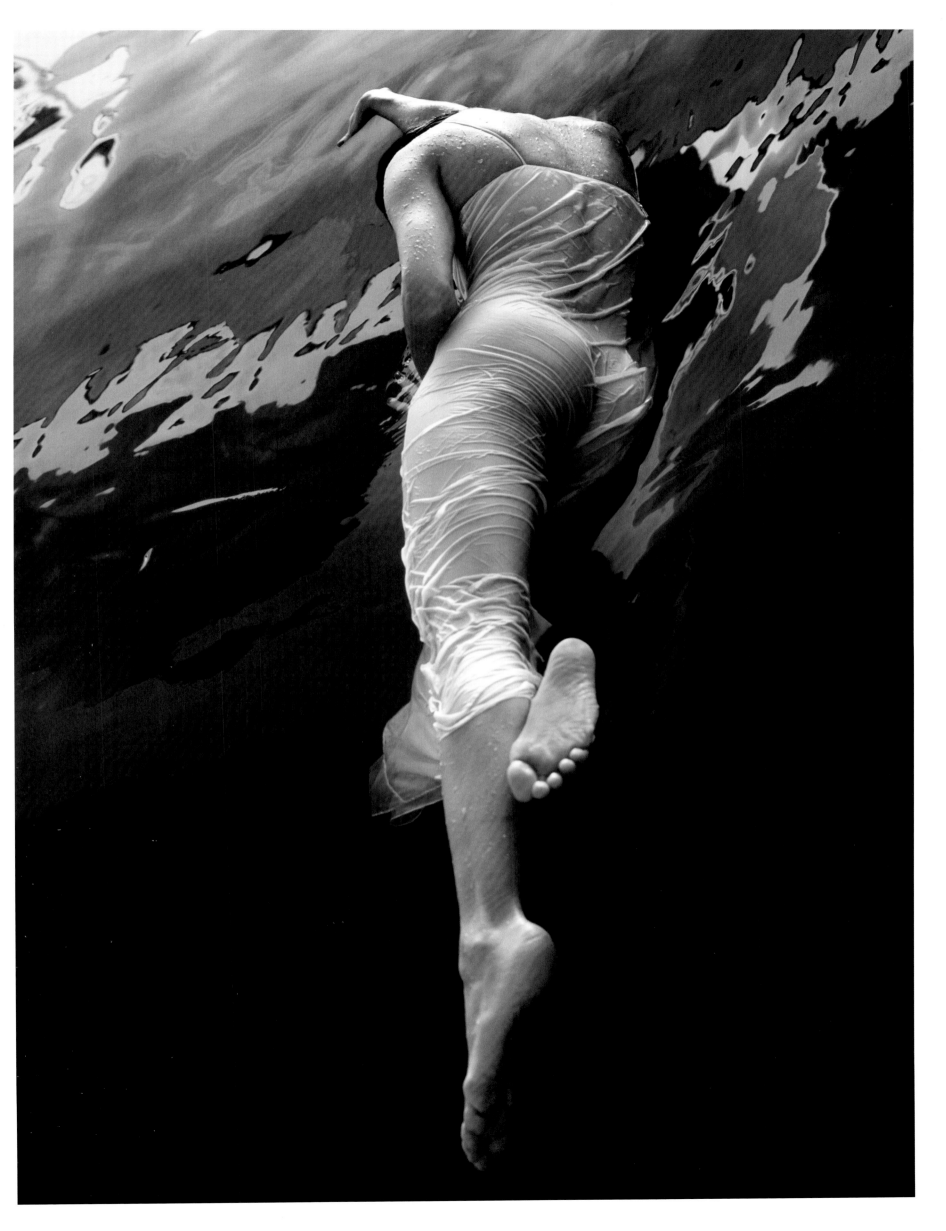

shutter. To create compositions that range from serenely (if deceptively) simple to group portraits that are nothing short of theatrical set pieces, he puts to use all the gifts that water gives him – the ripples, the bubbles, the myriad reflections, the impressionistic light and shadow, the lyrical suspension (of bodies and disbelief), and, above all, the mystery – and goes on surprising himself and us. Like a modern-day Prospero, he has conjured a brave new world where we, like Miranda, can be awed by the wonder and beauty of the people in it.

There is a sense of magnum opus about this book, of a summing up, of the last word. What more, after all, can possibly be done? Looking at a photograph such as *The Last Supper* (p. 149), one can't help but think this is surely the final word on what can be accomplished using a camera underwater. With its masterful costumes, makeup, and pantomime, and its dizzying complexity, the dazzling ensemble piece, like Joe DiMaggio's fifty-six-game hitting streak, can be viewed as something no one will surpass, not even Schatz himself. The group portrait is Irving Penn's classic 1947 *Twelve Beauties* (plus one) transported to

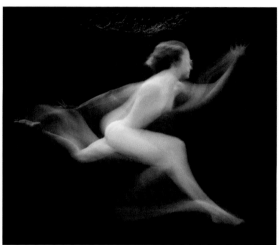
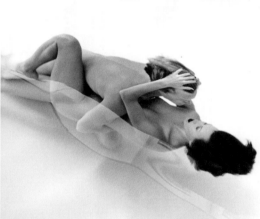
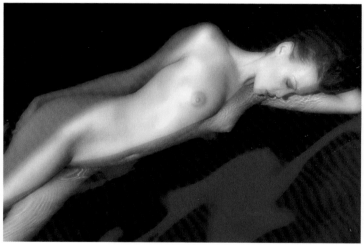

another, implausible realm. How is an encore possible? But doing what Schatz does is hard, no matter how much he knows about doing it, and the constant effort to leap the bar he himself keeps setting higher will no doubt prove impossible for him to resist. And, not the least of lures to continue: Prospero in the pool is having a fine time surprising himself and us.

I have had the pleasure of writing about Schatz and his extraordinary work on many occasions, starting in 1993 with an introduction to his second book, *Seeing Red: The Rapture of Redheads*. I've been most intrigued by his pool pictures and am always challenged to find the right words to describe them. As a matter of professional pride, I don't like to repeat the same words over again to describe photographs, and I particularly don't like to use especially resonant words twice to describe especially resonant work. But looking at the ceaselessly engaging inventions that make up the harmonic whole of Schatz's visual water music – the soaring arpeggios, glissandos, and cadenzas that he composes for his models to perform – I can only return to a word I've used at least twice before in writing about his astonishments, and cannot improve upon: Rhapsody!

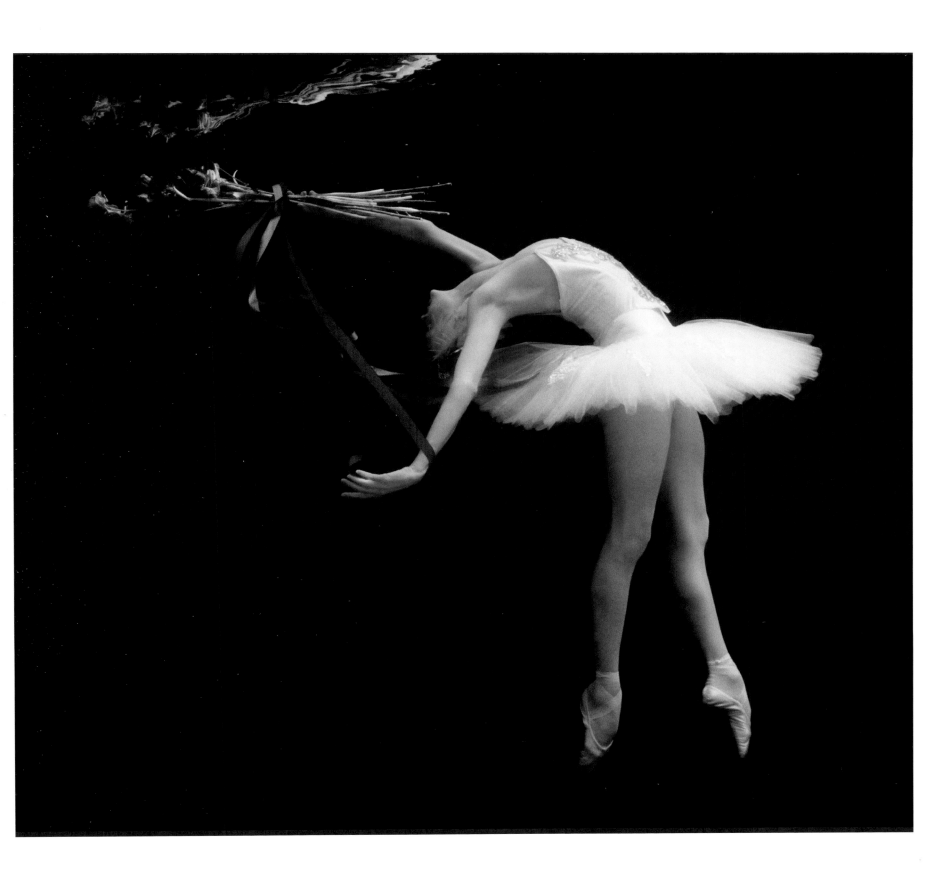

H_2O

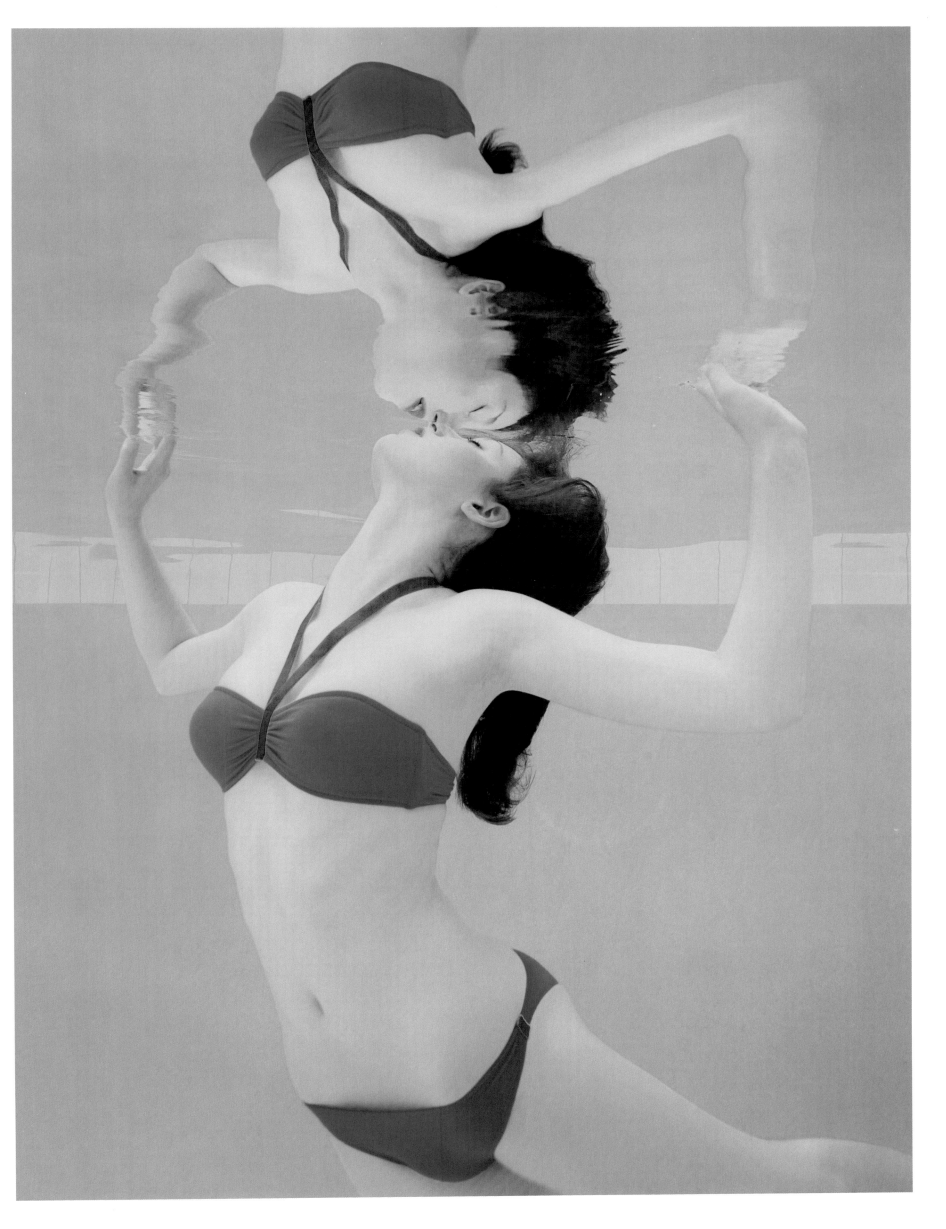

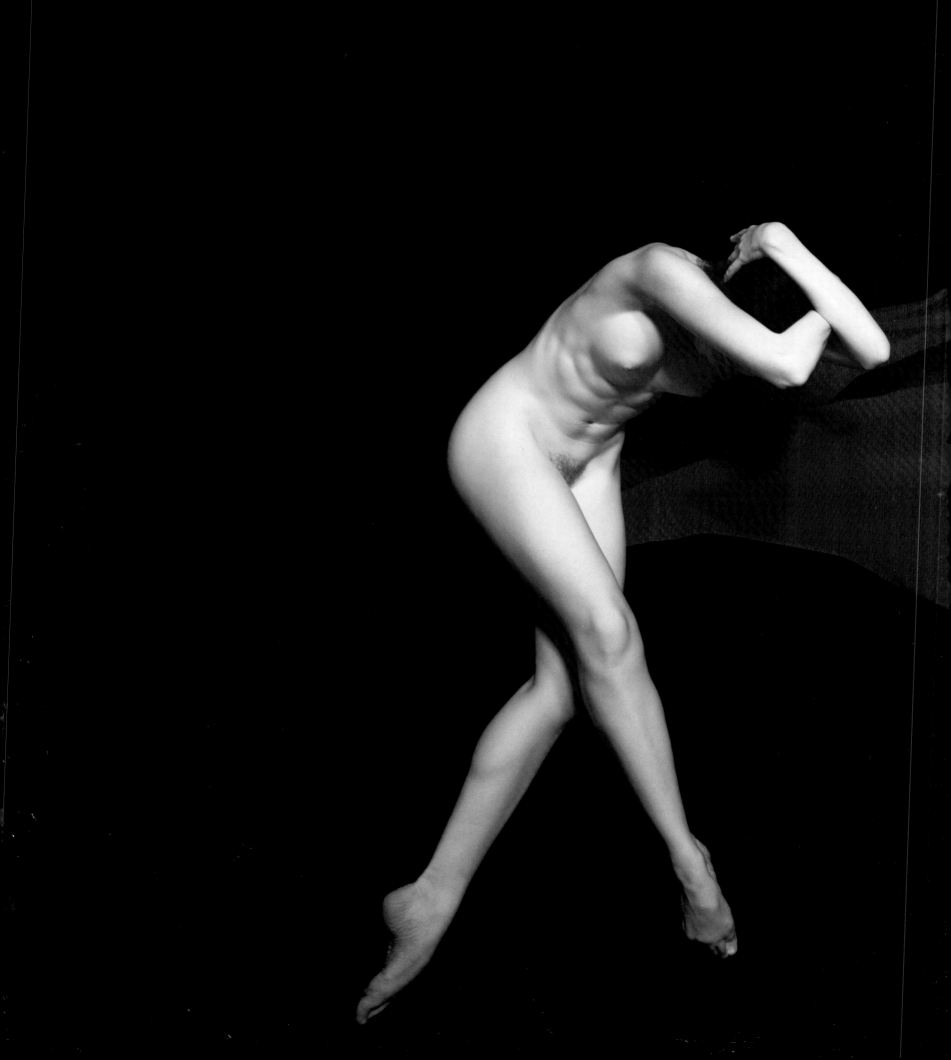

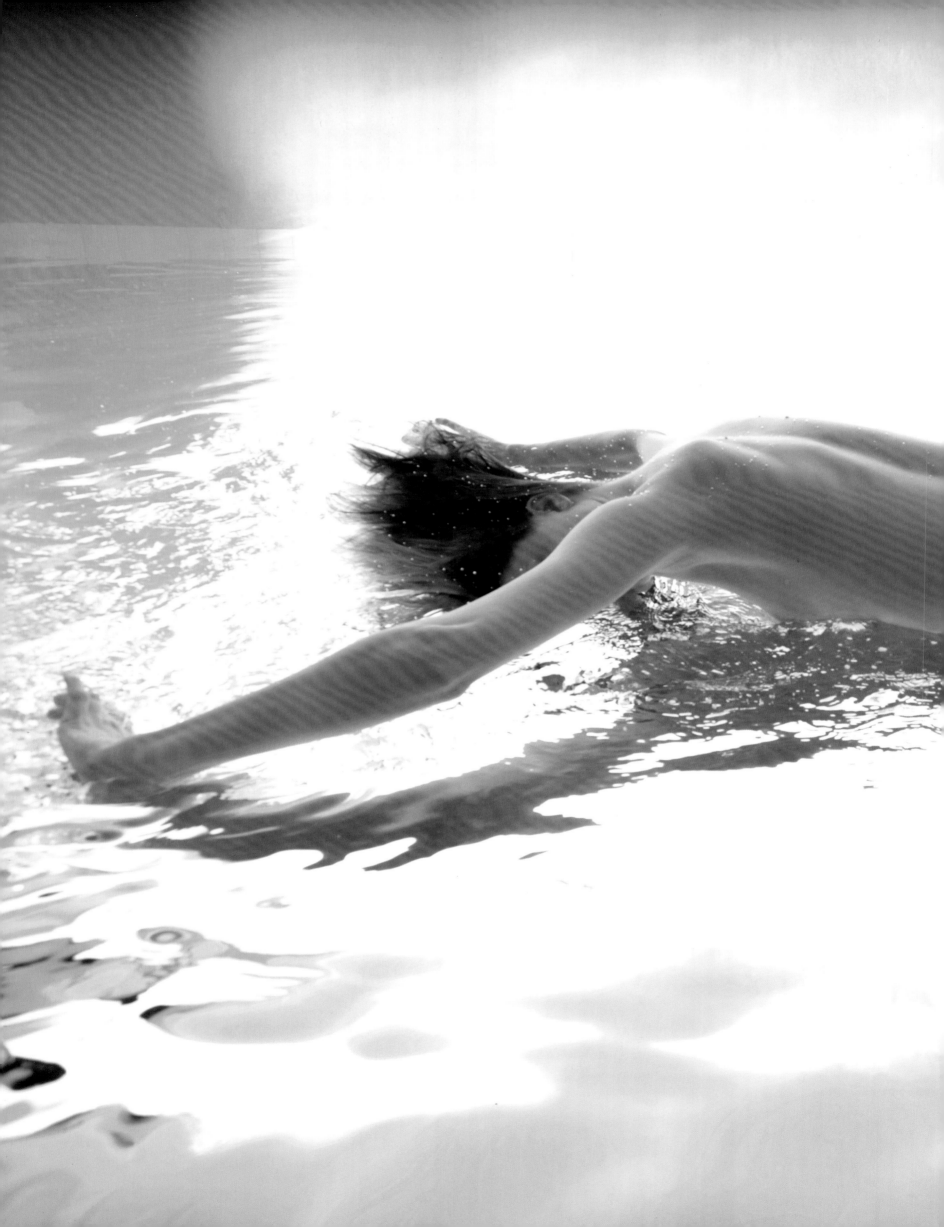

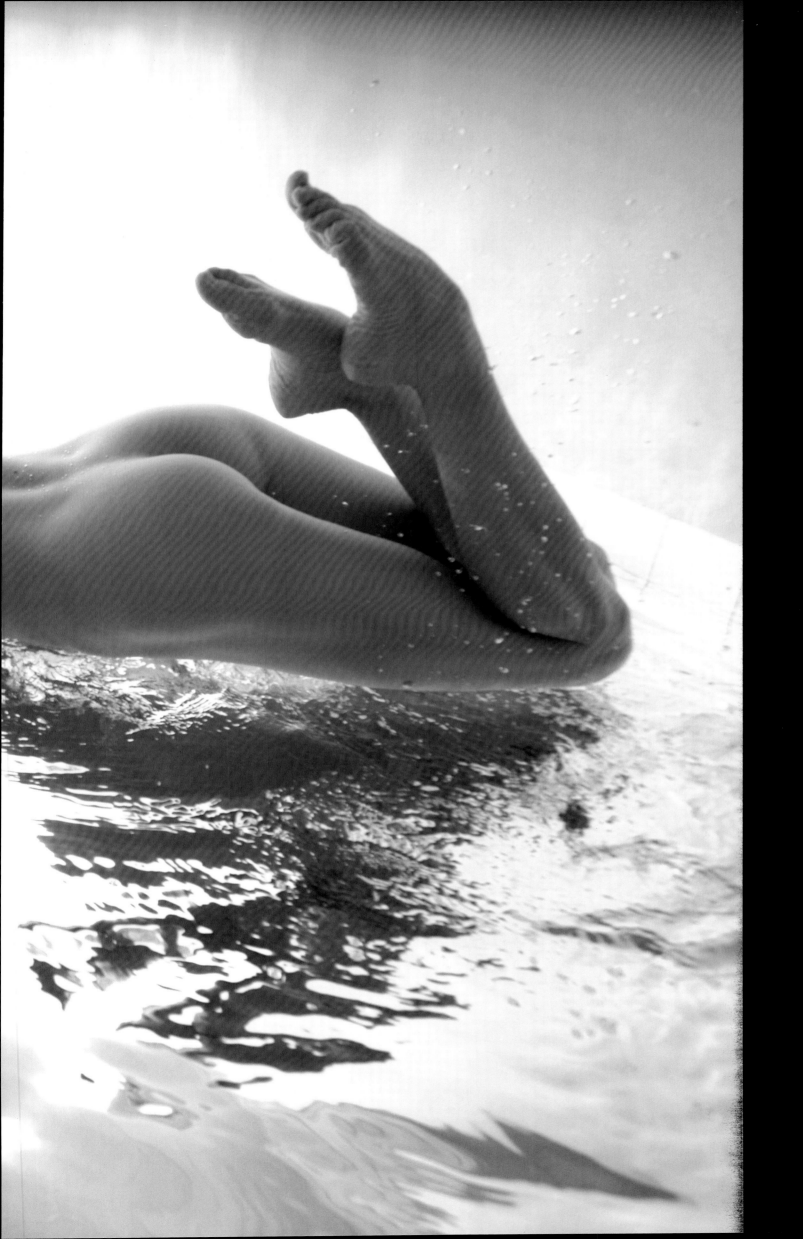

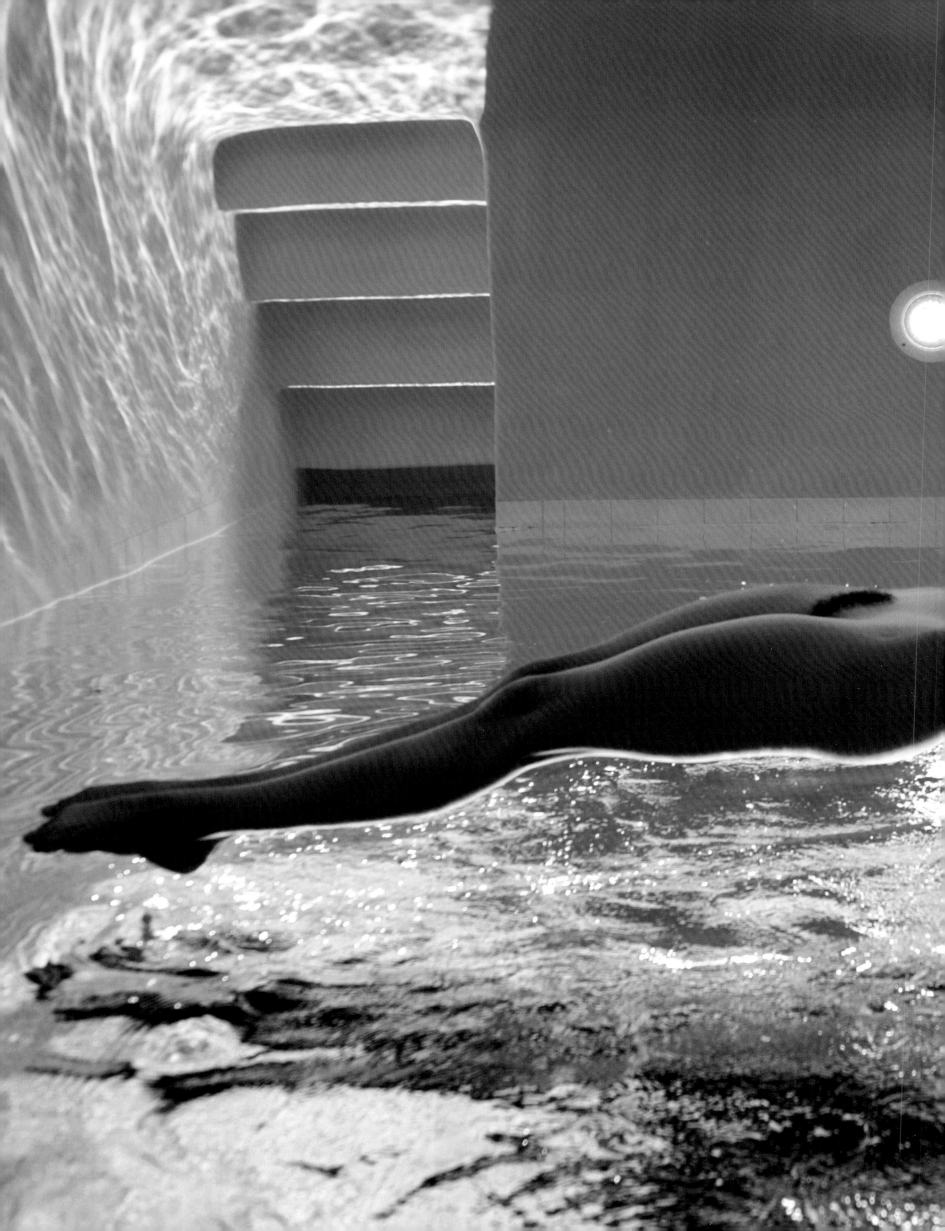

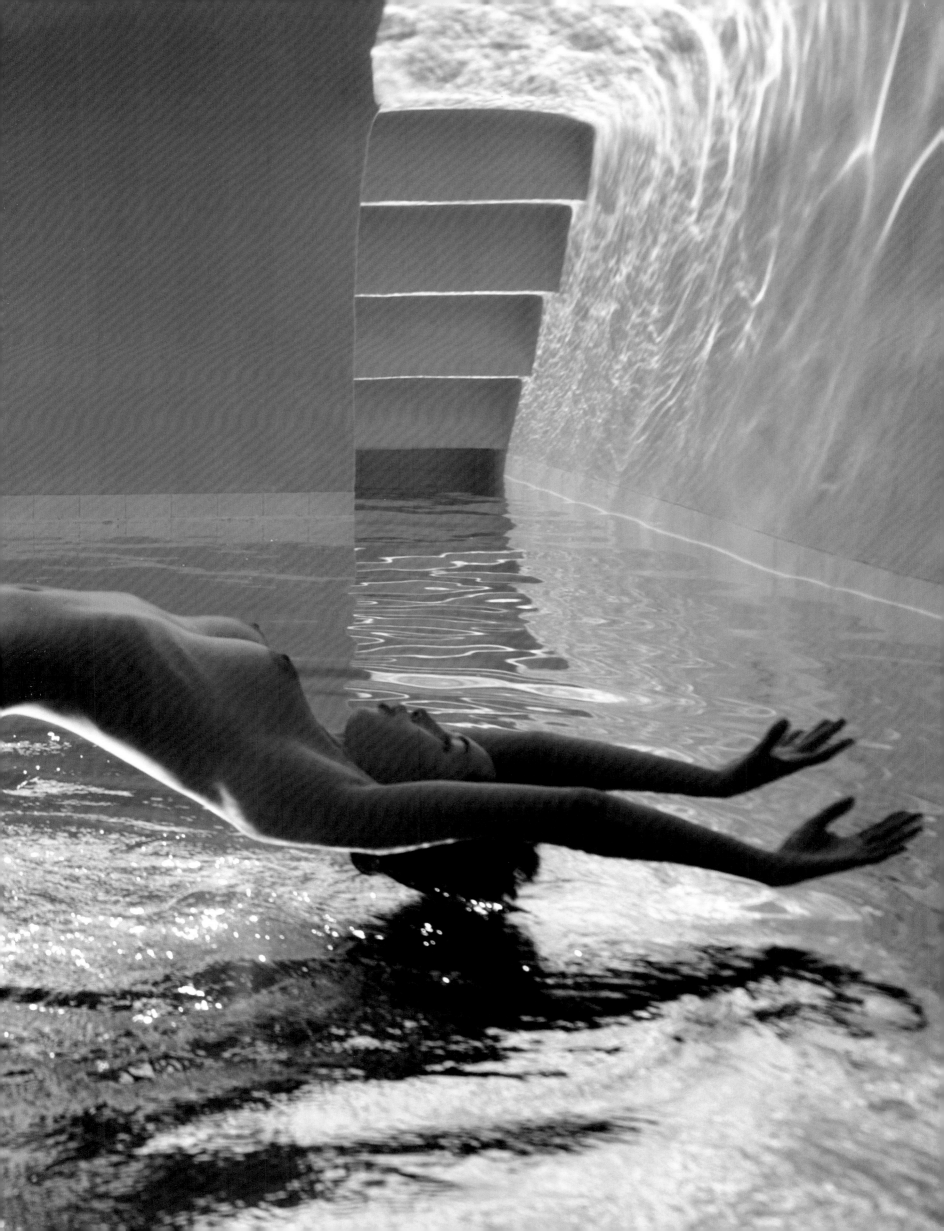

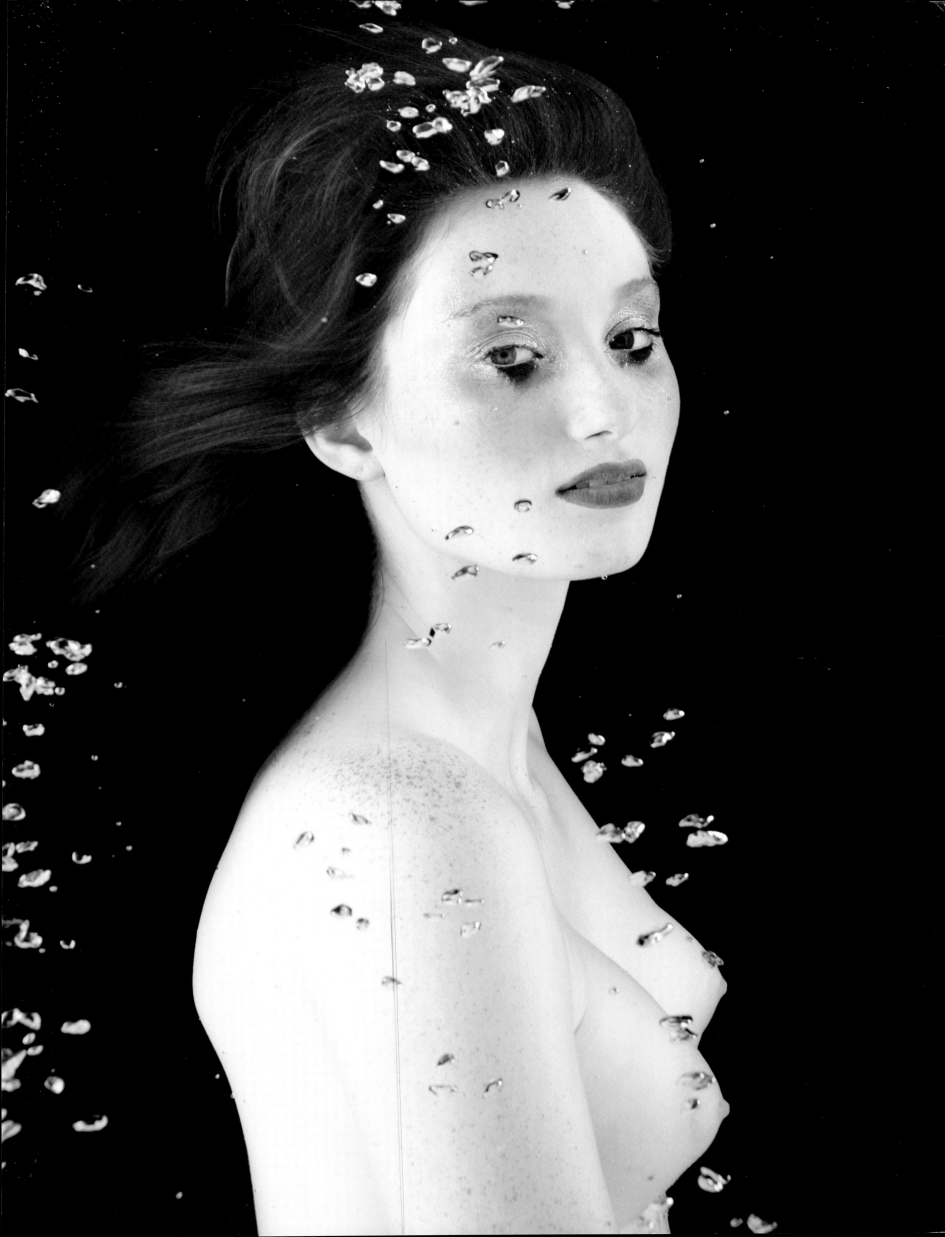

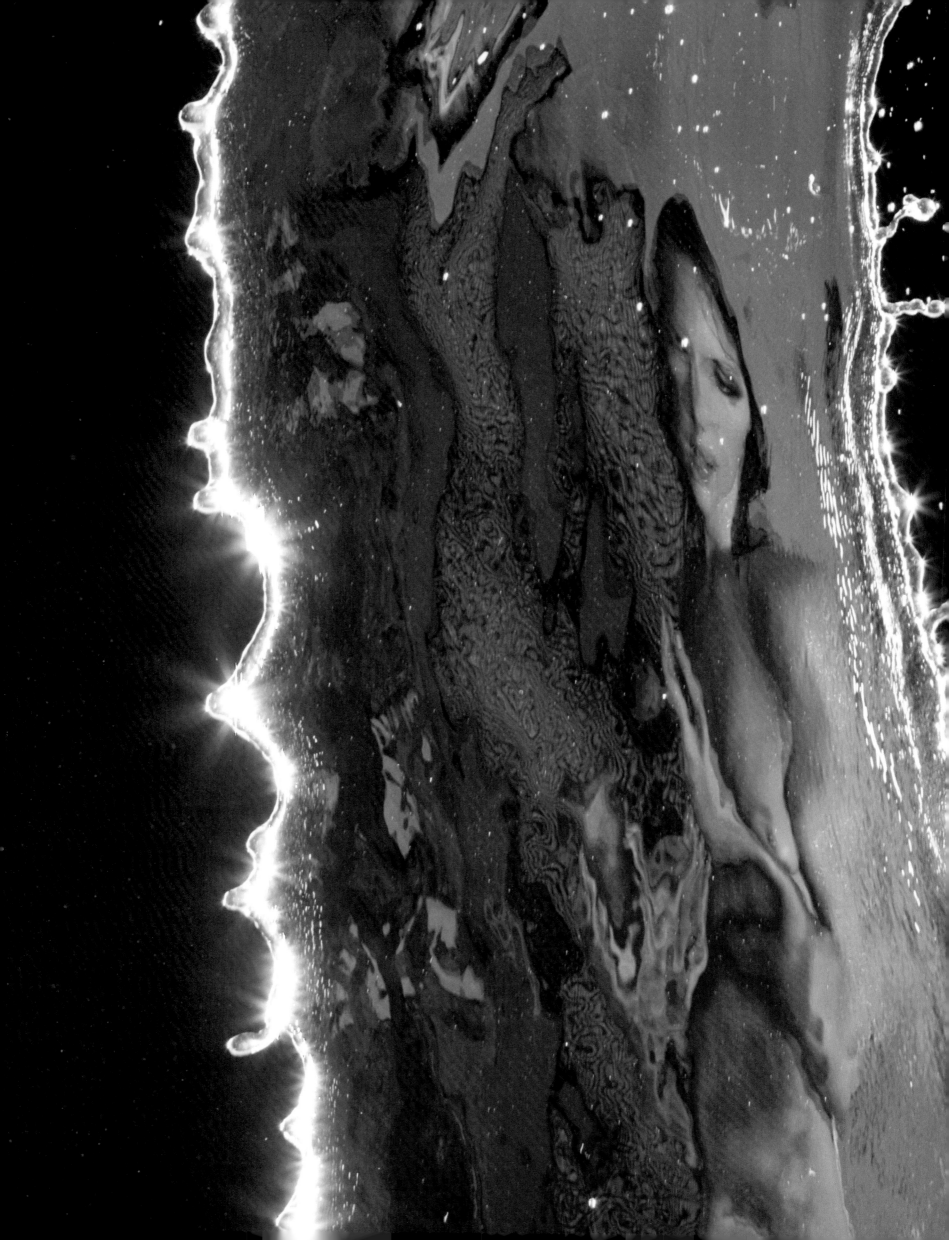

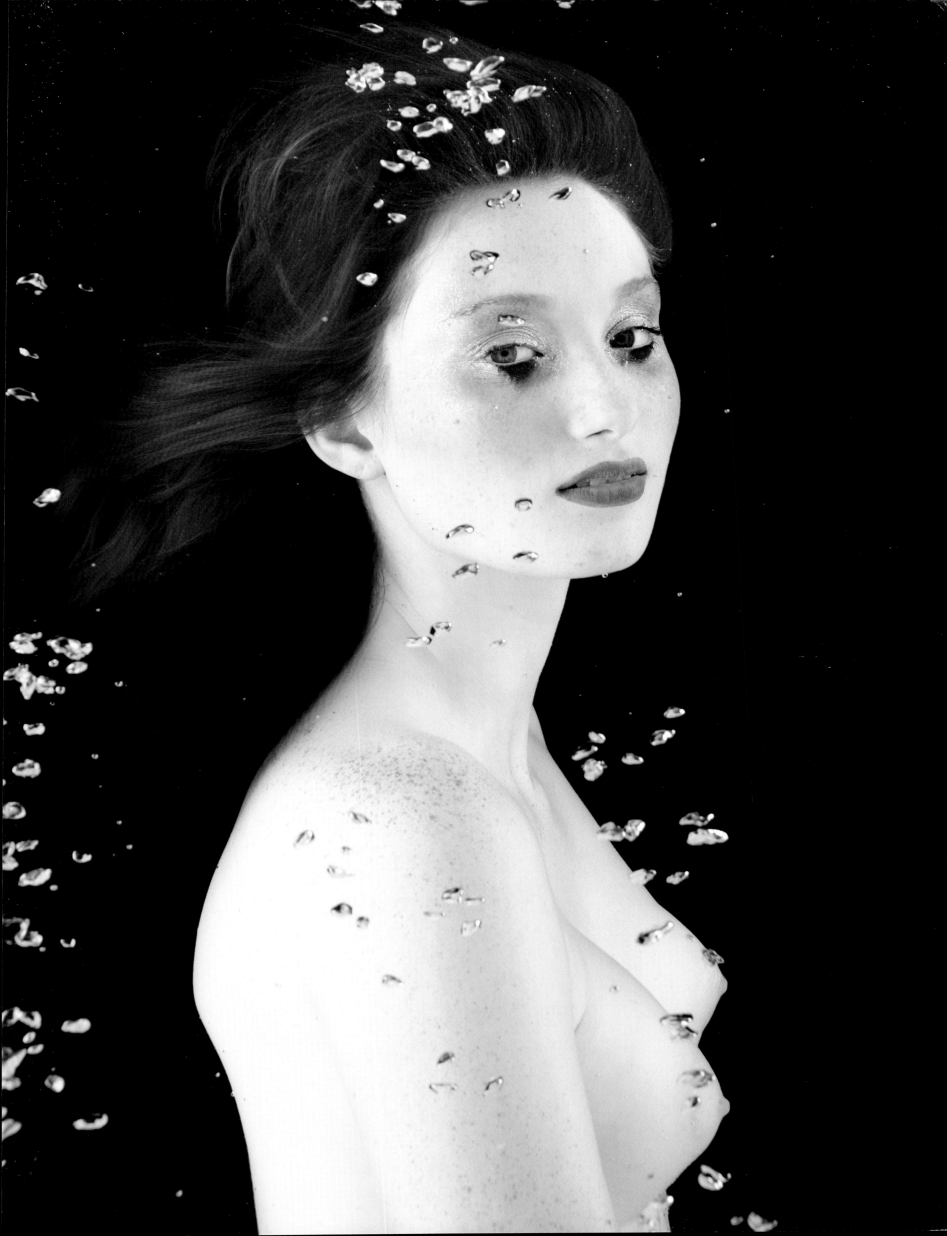

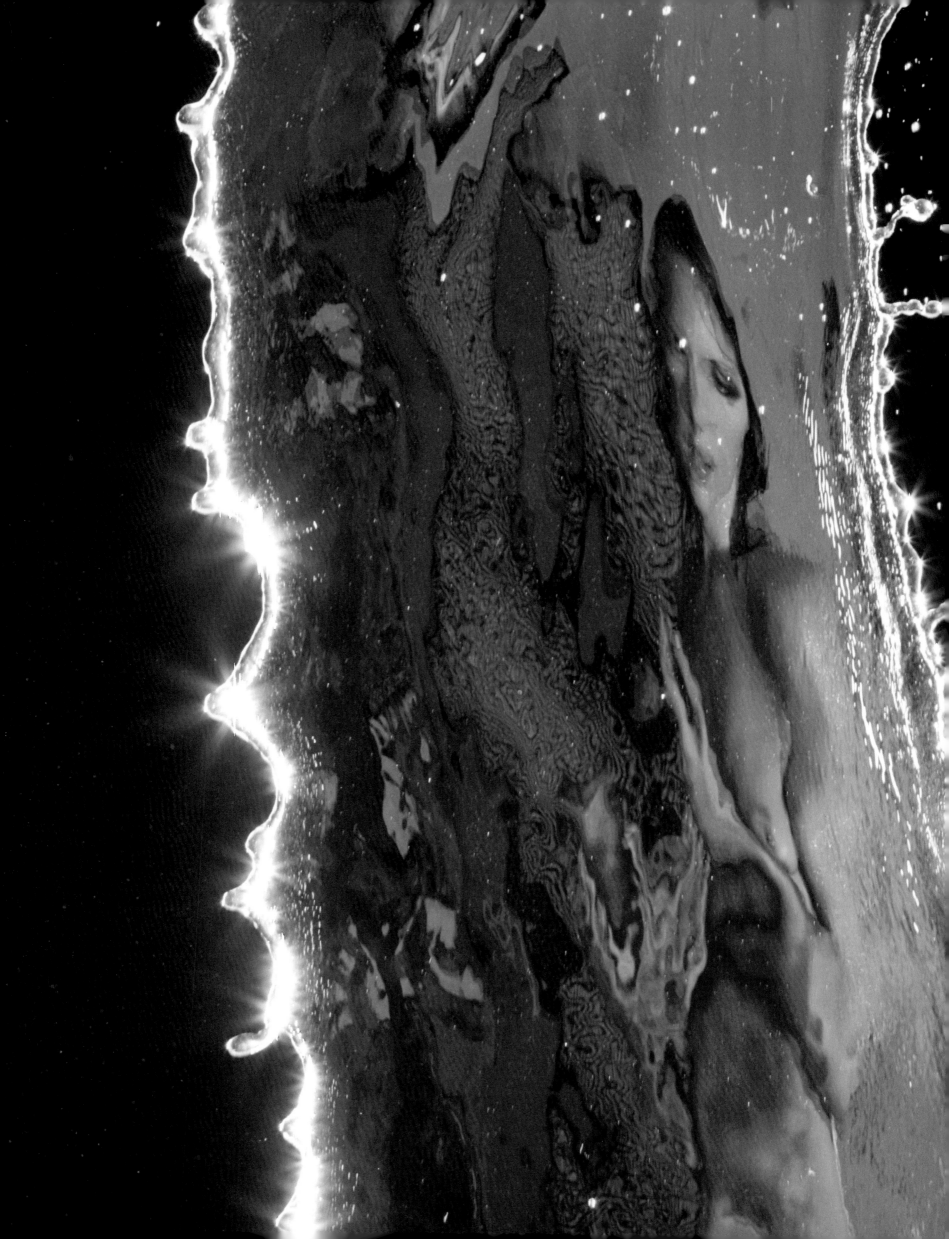

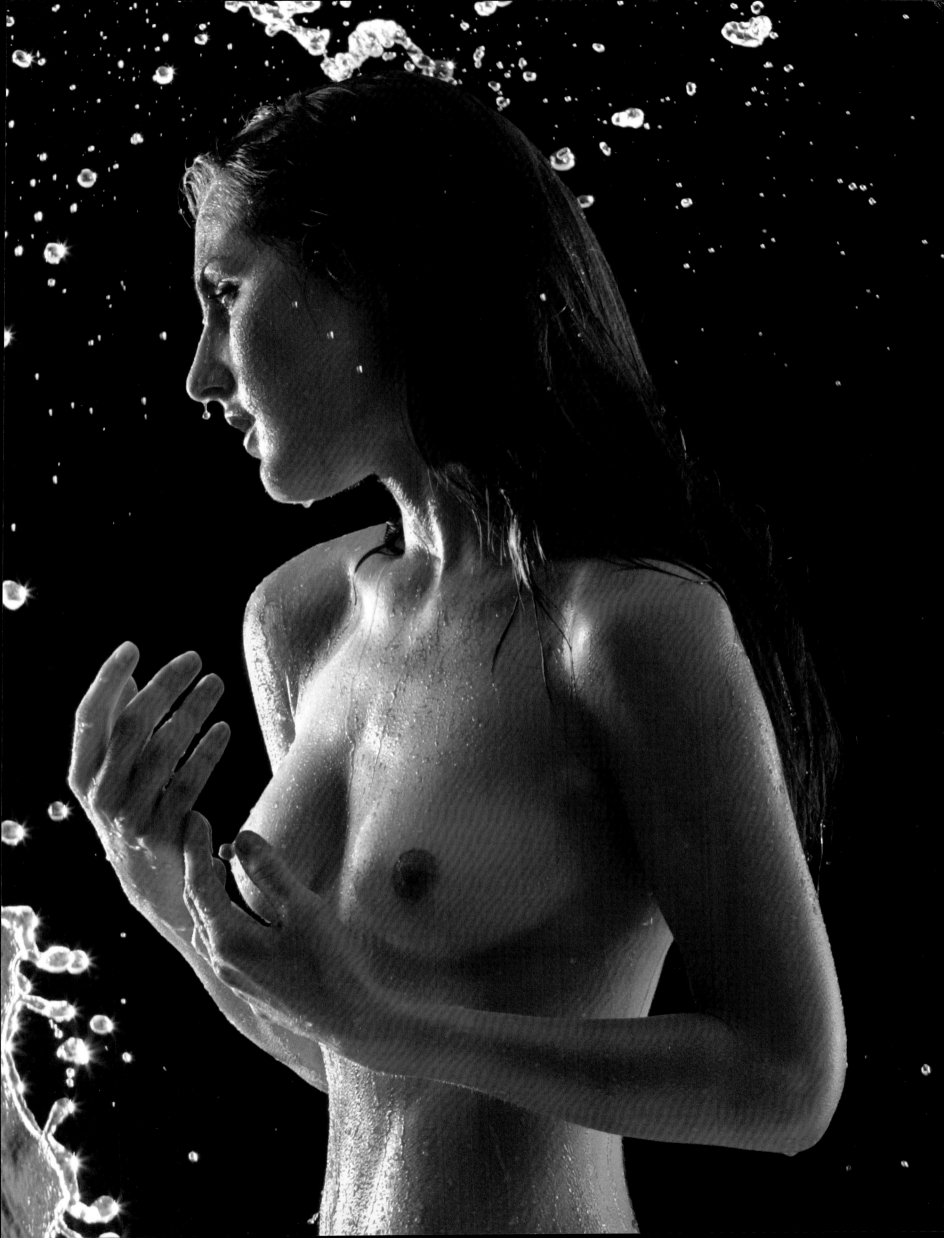

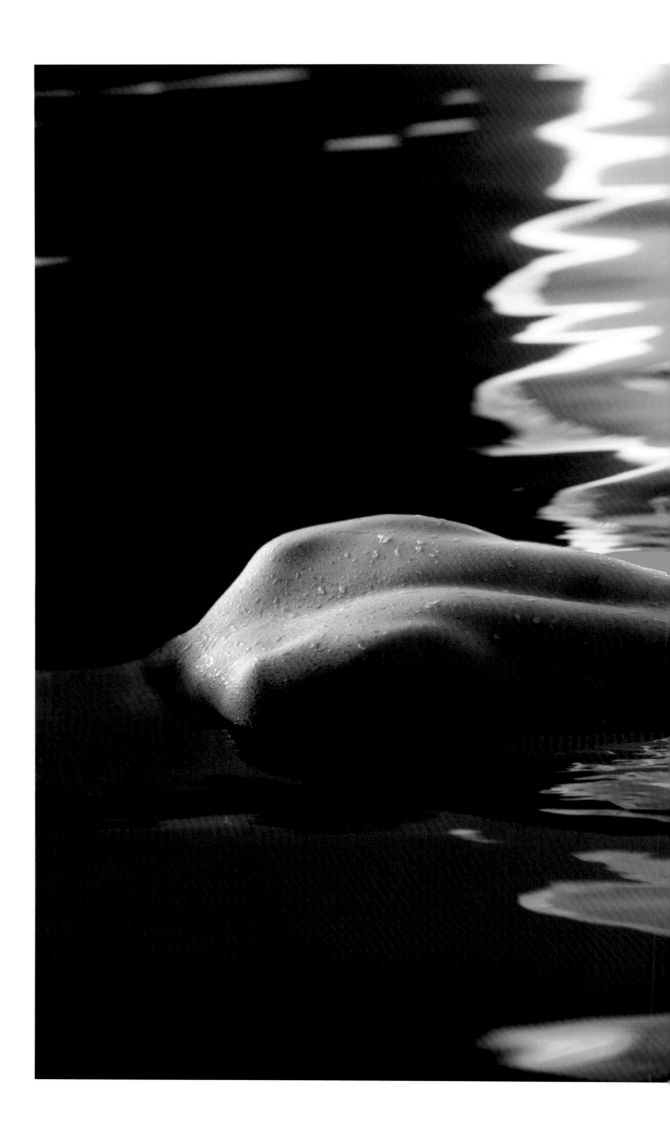

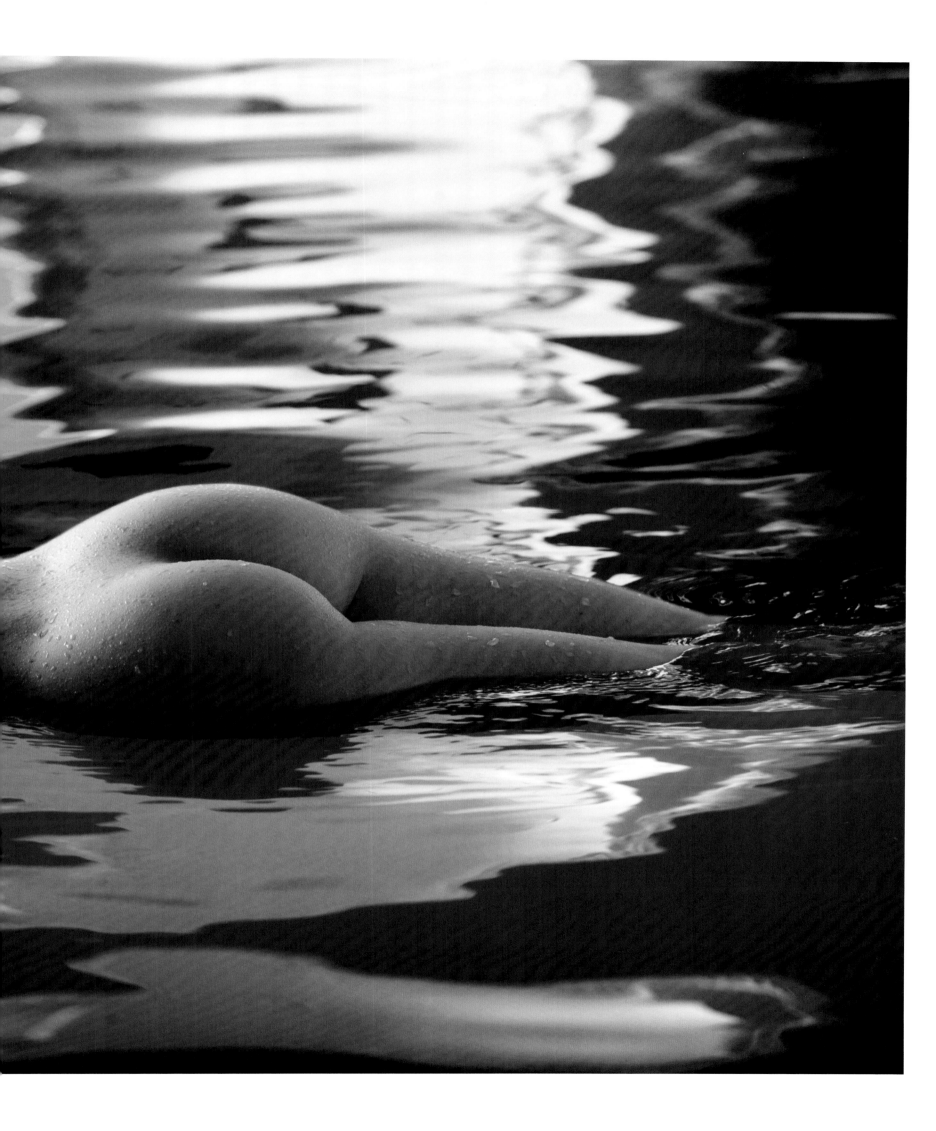

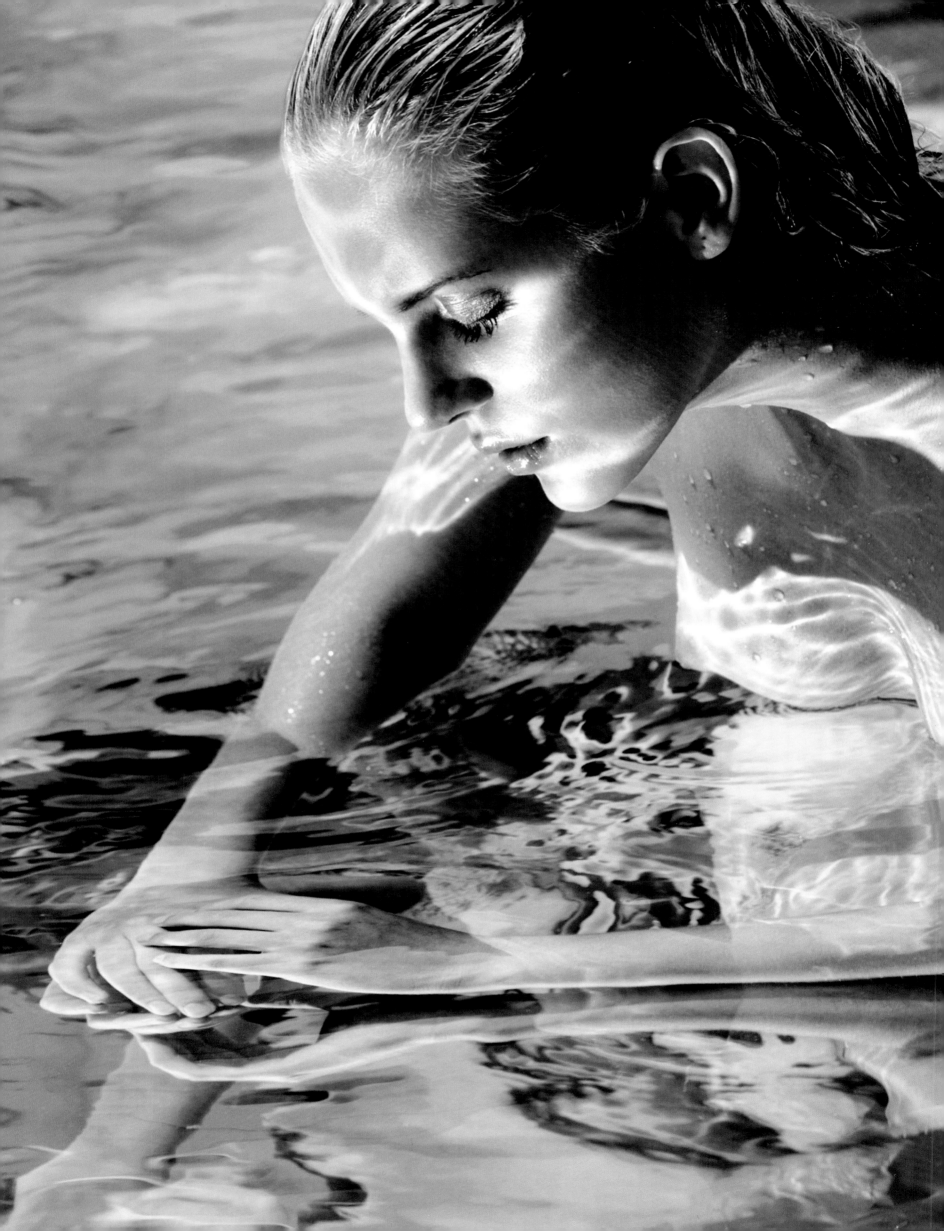

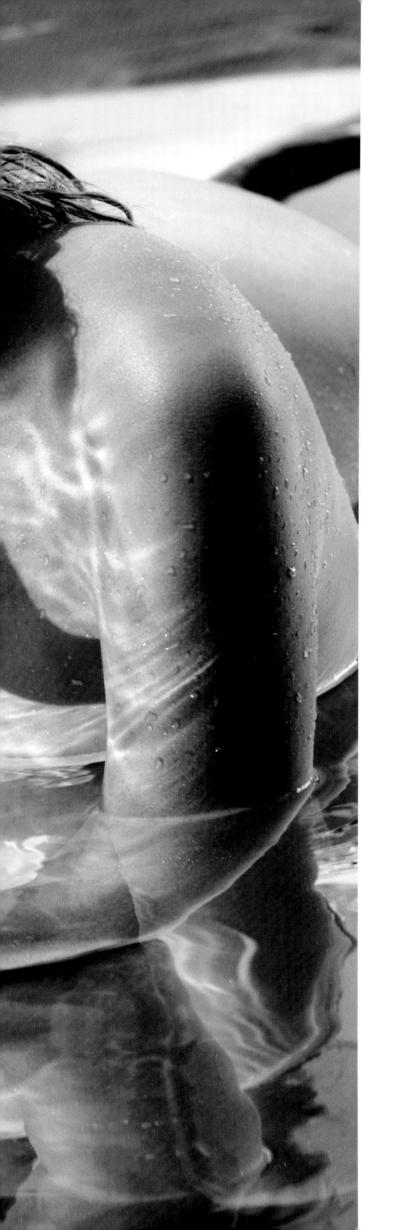

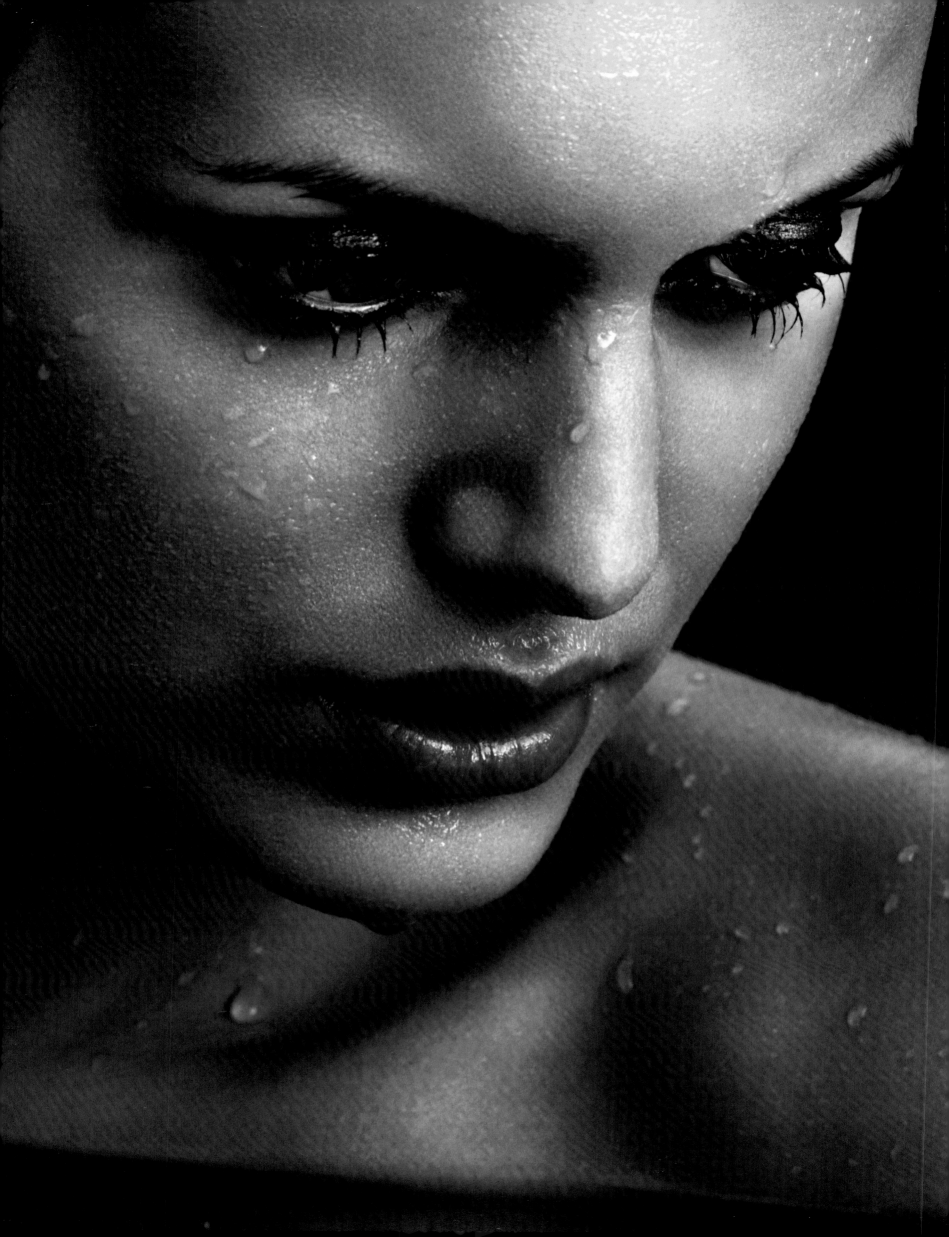

Atlantis

My dear friends of the Submerged Sisterhood,

As we approach the Fourth Millennium, Sisters, it's important to review the strange history that lies between the first Atlantis and our beloved New Atlantis. The long years of the Dry Ages – more than twenty centuries! – were a time when humanity eked out a shallow, brutal existence entirely on the land. So sure were the benighted air breathers that life above water was the natural way to exist that they spoke of mermaids, naiads, Rhine maidens, and our other ancient goddesses as if they were mythic creatures. Few believed that these beings actually lived, but those few believers carried the wisdom of the water through the endless years of burning sun and freezing snow. Until, at last, the seas rose and those who had suffered the heartbreaking loss of gills millions of years ago once again returned to their true home.

Since all records of the above-water life have been destroyed by the melting of the ice caps and the Great Flood of Salvation, it is difficult for us to truly understand how women lived in those bygone days. Our grandmothers' grandmothers' grandmothers have passed down stories to us, though some seem so hard to believe that they may be the rapturous imaginings of those who dive too deep. Males, once called men, had many roles in the arid upper world, not simply the function of fertilization they provide today. Some historians claim that men and women actually touched, though the thought is so shocking that few believe it. Surely, there must have been some dry-land version of our ability to reproduce by swimming through clouds of male seed. The ritual Dances of Fury and Ferocity we perform each year is thought to derive from something called War, in which beings were actually killed by their fellow beings. Murderous machines, capable of destroying vast cities, were sent onto the water and down into the innocent depths. For hundreds of years, many of their hulks remained on the bottom. Even in the times between wars, danger was everywhere. Whales were hunted, and sea creatures of all kinds were dragged out of our world and into the deadly zone above. So ignorant of our realm were the Drylings that when some men died violently, they were said to "sleep with the fishes."

Now, Sisters, with water everywhere and all memory of the dry tribes sinking away, we Blessed Subaquanauts truly do sleep in harmony with the fishes, living a life of perfect beauty, at peace with all that swims, gloriously and gratefully wet, forever and ever. Amen.

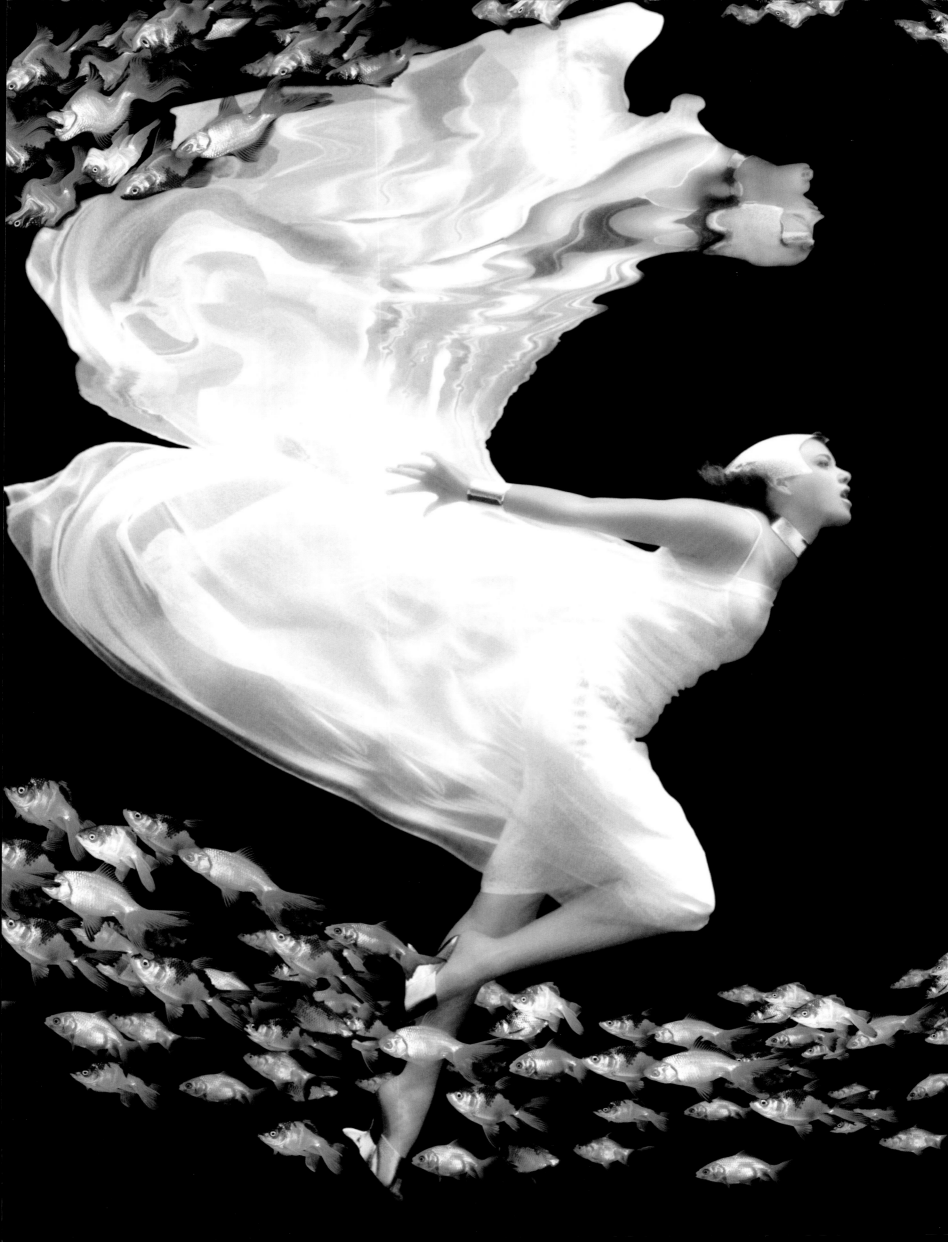

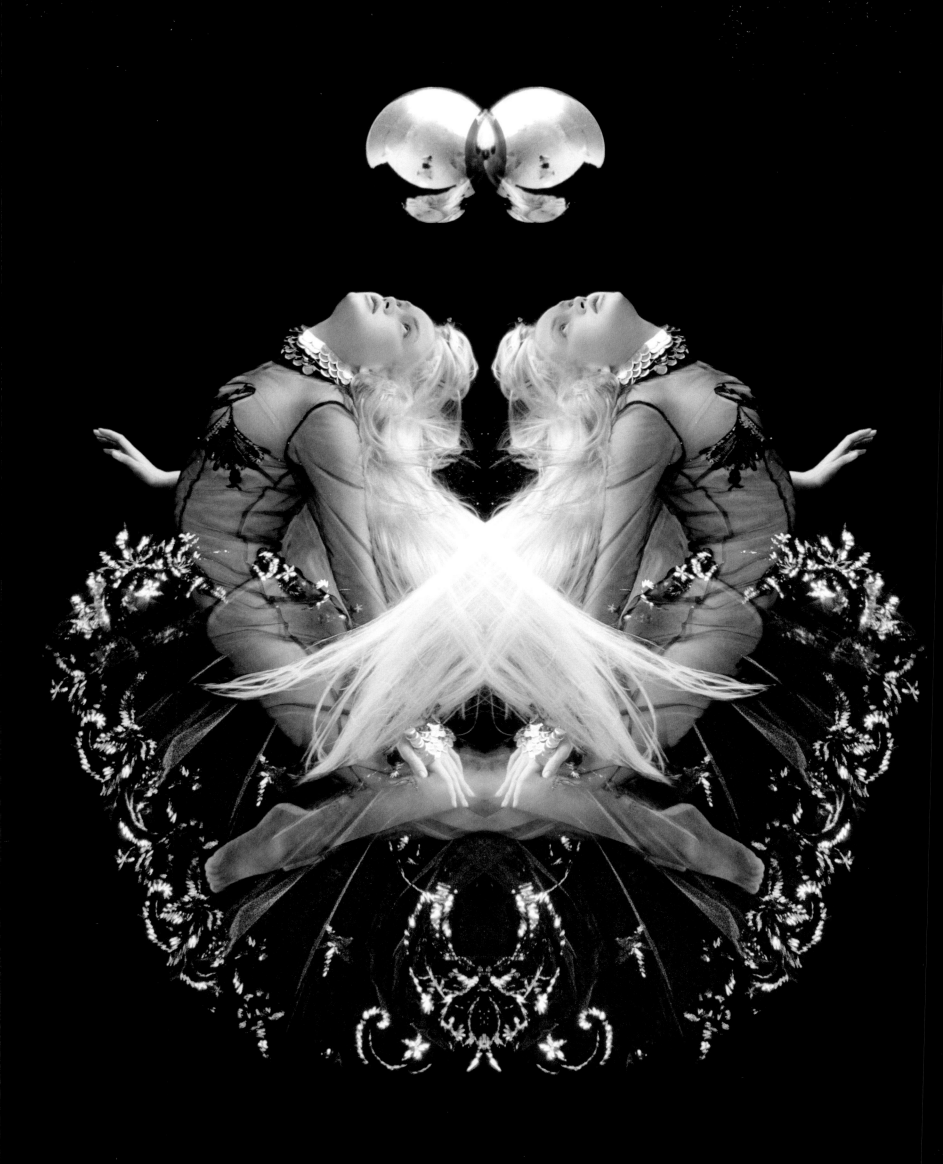

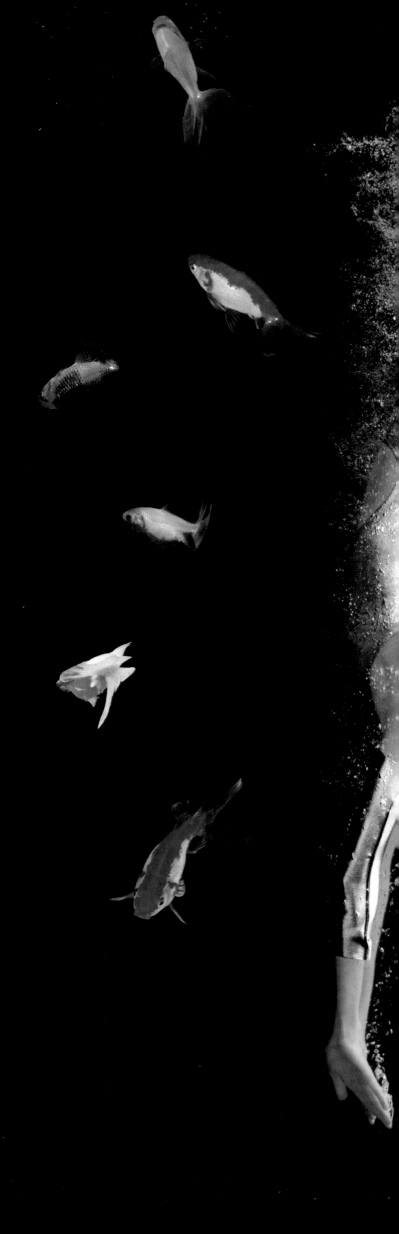

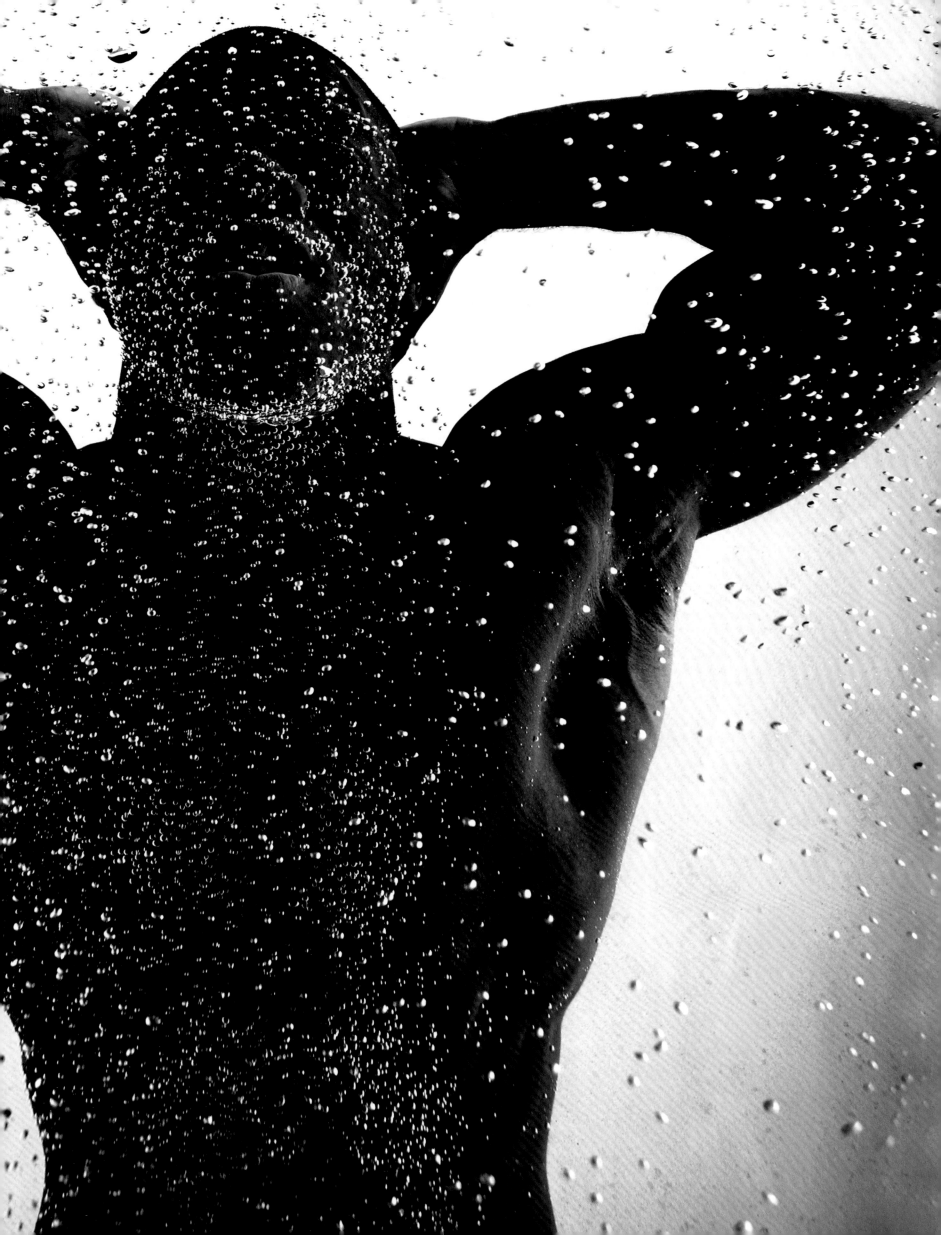

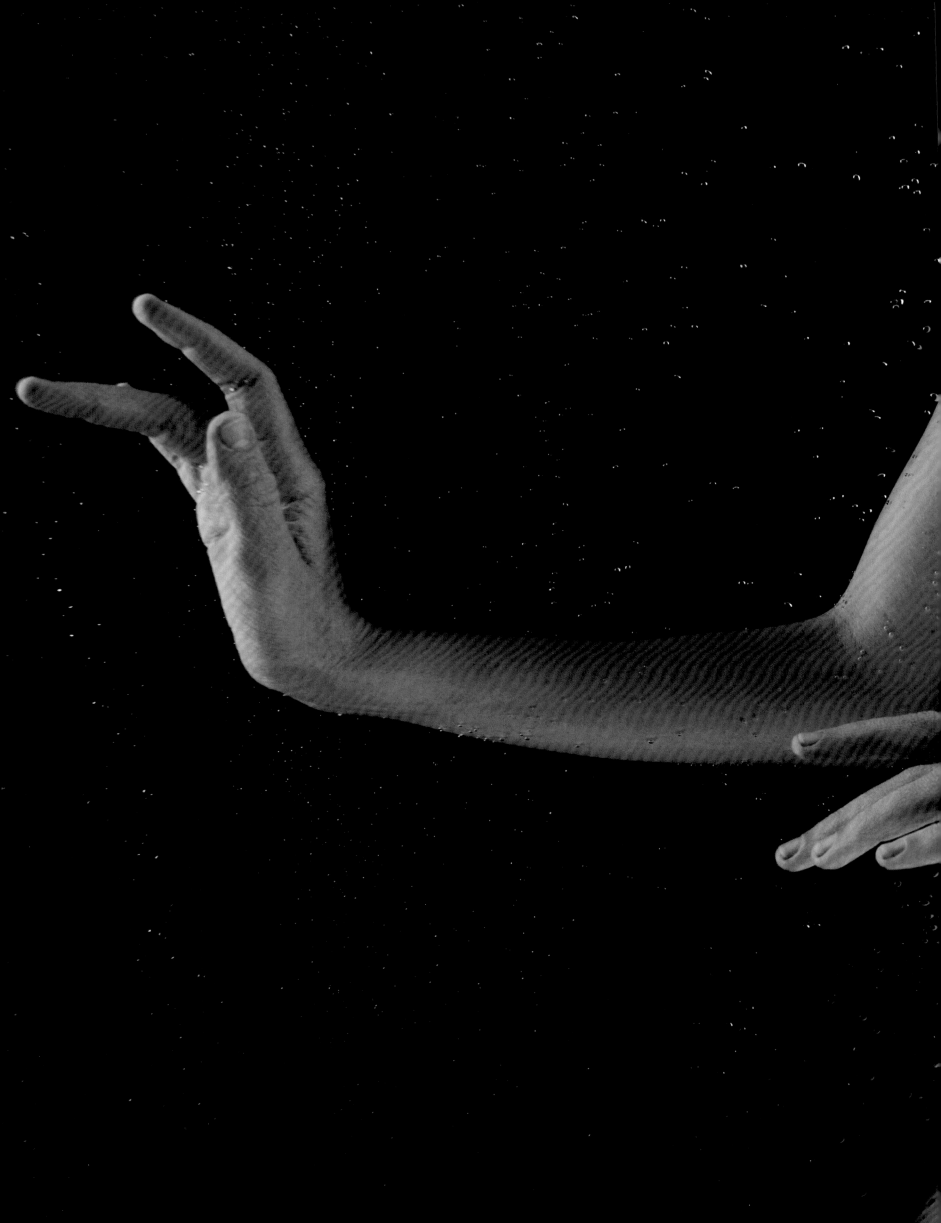

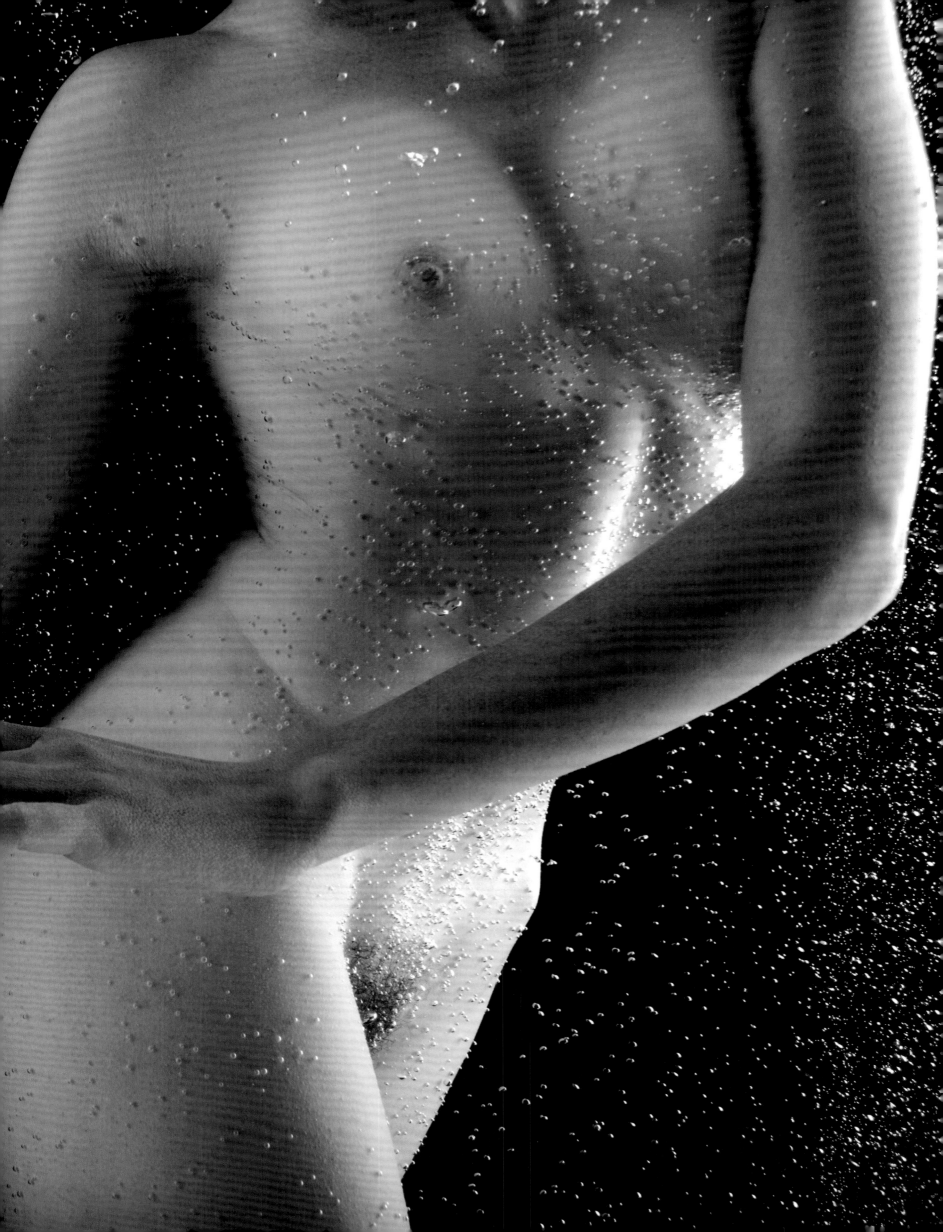

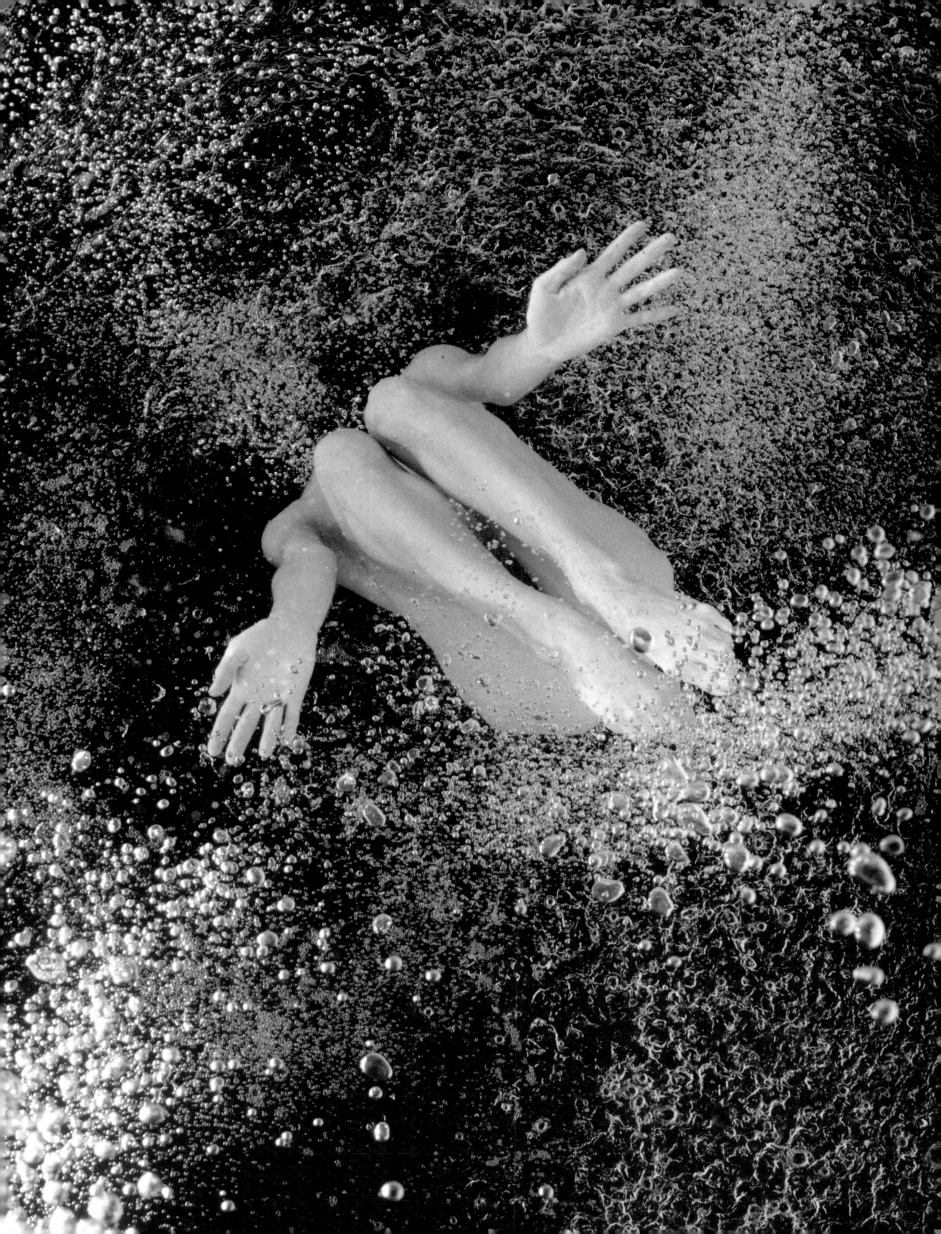

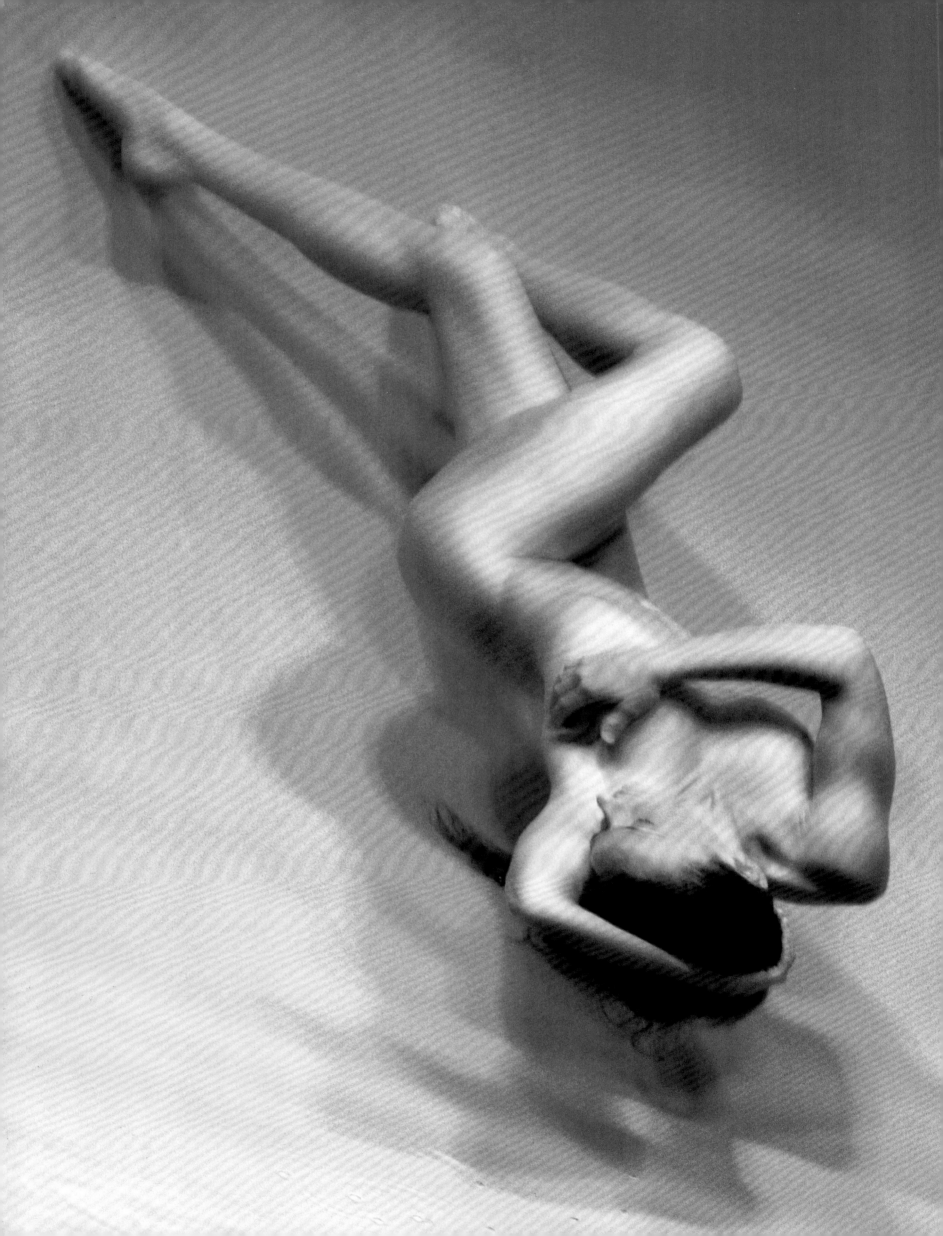

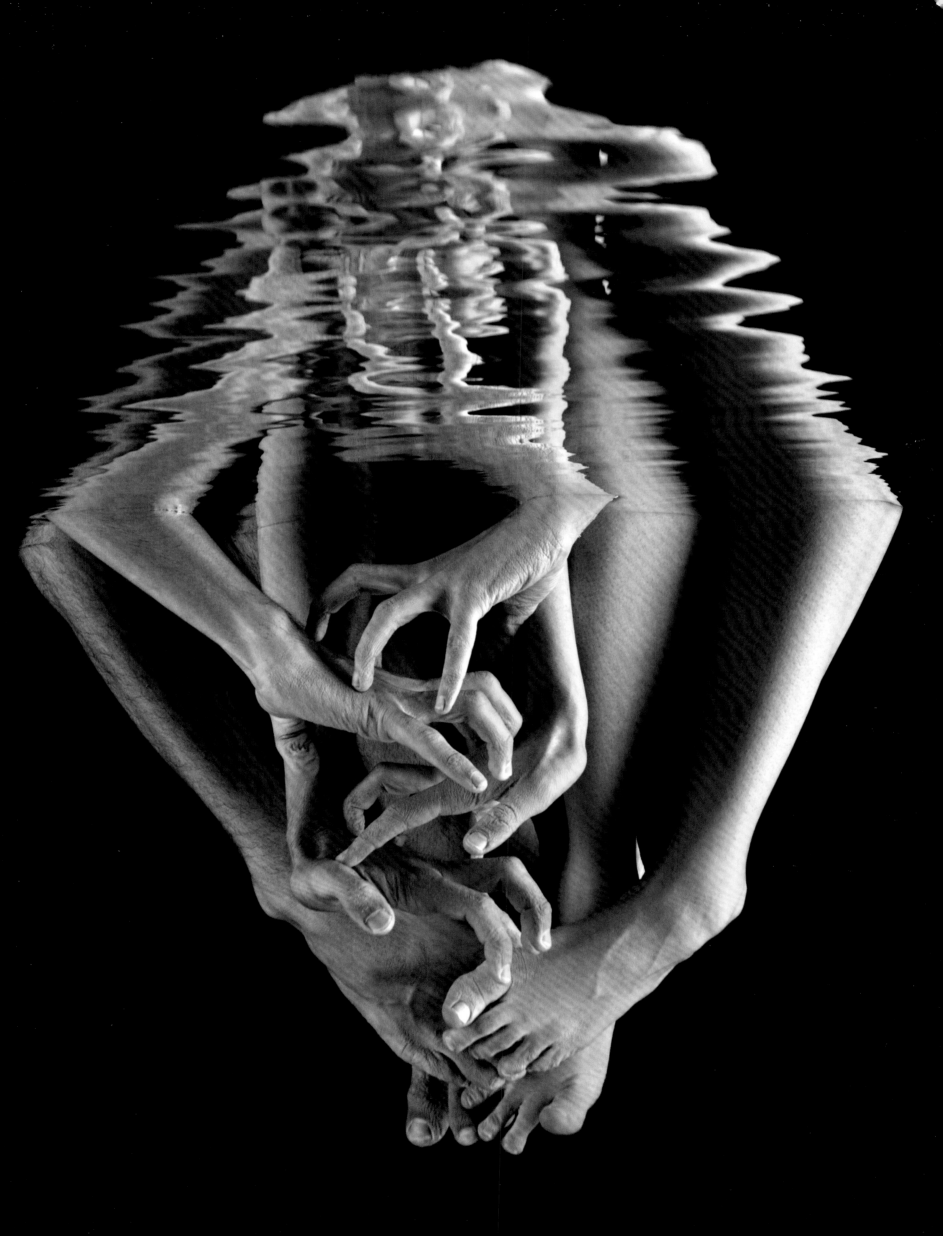

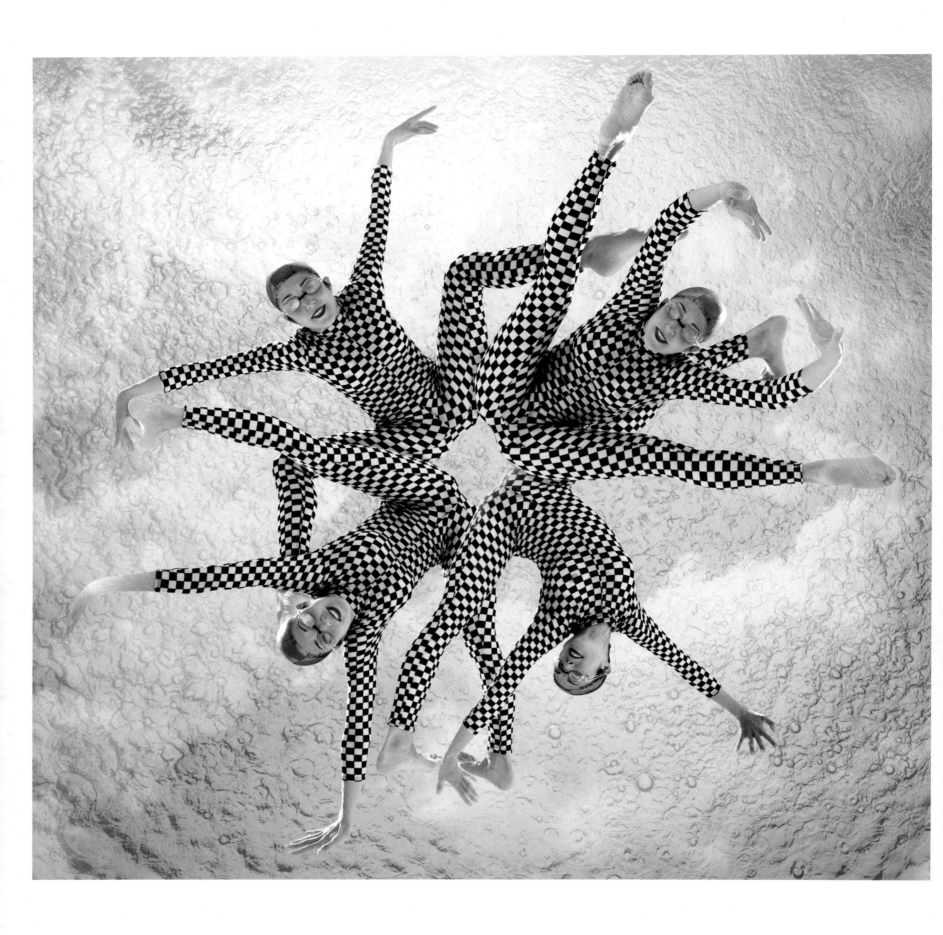

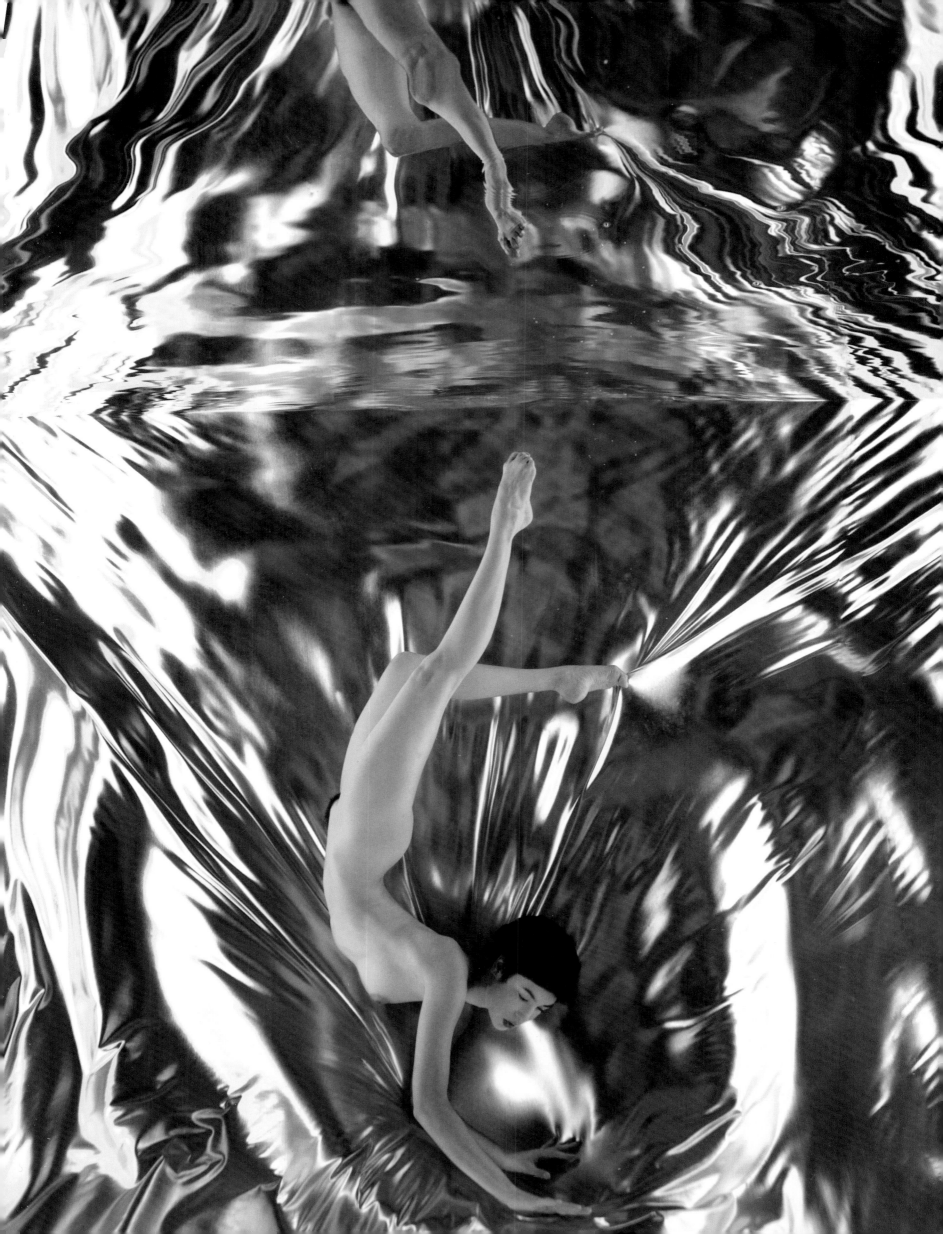

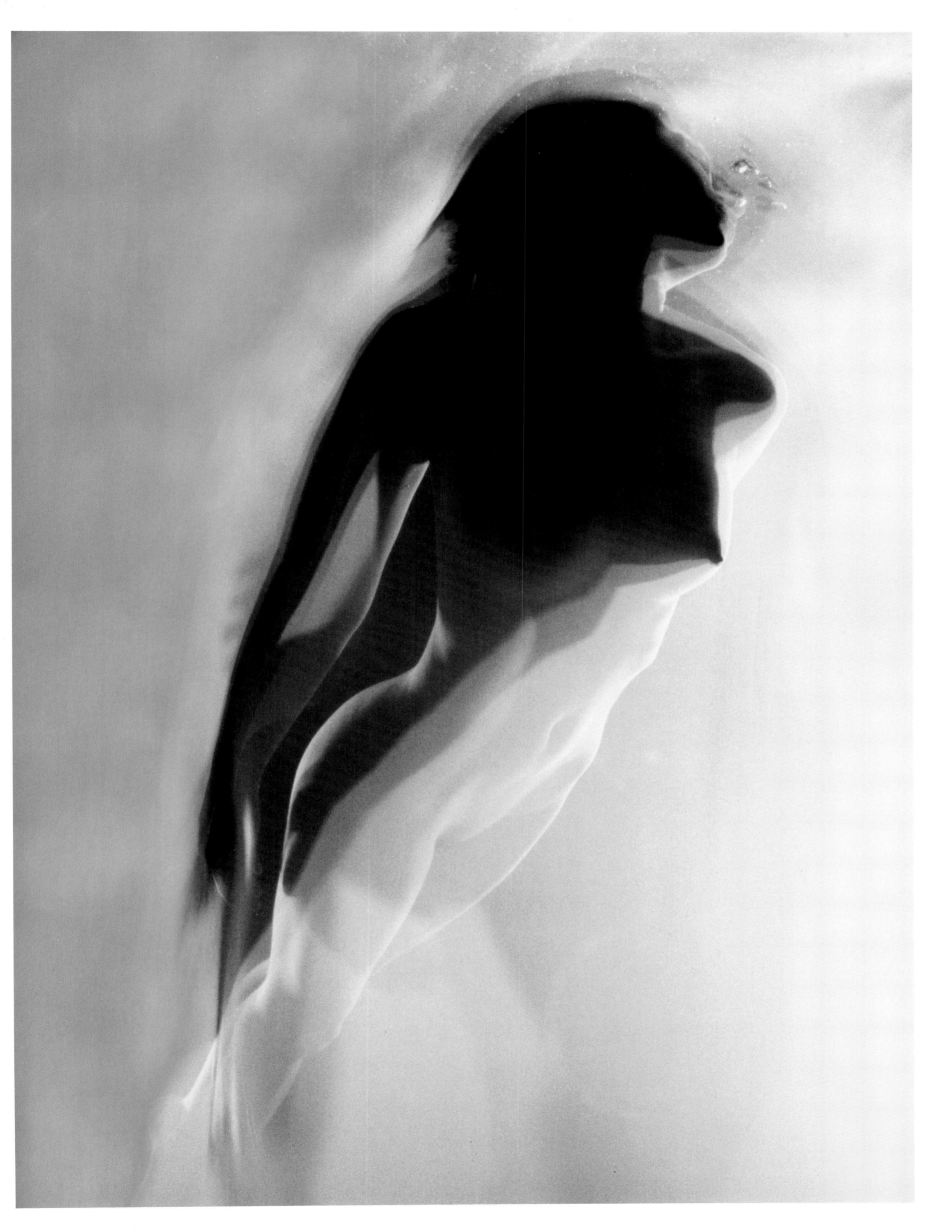

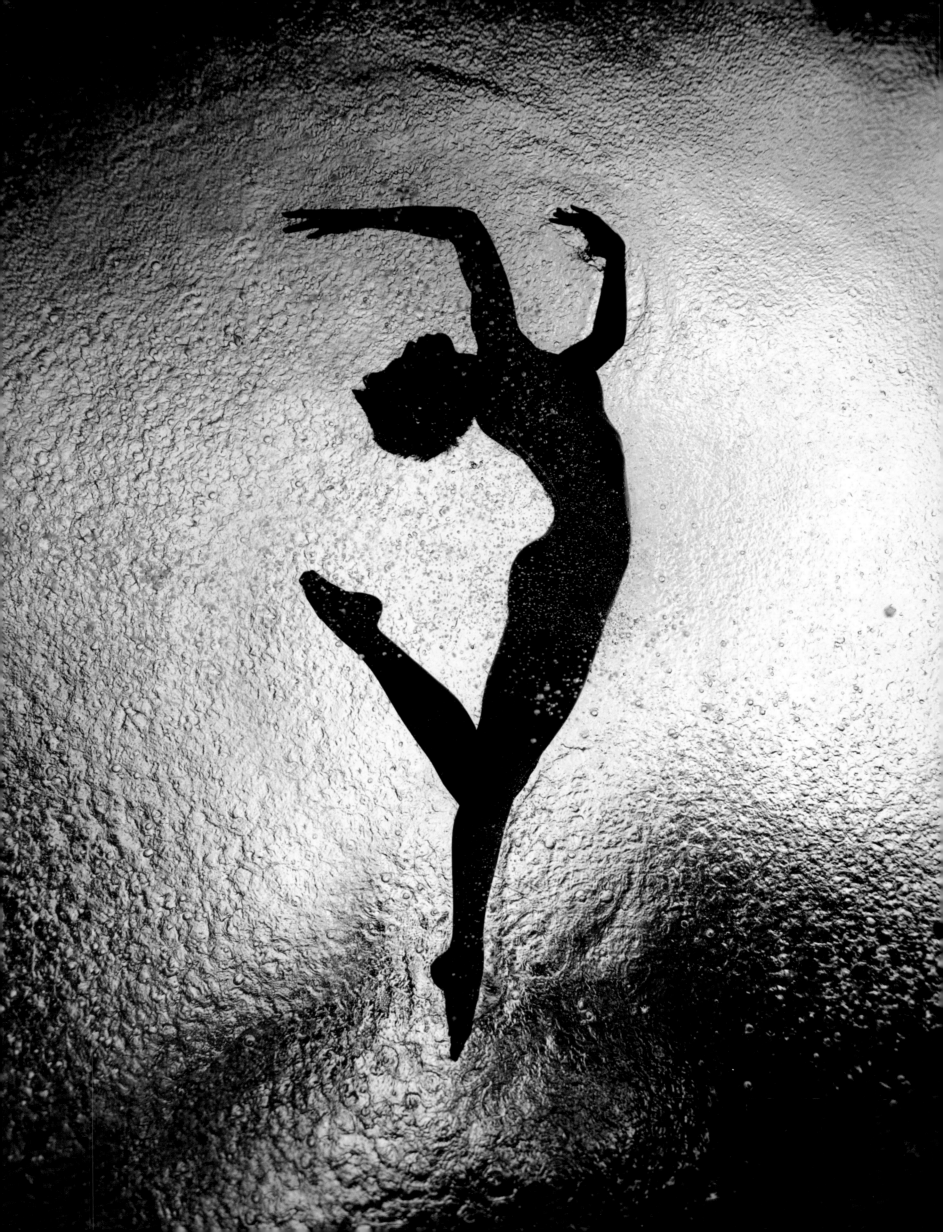

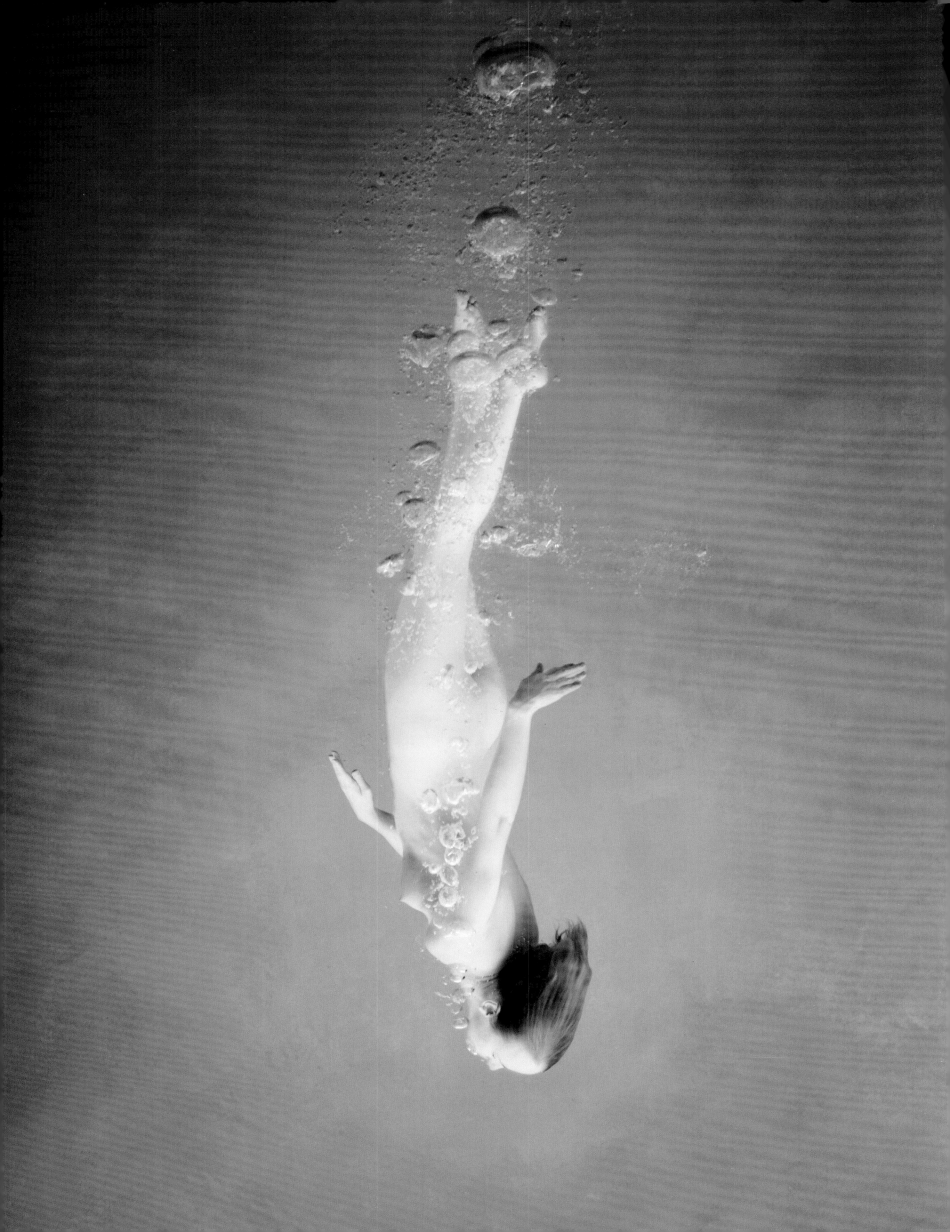

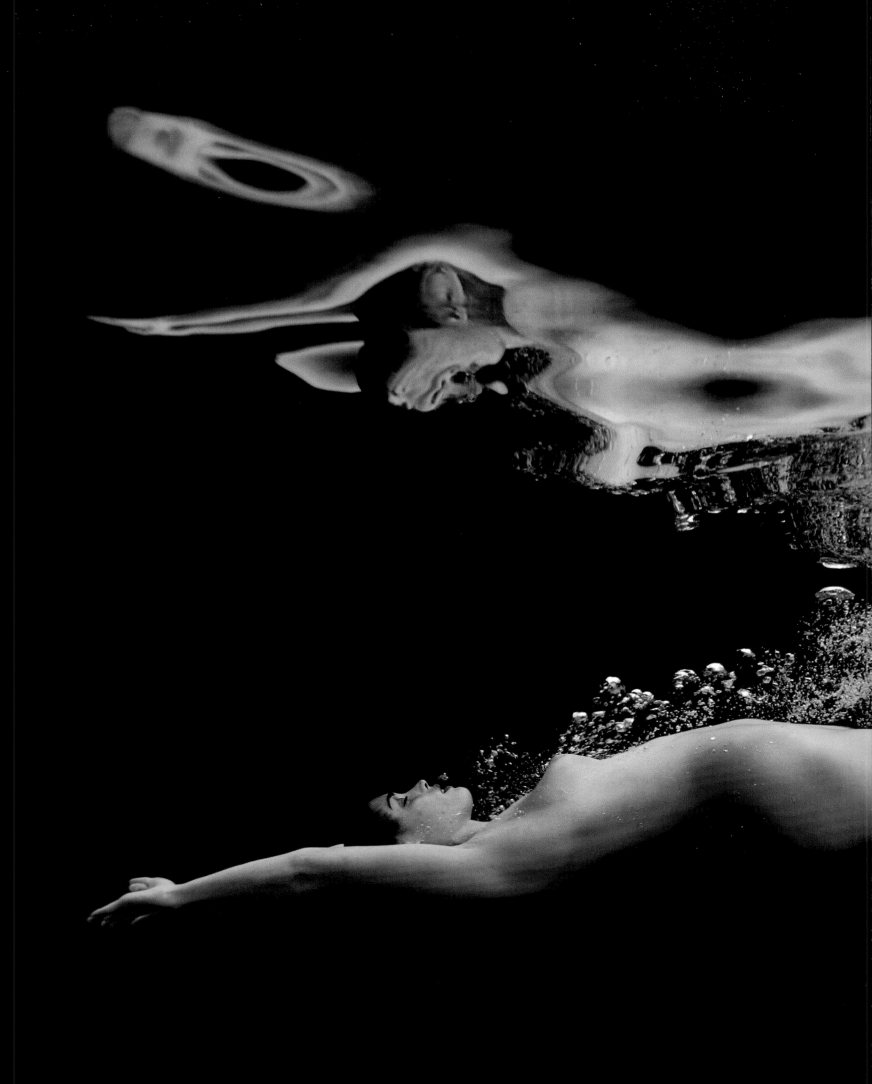

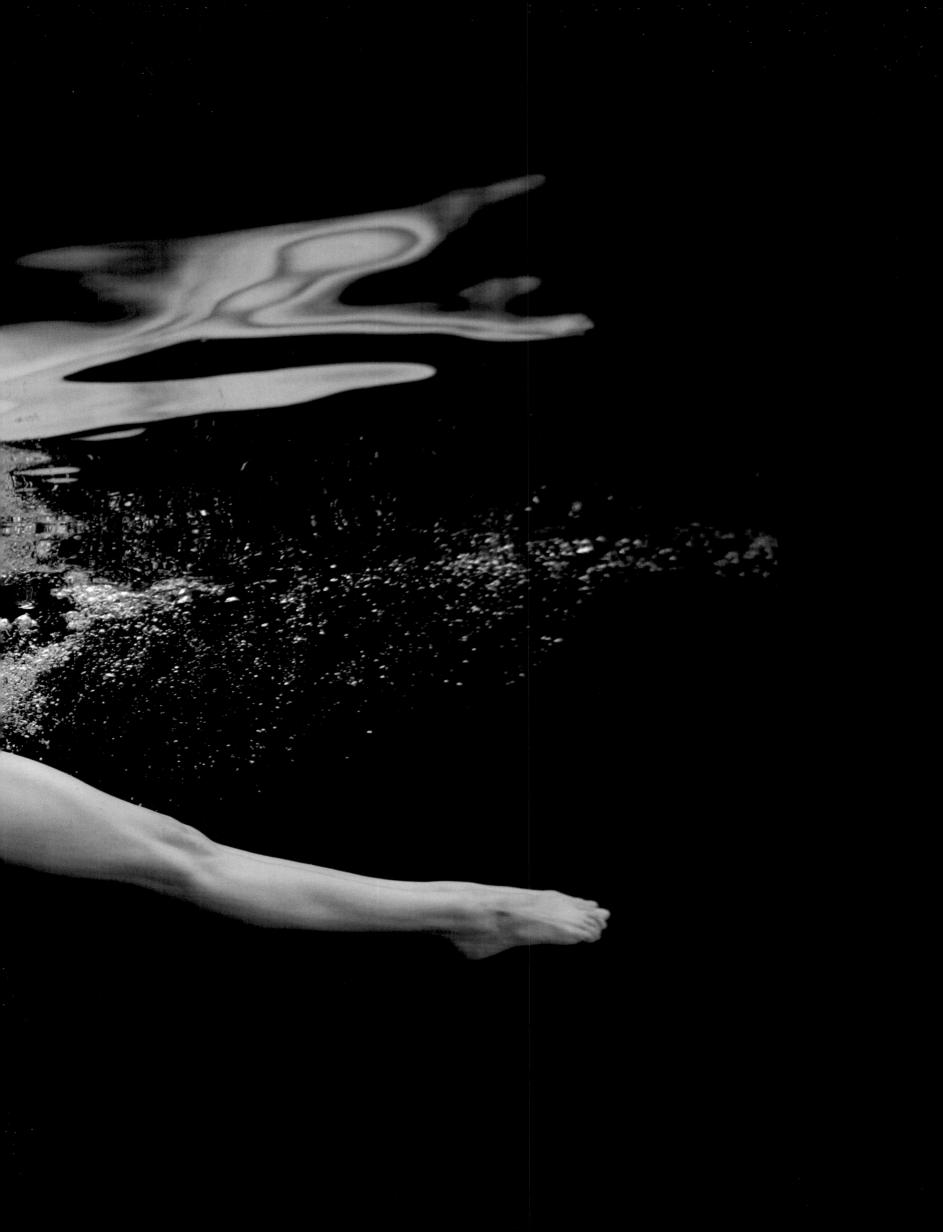

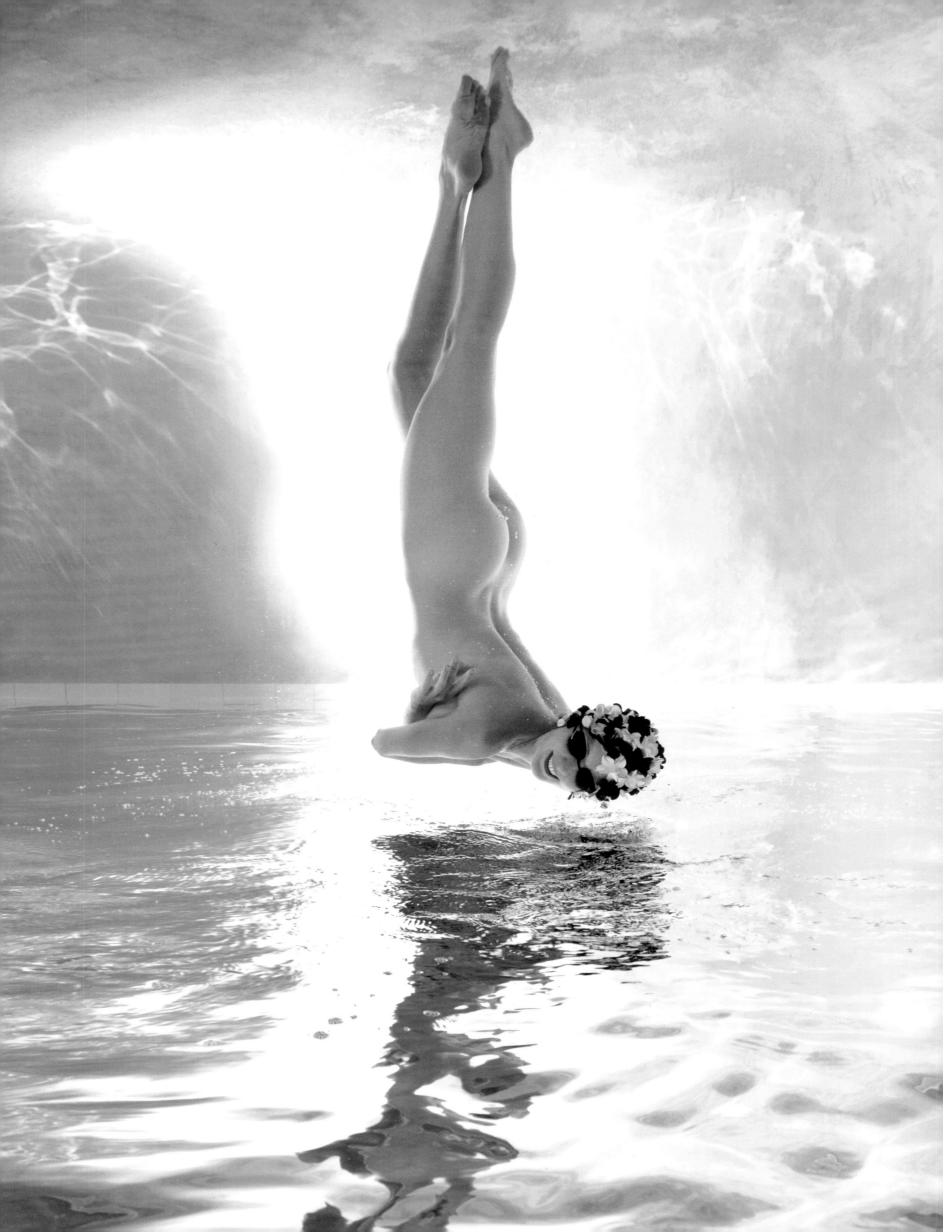

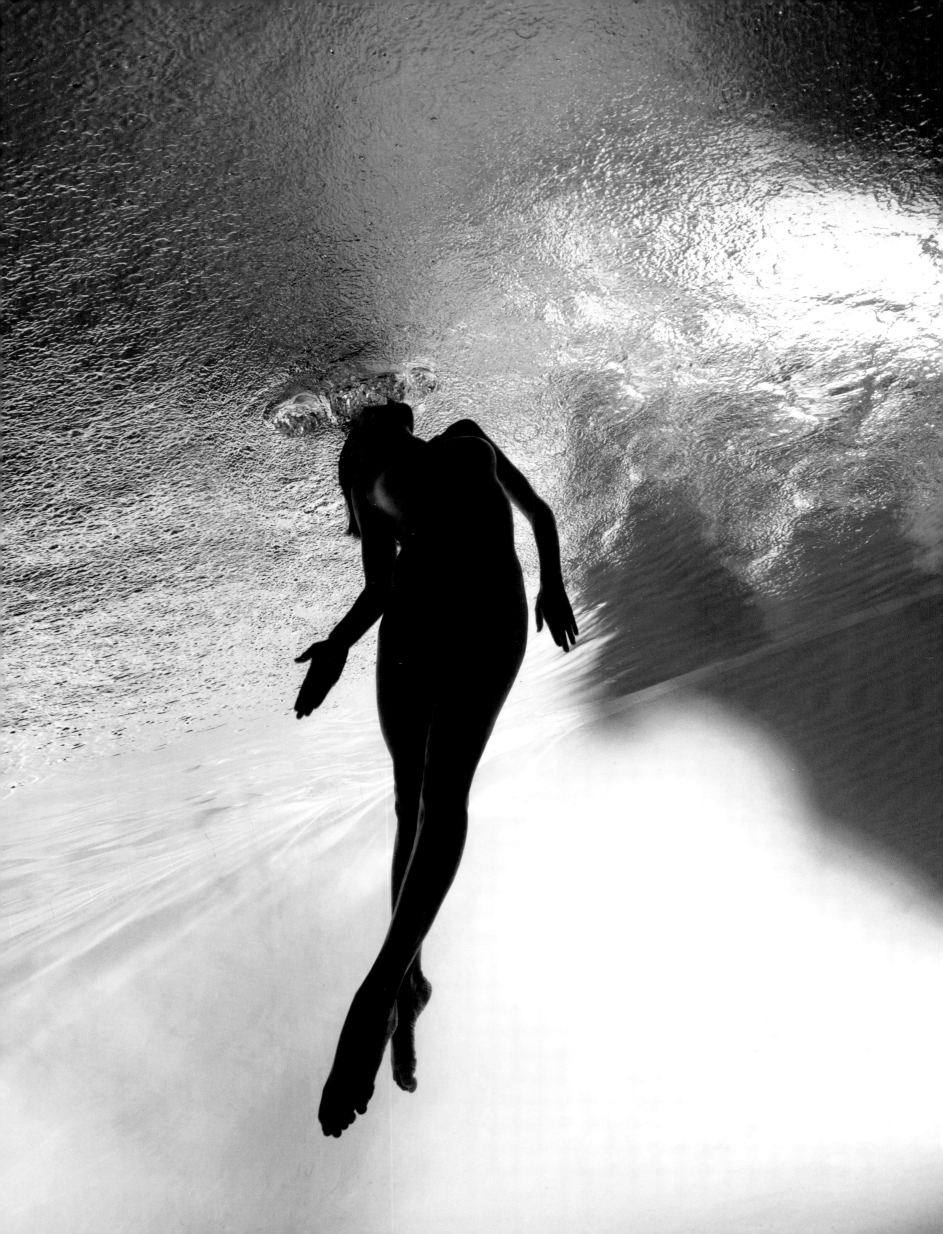

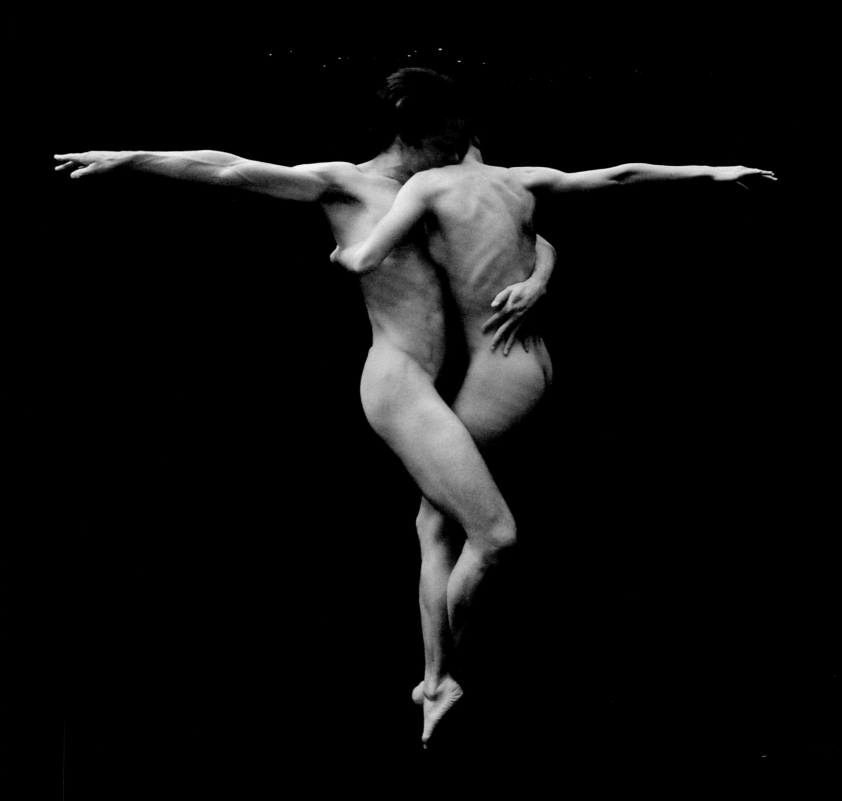

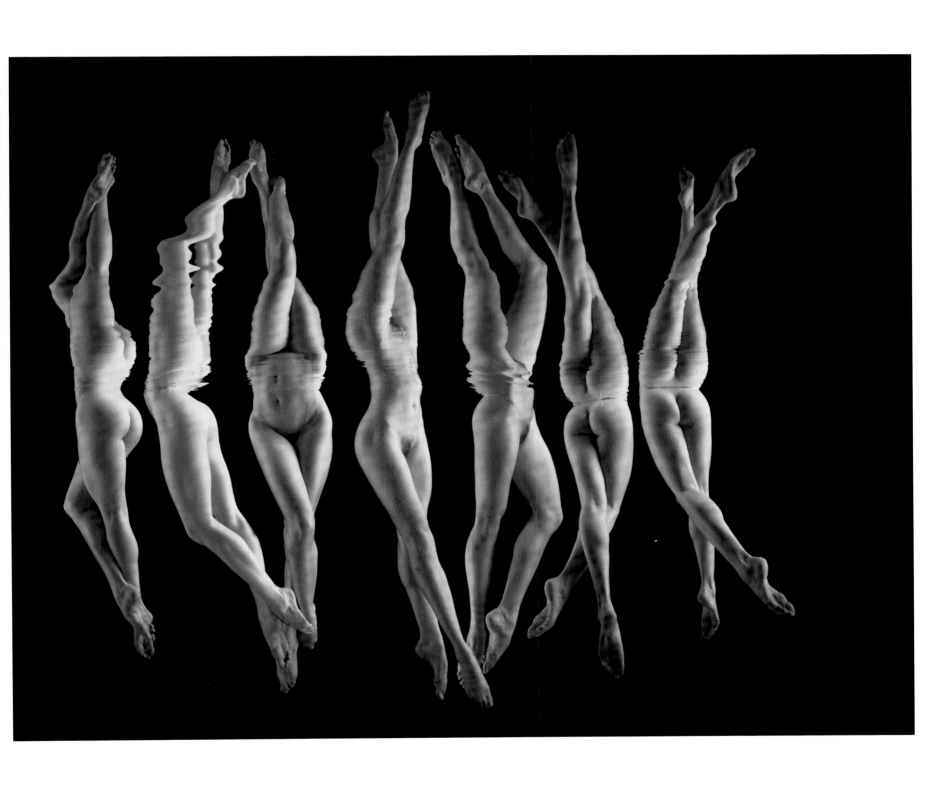

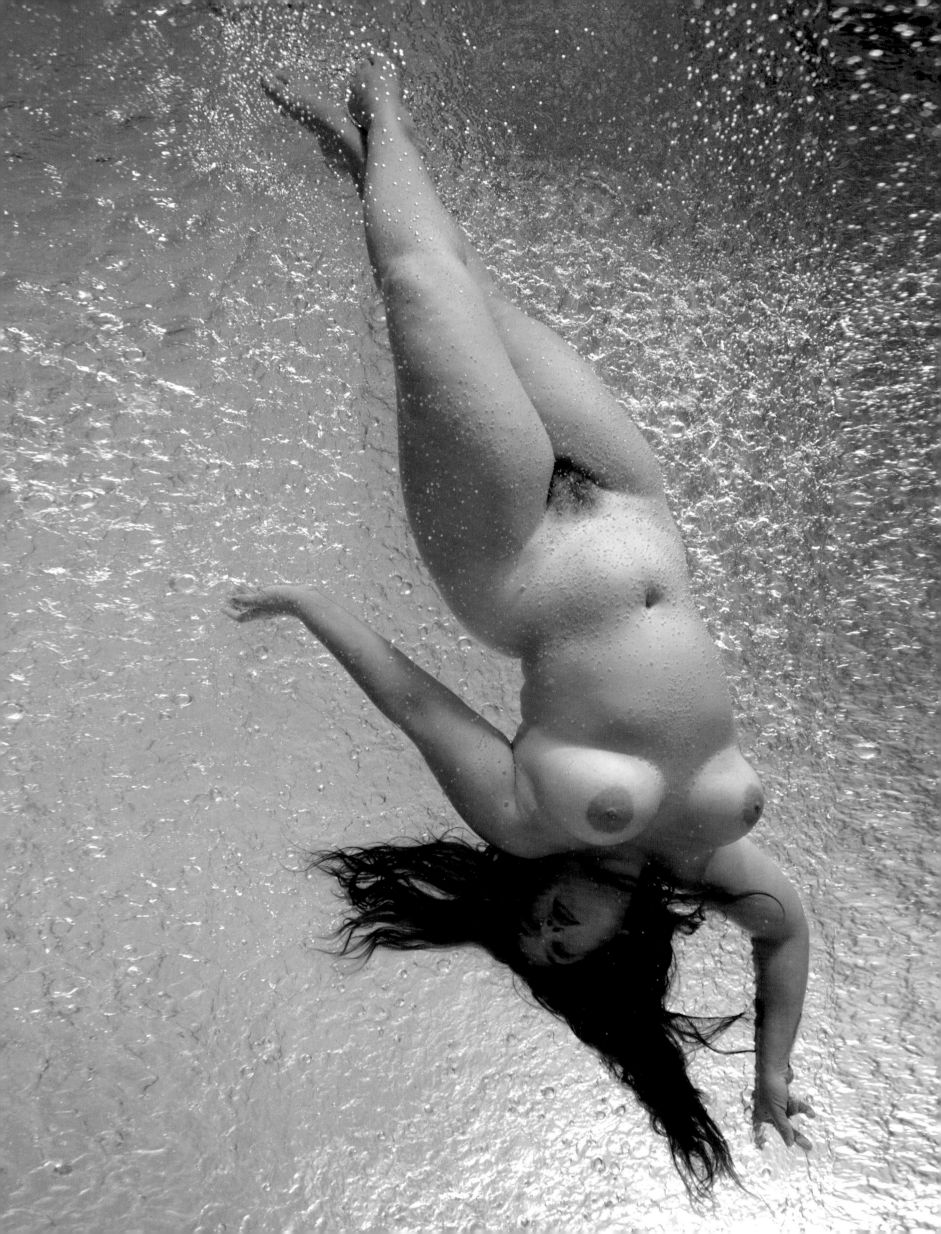

Cirque du Soleil

O

O™ (as in "eau," the French word for water) is the lavish, long-running crowd-pleaser created by Cirque du Soleil™ at the Bellagio Hotel in Las Vegas. *Zink* magazine sent Schatz to create a photo-essay of this splashy hit, not as a theater photographer recording the spectacle for posterity but as an artist, capturing the feeling of the show, the phenomenon beyond the facts.

Before going to Vegas, Schatz studied videotape of the show. Once there, he spent two evenings photographing the show during the performances, and then two days putting the cast through paces of his own devising. The main challenge for the photographer is that O™ isn't an underwater show. Though a round pool, fifty feet in diameter, serves as the stage, the action is above and on the water. And while Schatz did photograph some of the performers out of the water, the challenge was to direct the swimmers underwater. To ask professional artists who perform the same remarkable acts night after night for an entirely new approach is neither easy nor likely to succeed. Every complex shoot has its pivotal moment, and for Schatz that point came when he faced nineteen skeptical synchronized swimmers who performed in O™. They had seen more than a few terrestrial photographers and were dubious about taking direction for working underwater from another.

"Okay," said Schatz. "Let's go underwater for as long as we can." The collective look he received said wordlessly, "You're in over your head here, stranger."

Into the pool they went, everyone (including Schatz) letting out just enough air to sit on the bottom. The seconds ticked into minutes. One by one, the performers pushed themselves off the bottom and shot toward the surface for air. The very last to come up was the photographer, so much later than the professionals that the stage crew, observing the scene, burst into applause.

"Now we can work!" said Schatz. From then on, the shoot went swimmingly.

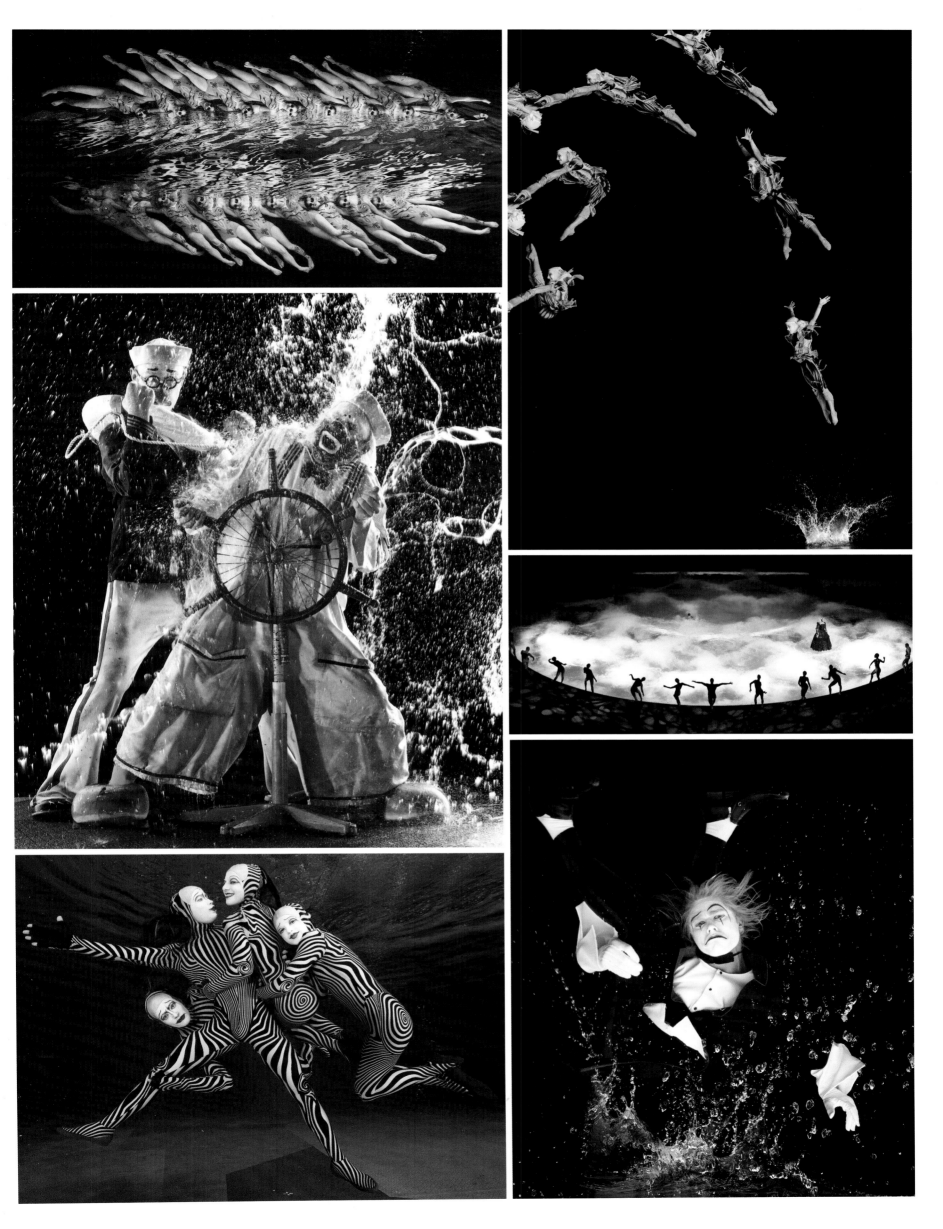

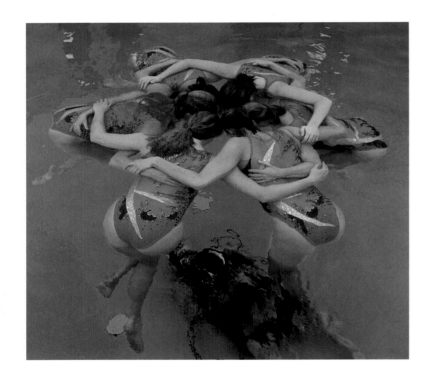

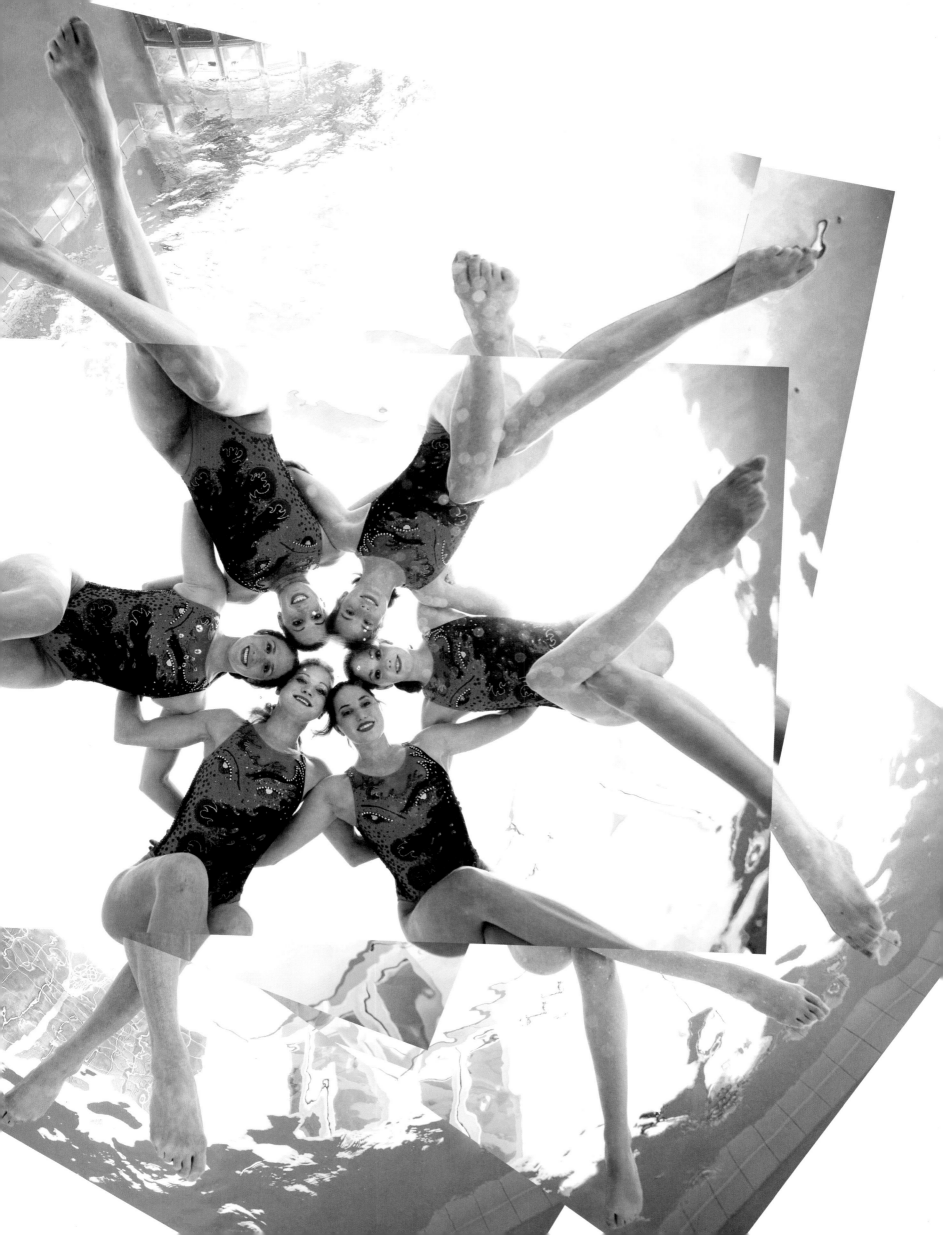

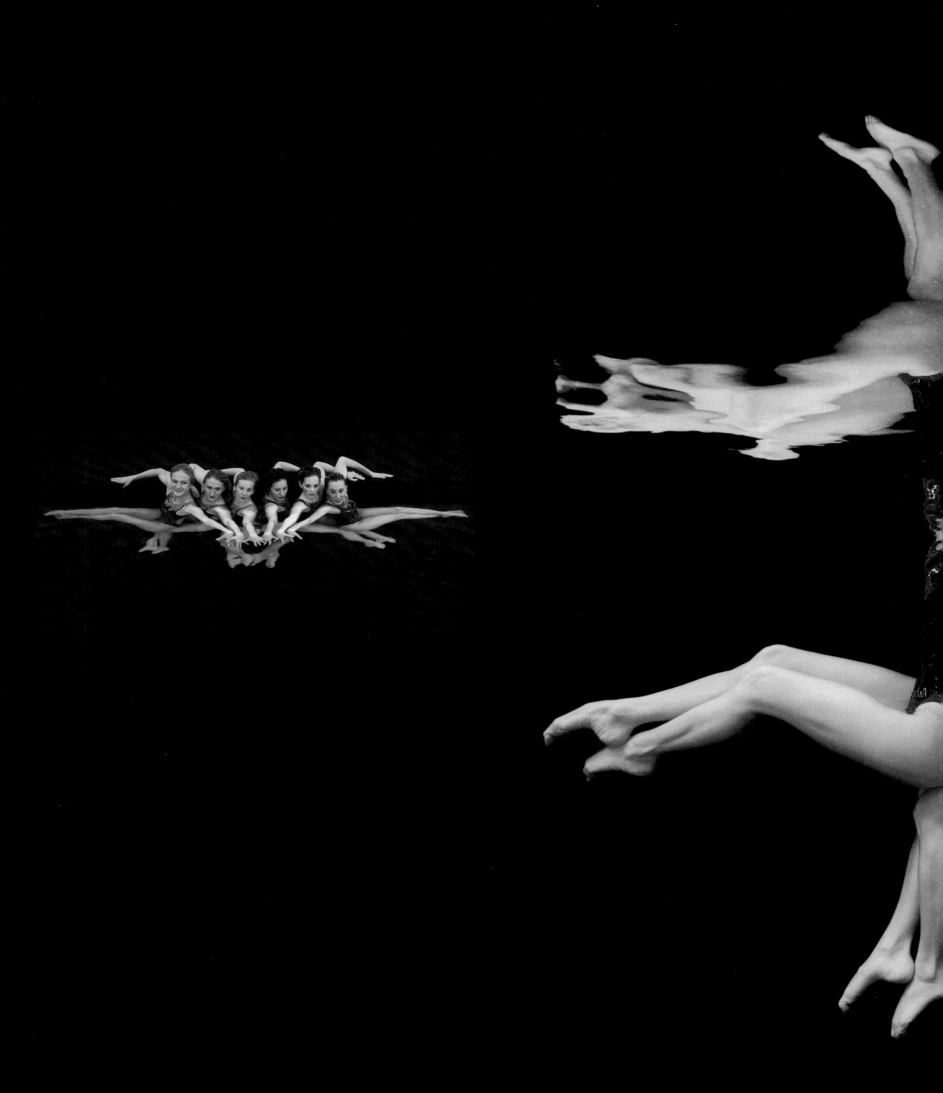

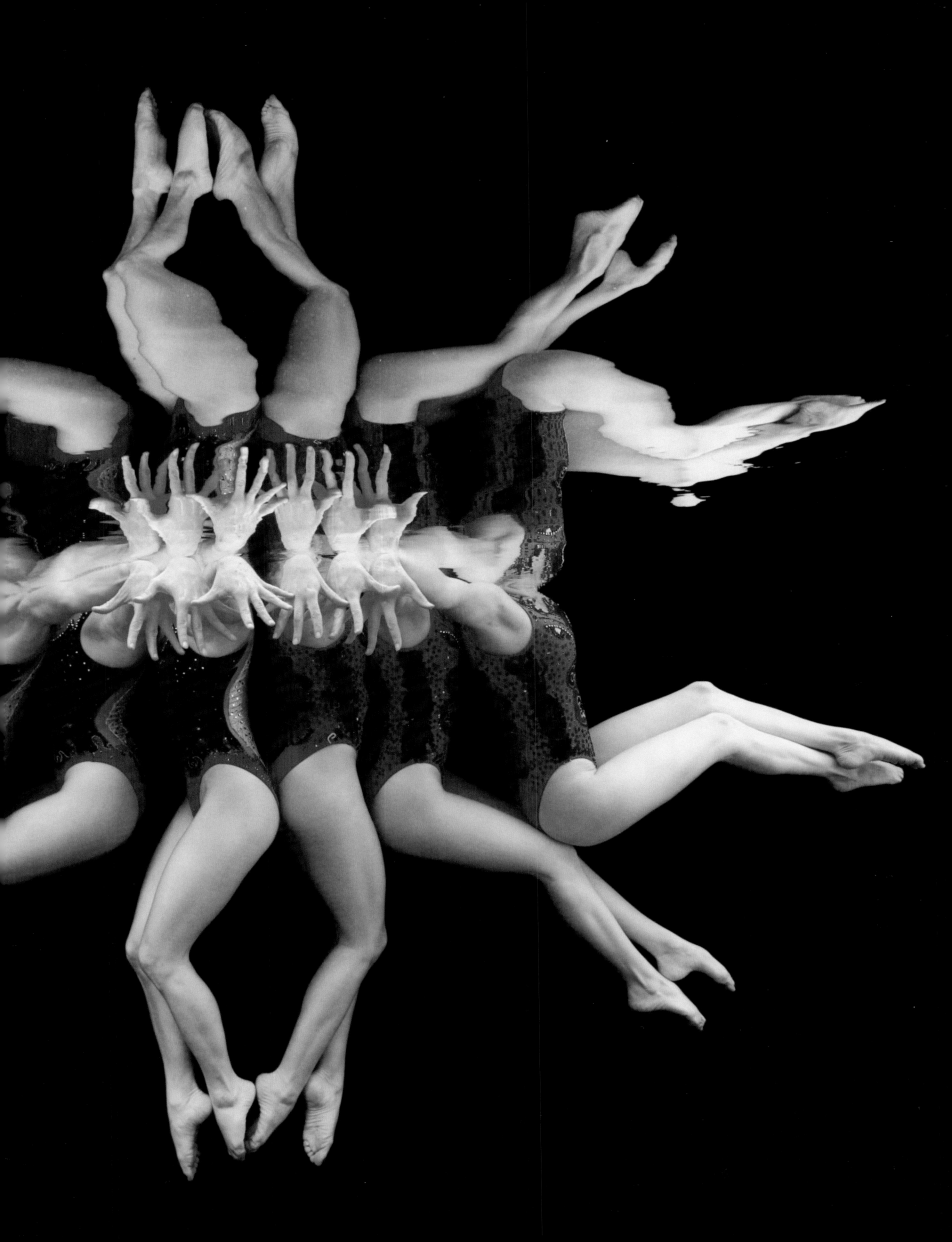

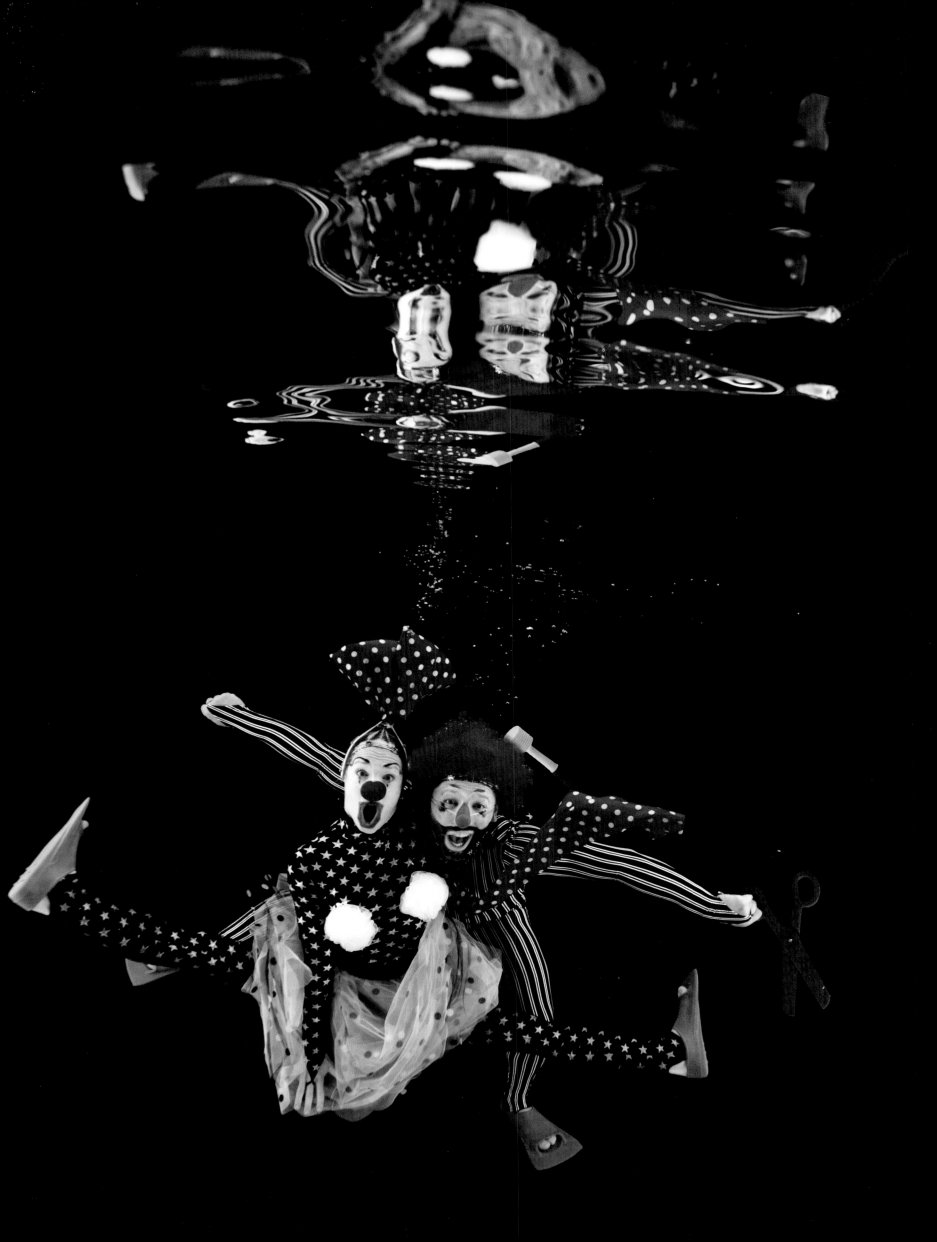

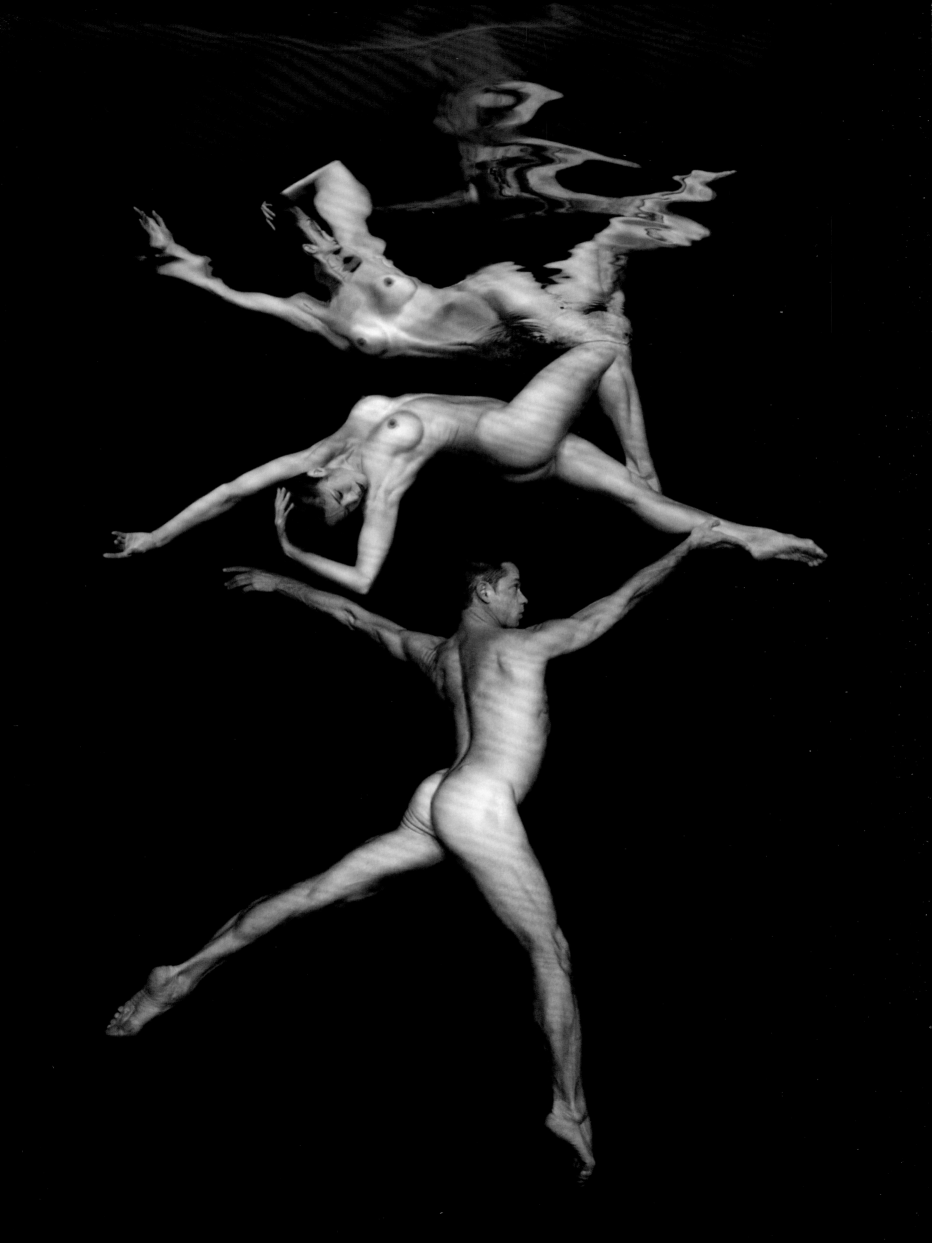

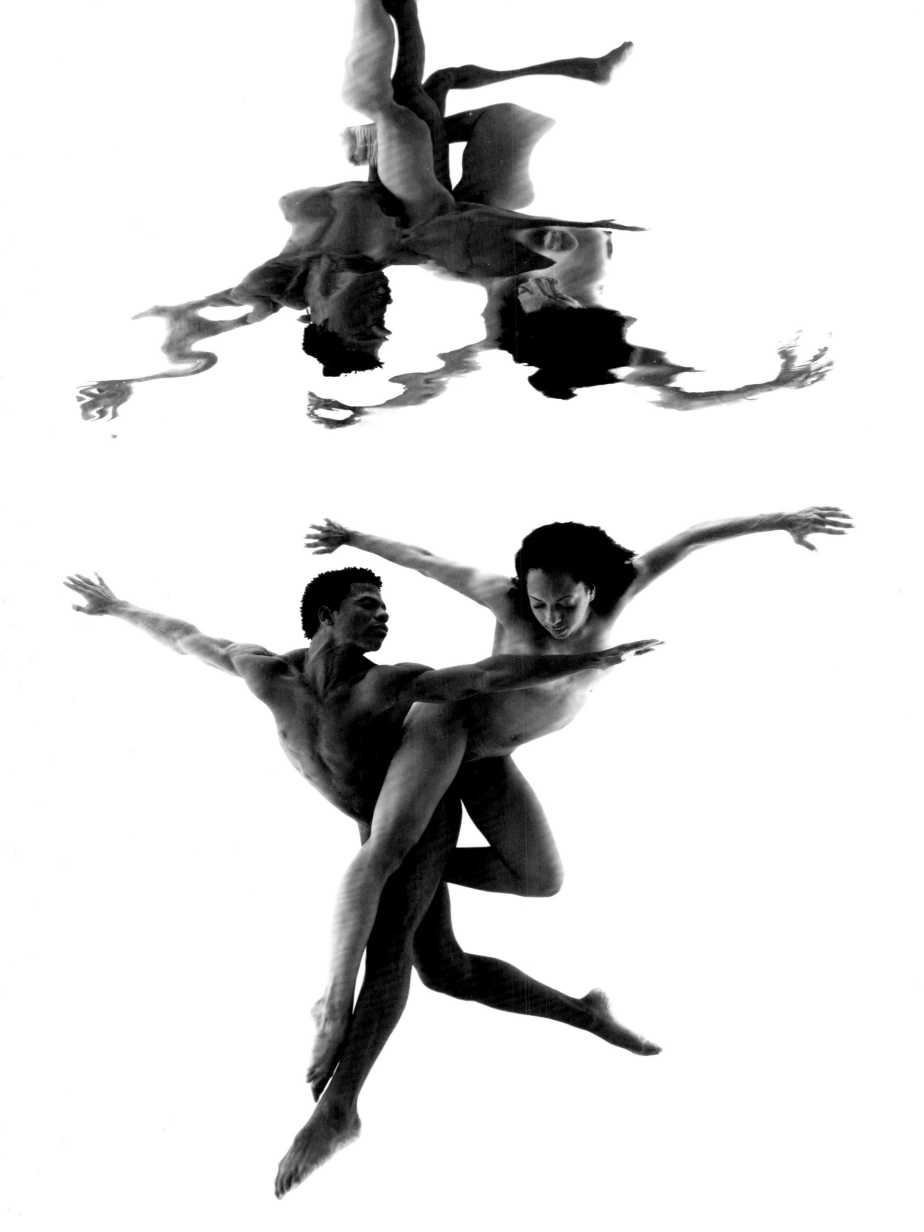

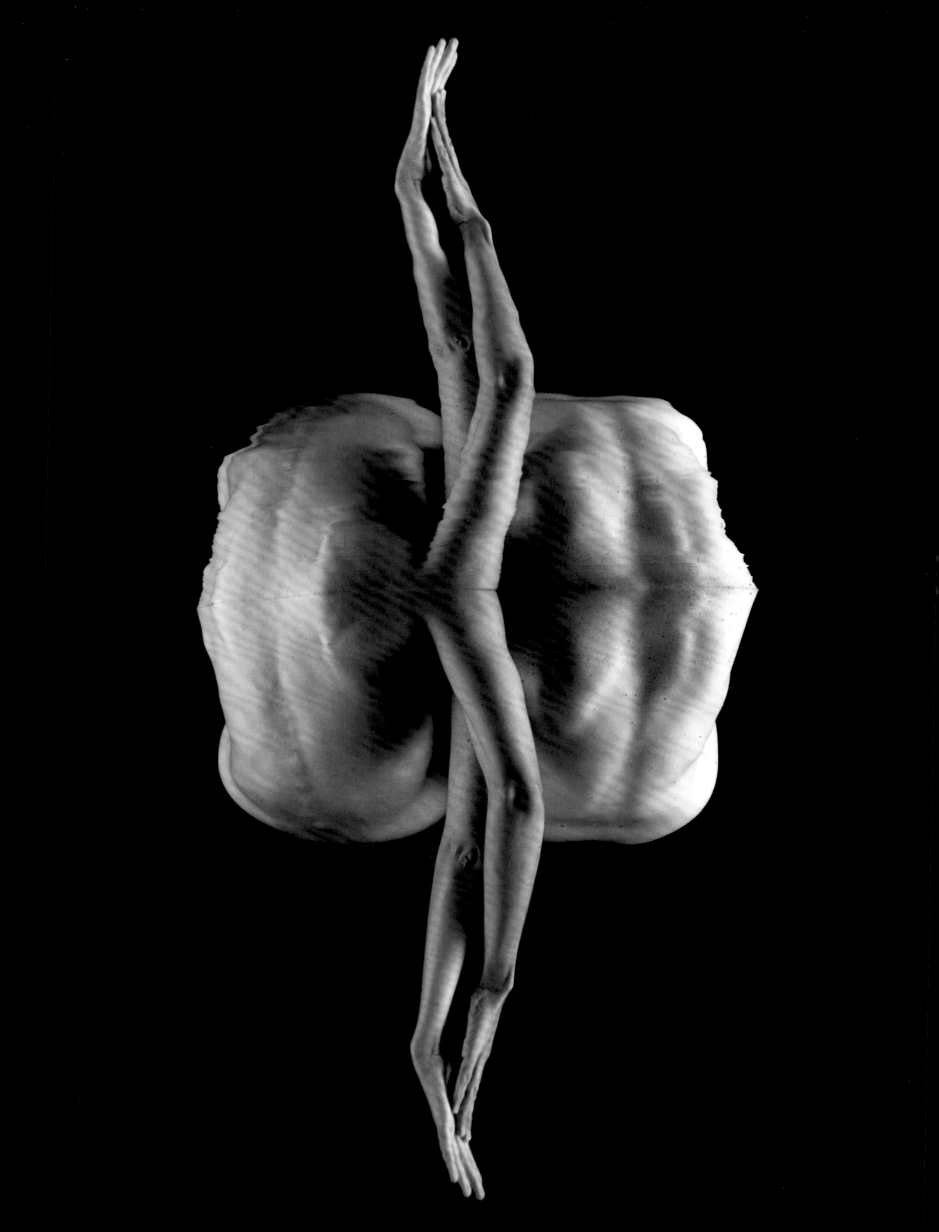

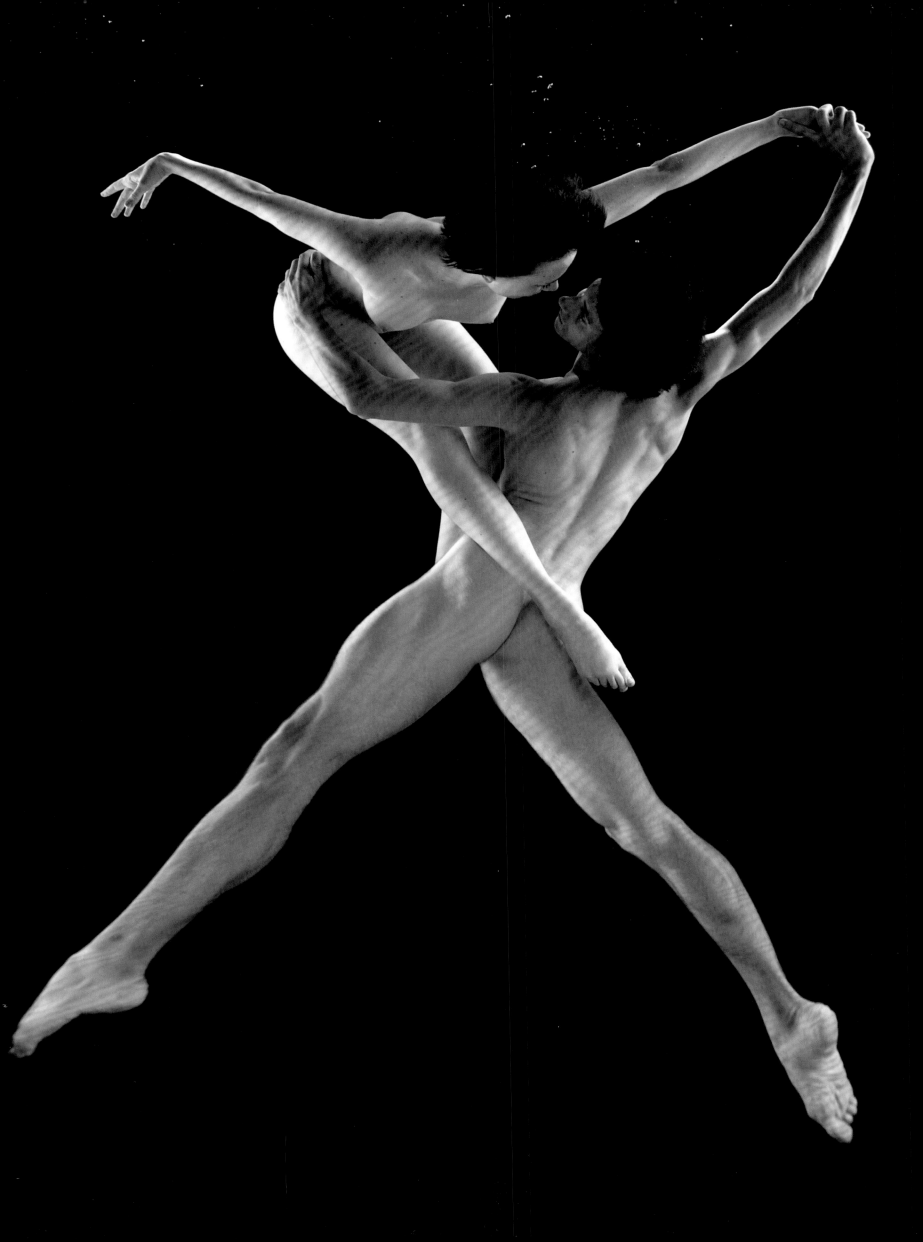

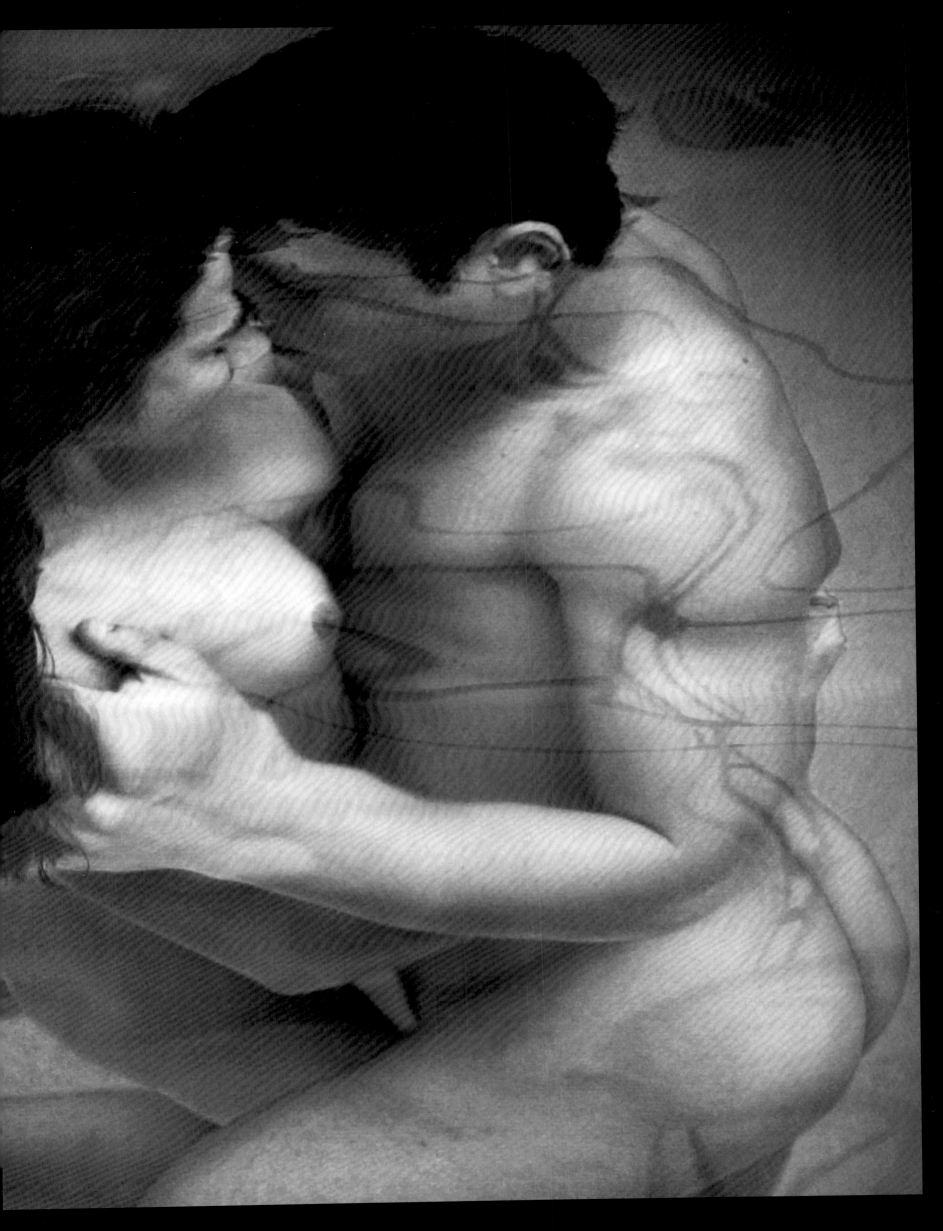

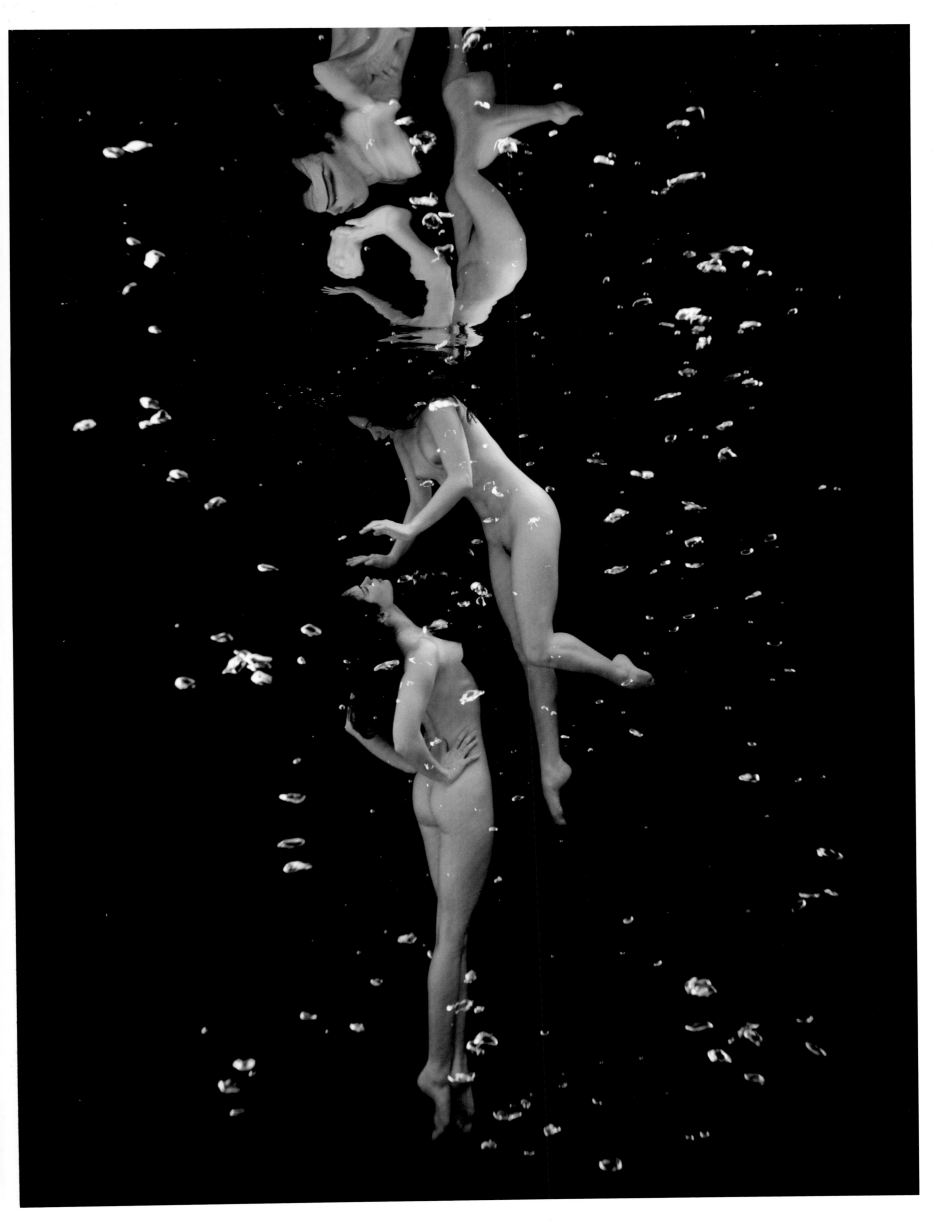

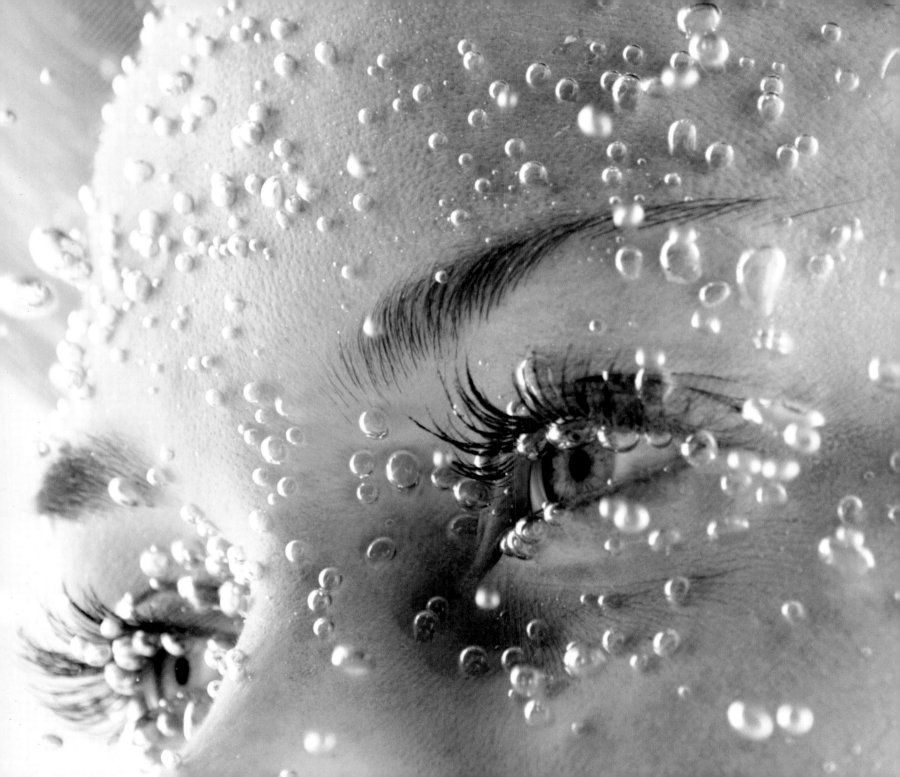

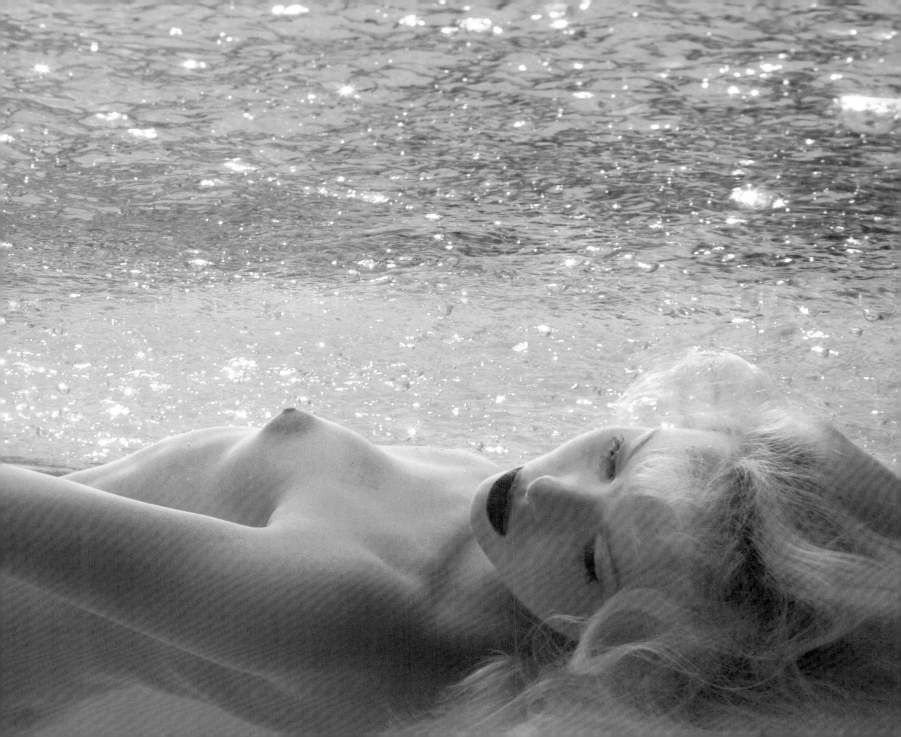

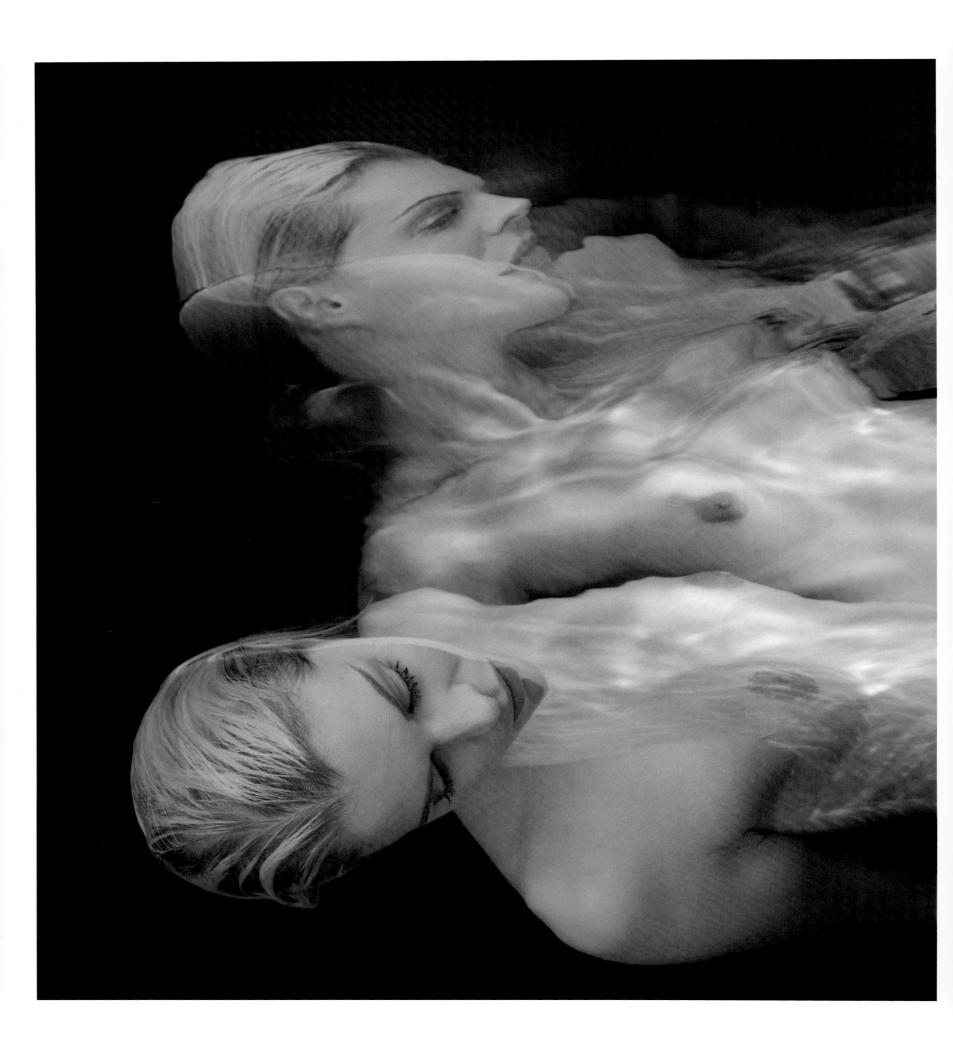

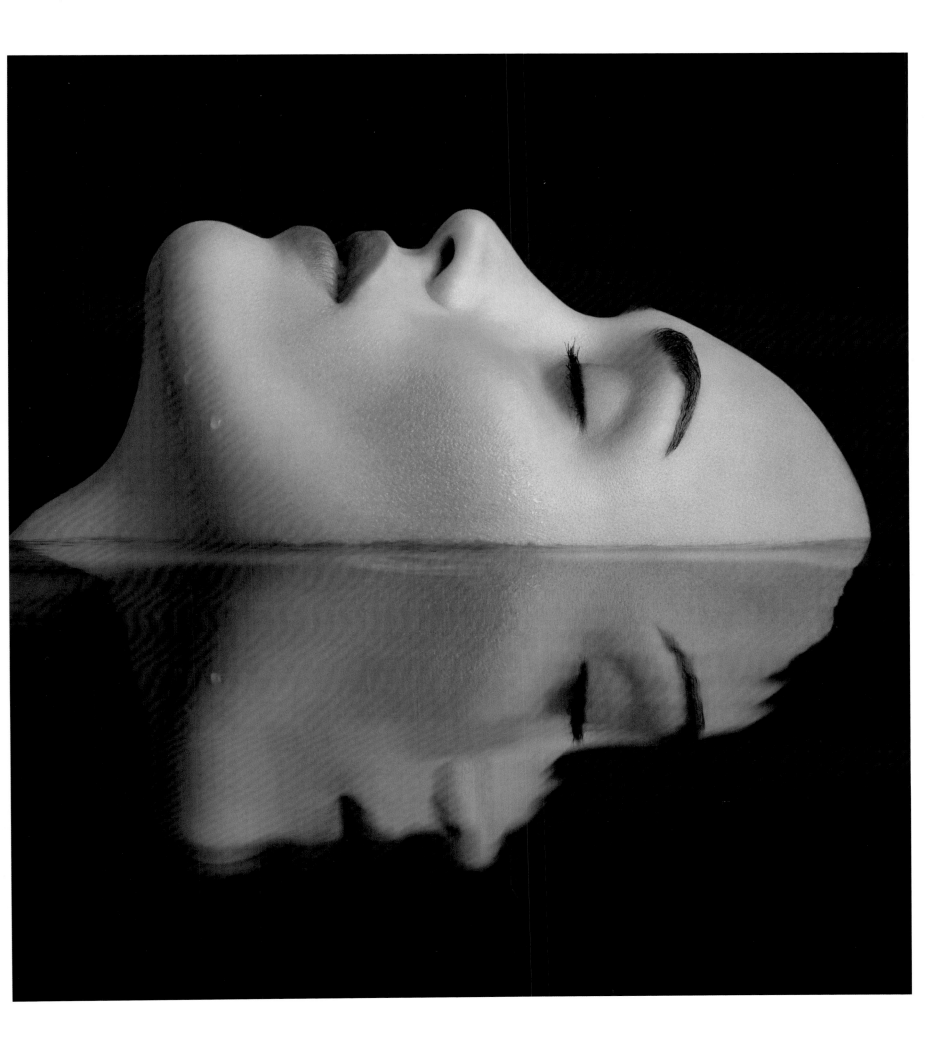

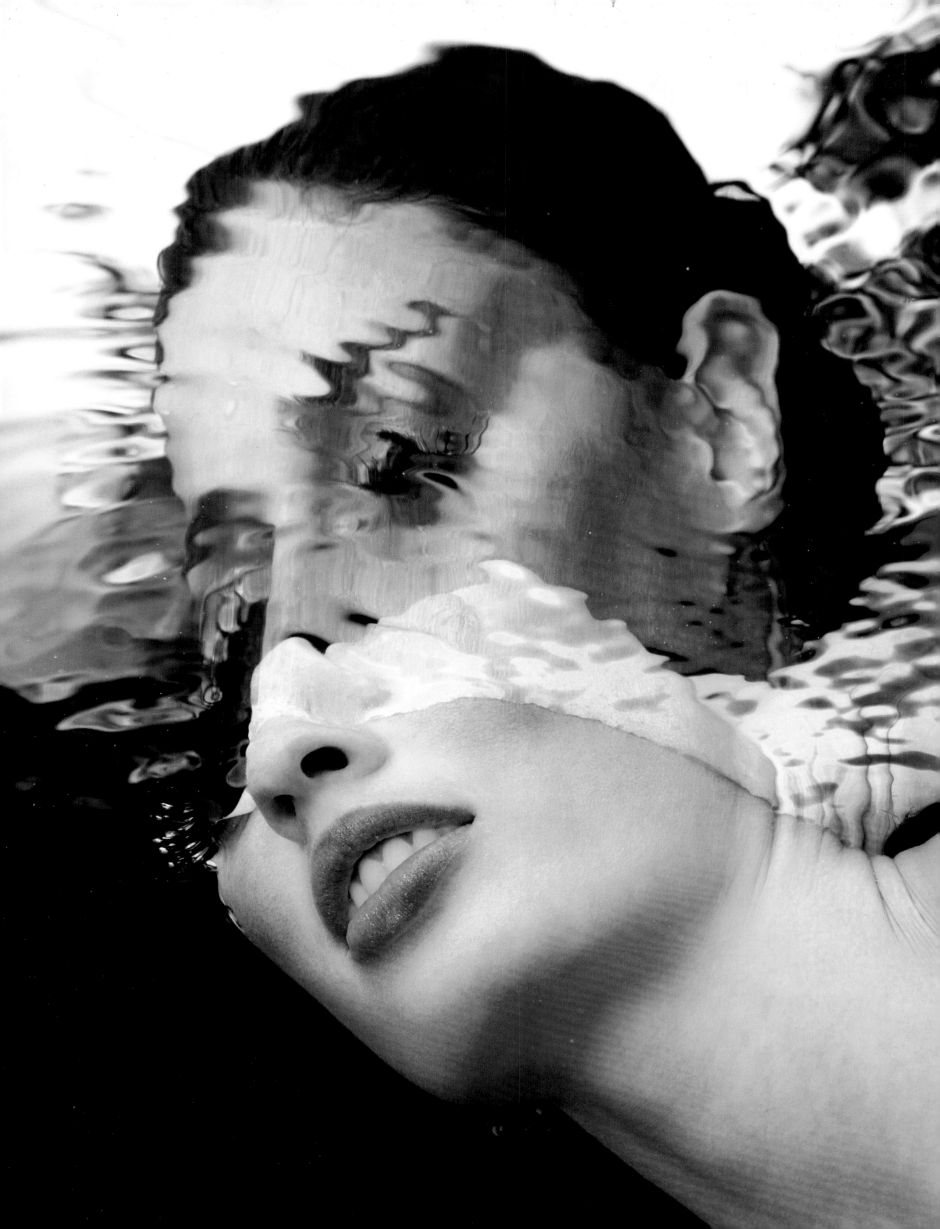

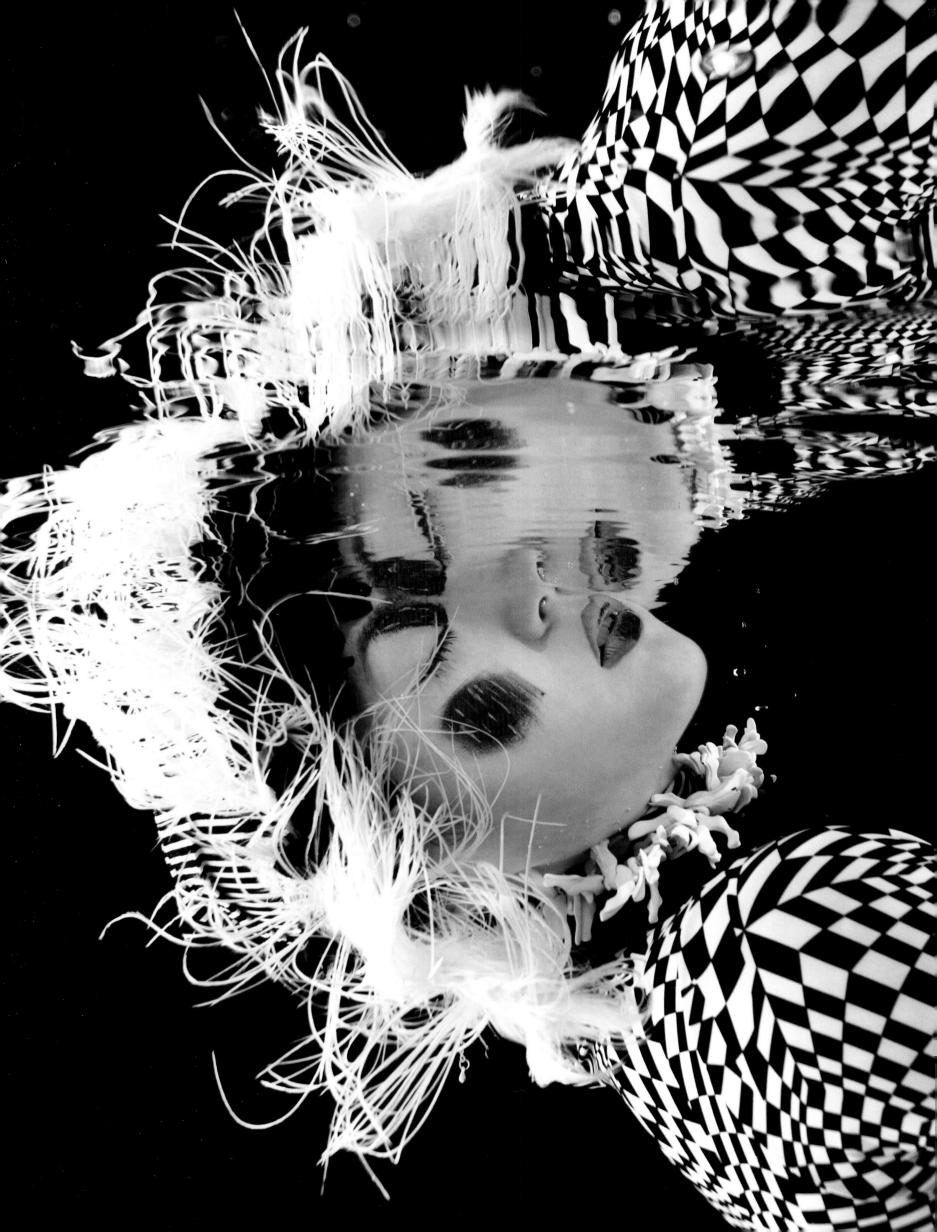

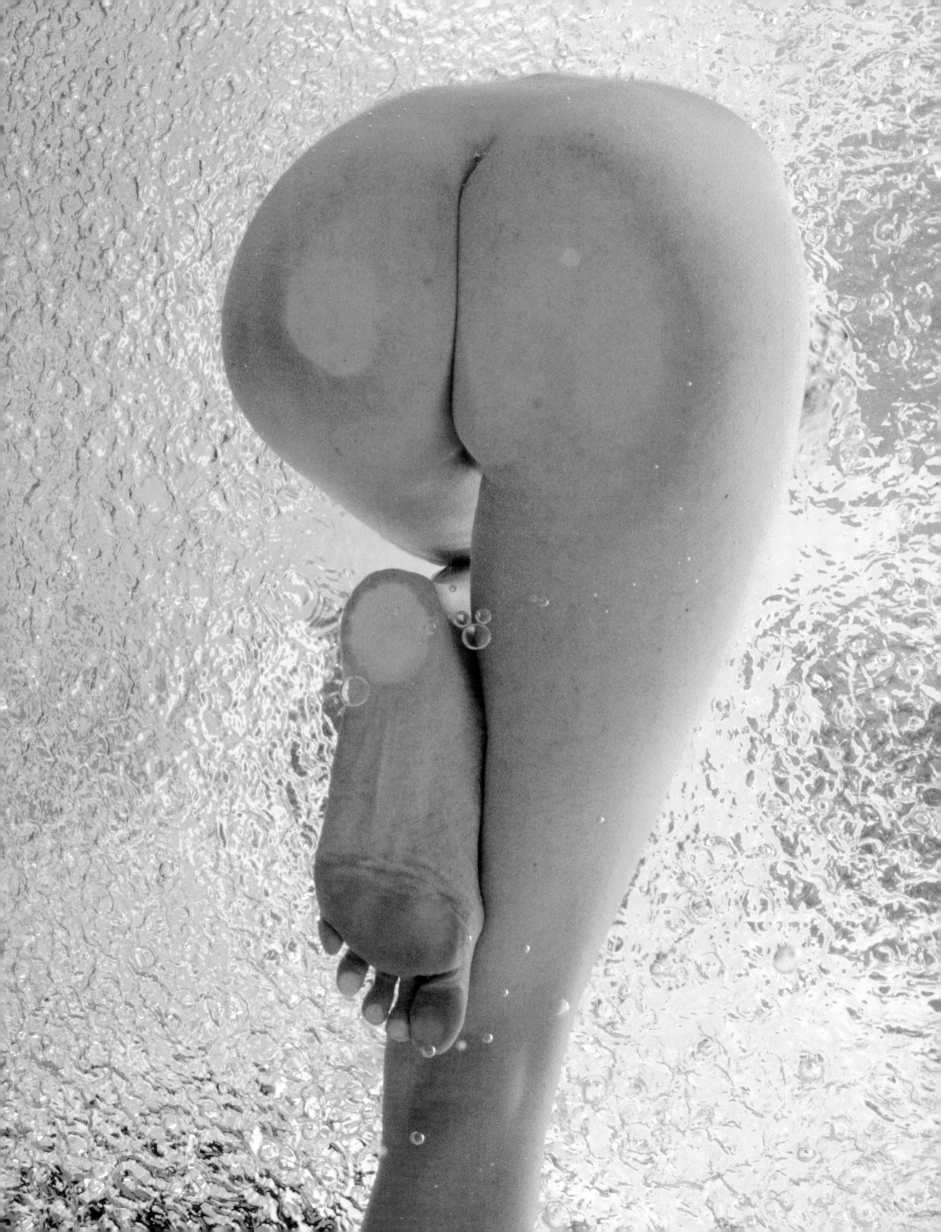

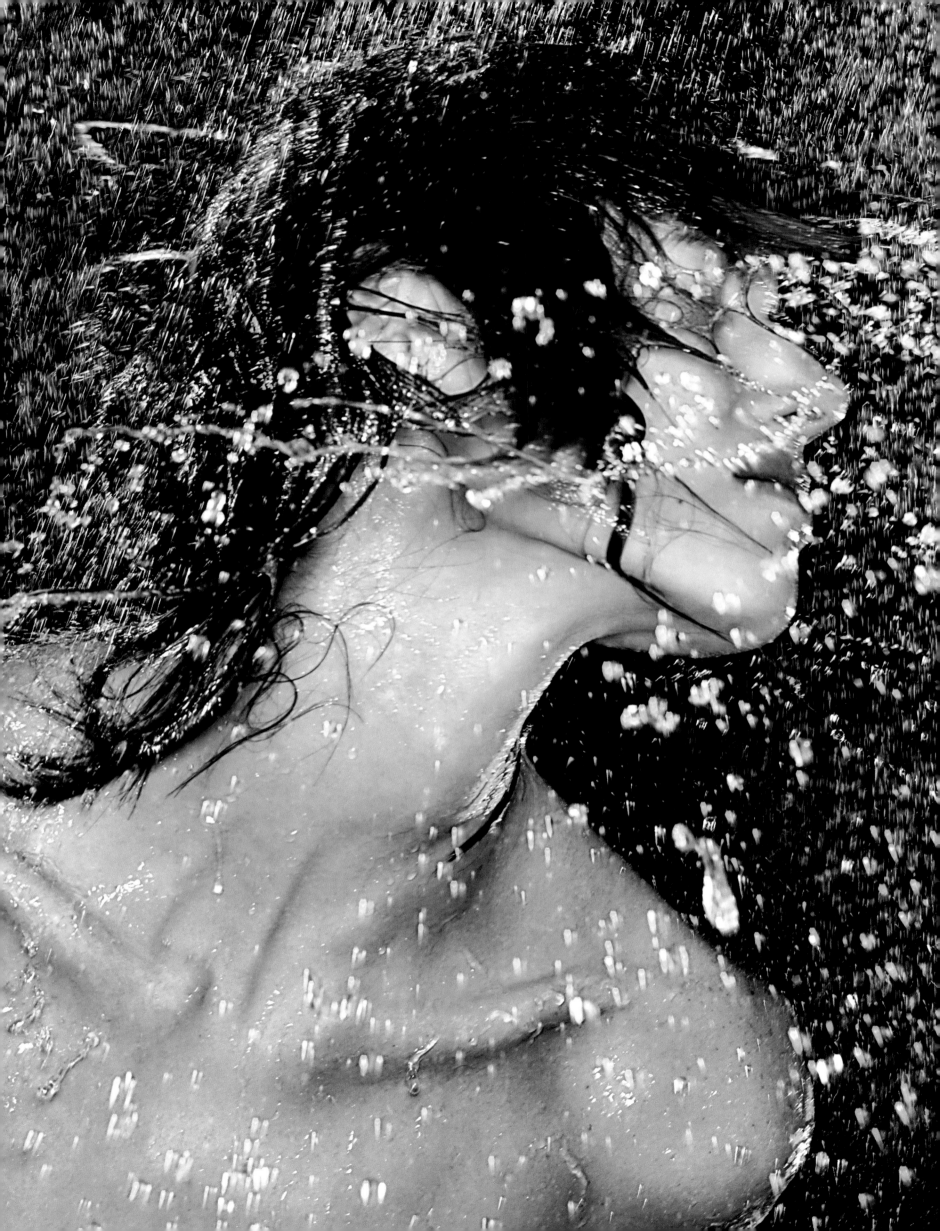

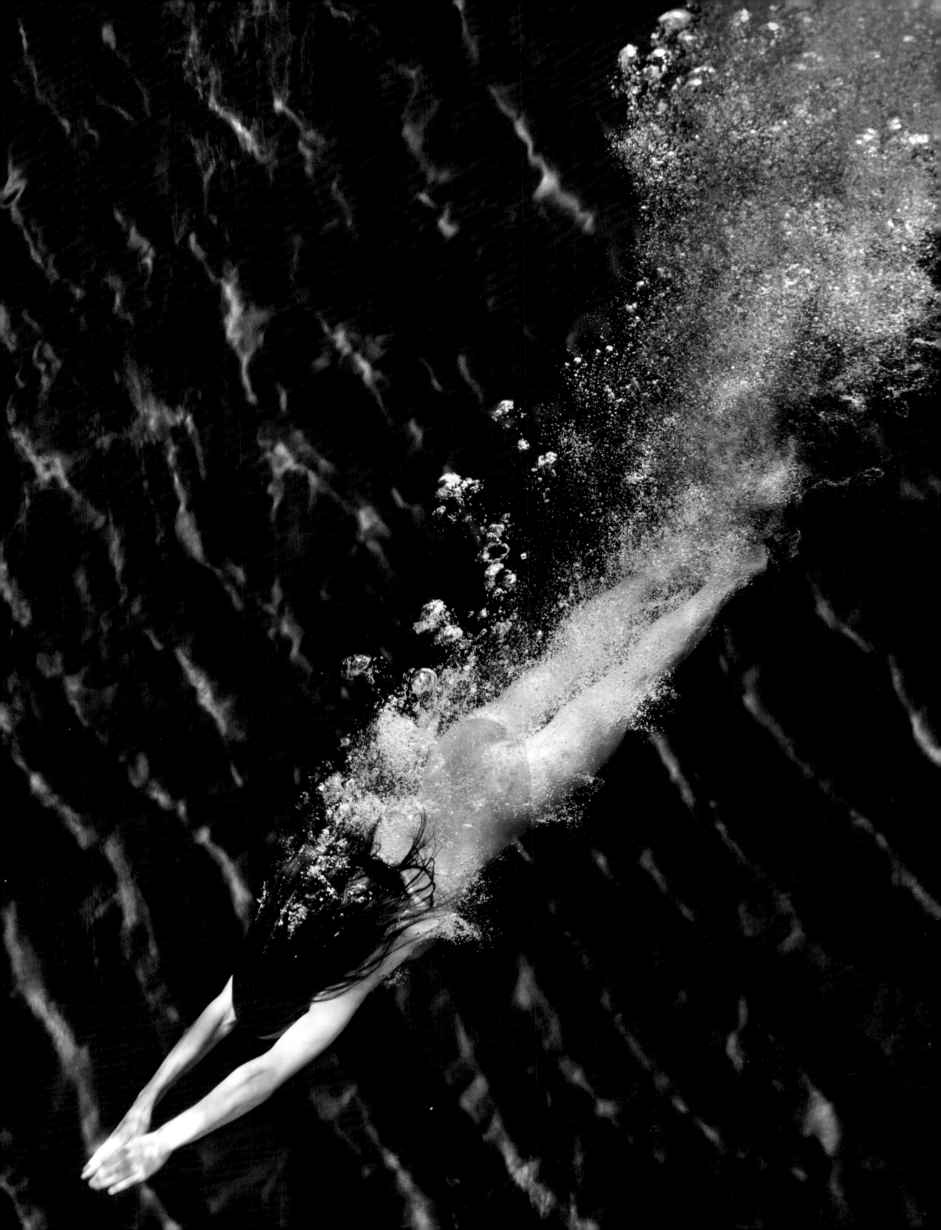

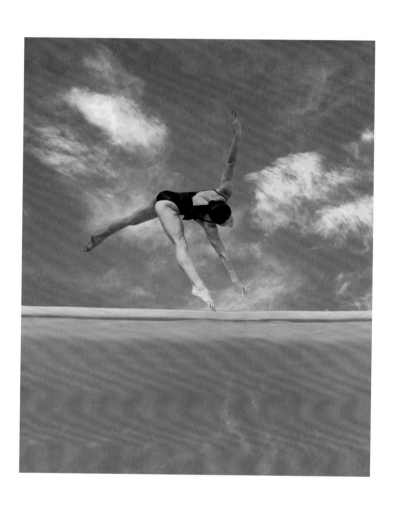

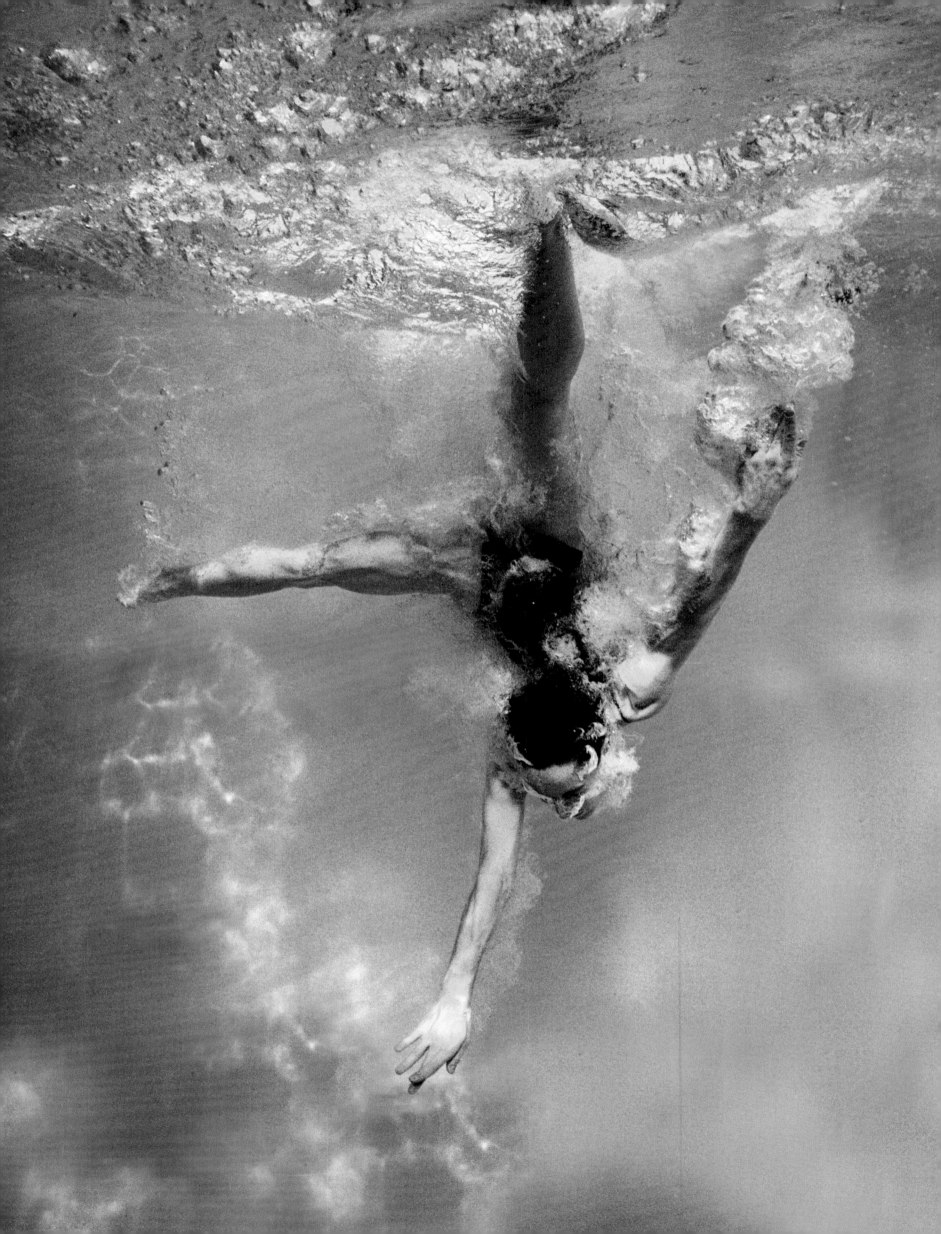

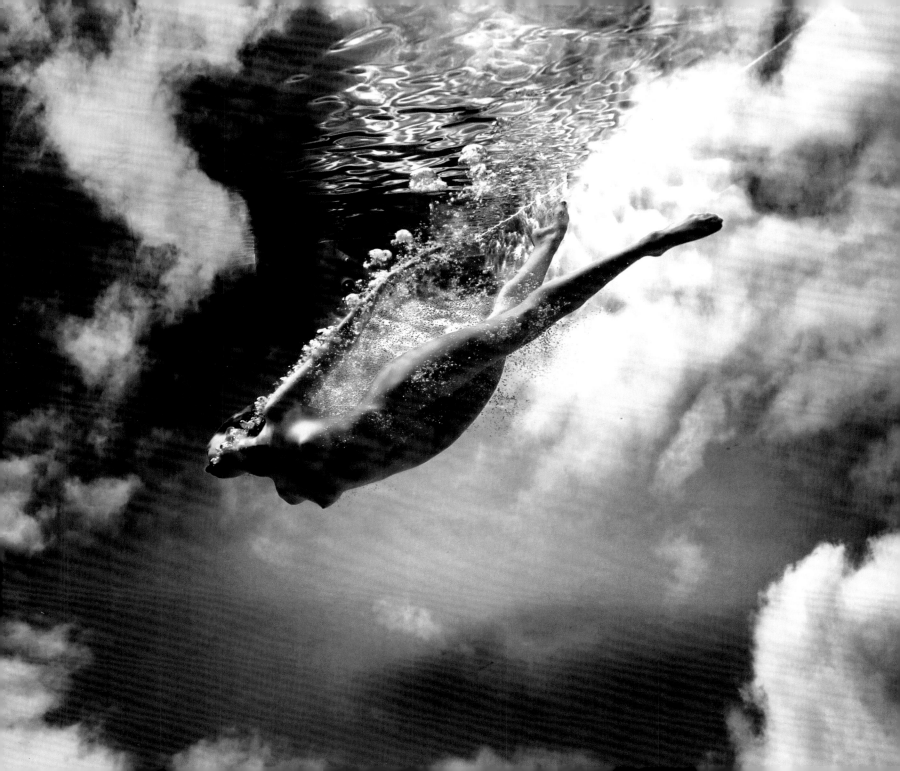

Escada: Into the Blue

Flowers produce pollen, and pollen (with a little entomological and wind-borne help) leads to the cross-pollination that creates new life. As it is in botany, so it was with an assignment that Schatz did for a European branch of Wieden + Kennedy. The client was Escada, and the campaign was for a new perfume, Into the Blue. Always on the hunt for singular talents, the creative director at the agency, Andy Walker, had seen Schatz's underwater imagery as well as his genre-bending 2005 book, *Botanica*, in which he made close-up photographs of flowers and then had the temerity to use the computer to reinvent nature's colors. What they asked for were flowers, underwater, composed of women, thus blending two entirely different concepts by the same photographer.

A bright idea, but far easier to imagine than to do. In his usual methodical way, knowing as he always does that when you put fashion models in the water – and Escada had specified a "supermodel" – there's no time to waste, Schatz prepared for his "floral design" by experimenting with six plastic articulated artist's dolls. Miniature chiffon dresses were fashioned for them, and Schatz did test photos to show the agency his ideas for compositions. When several were green-lighted, the photographer began his search for models. For the formal shoot he used a dancer, an Olympic synchronized swimmer, and a model, Alex Elliot. The results of two days in the water were almost thirty human blossoms, from which the final flower was chosen. It seems to come out of the blue to give a heady, unmistakably romantic essence to Into the Blue.

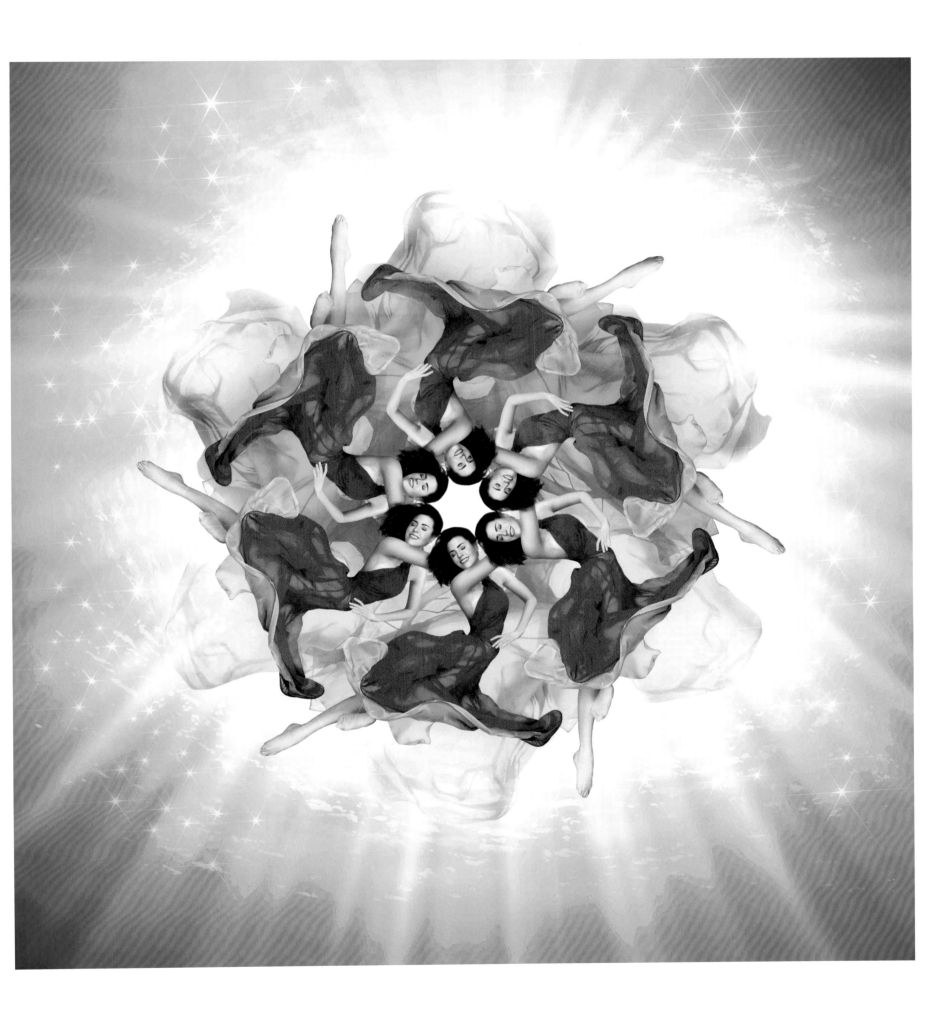

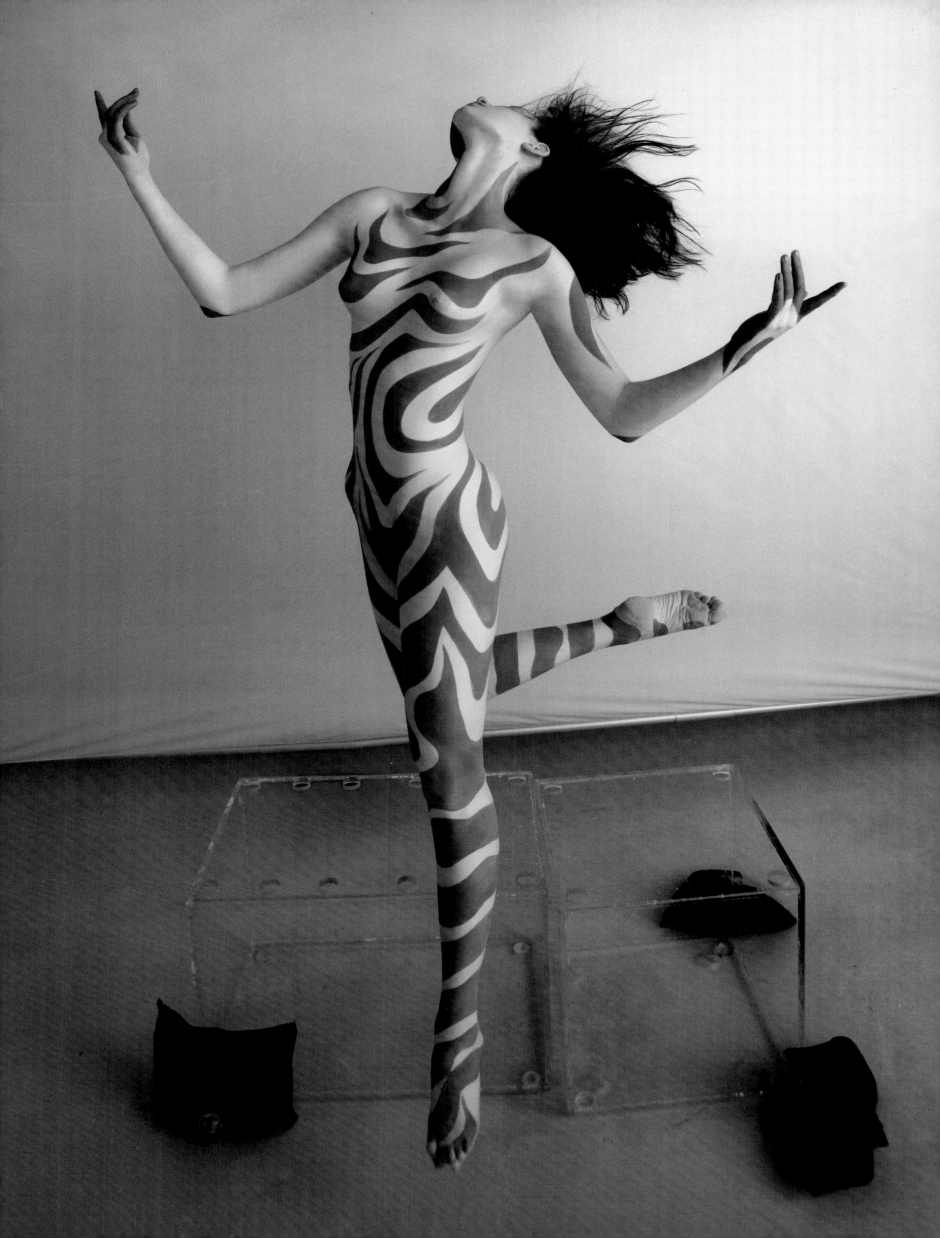

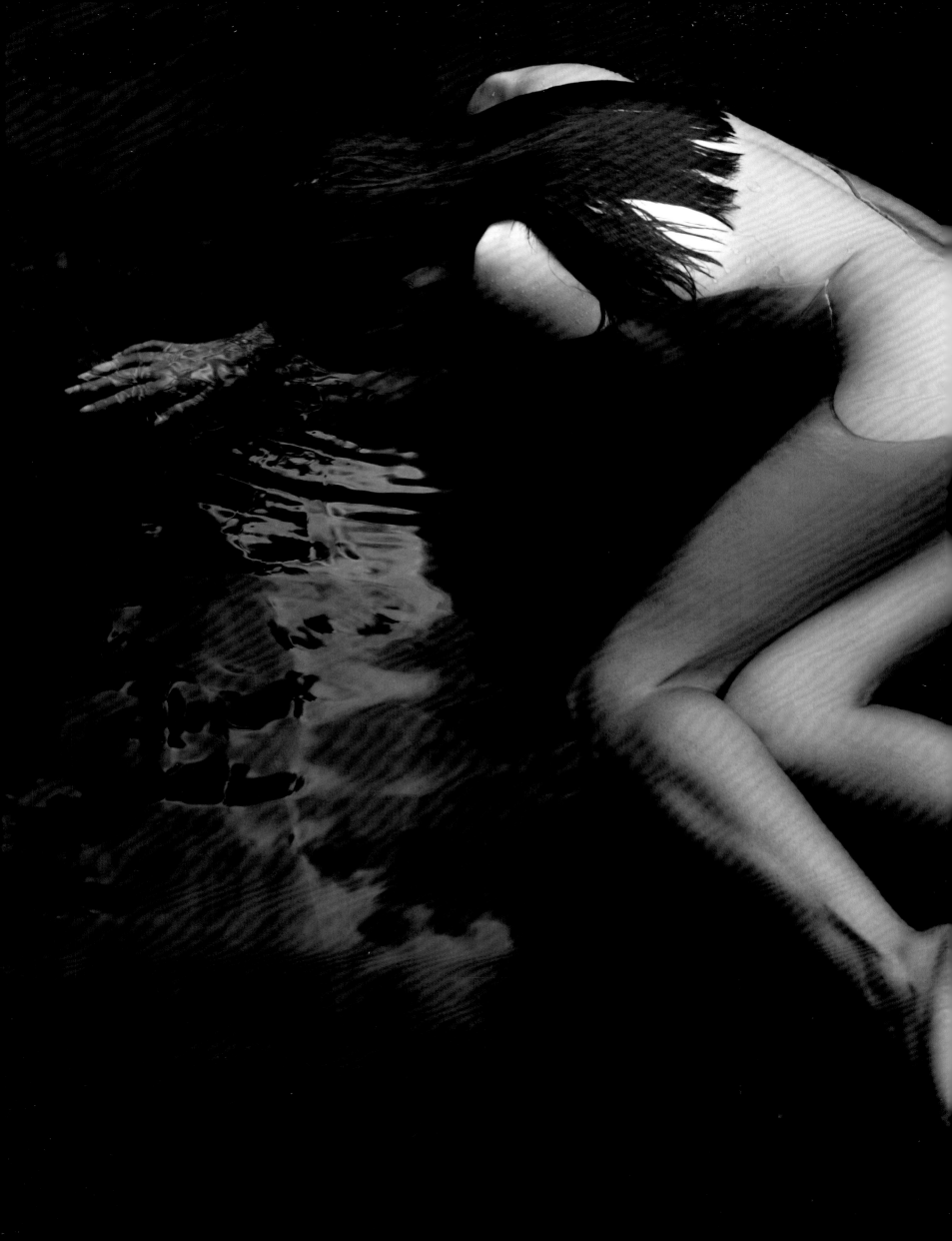

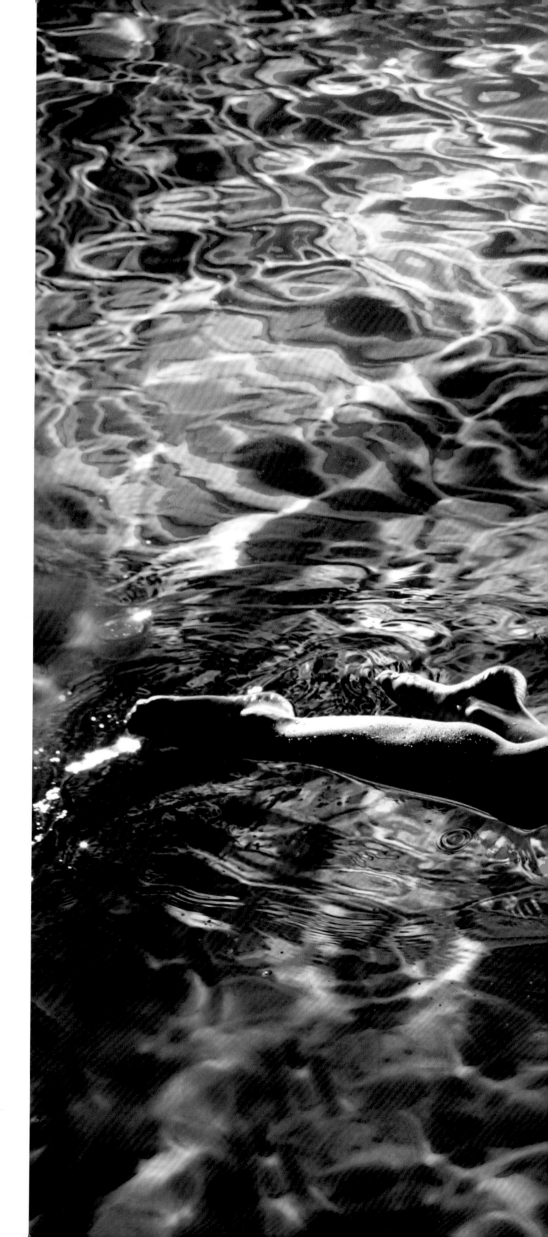

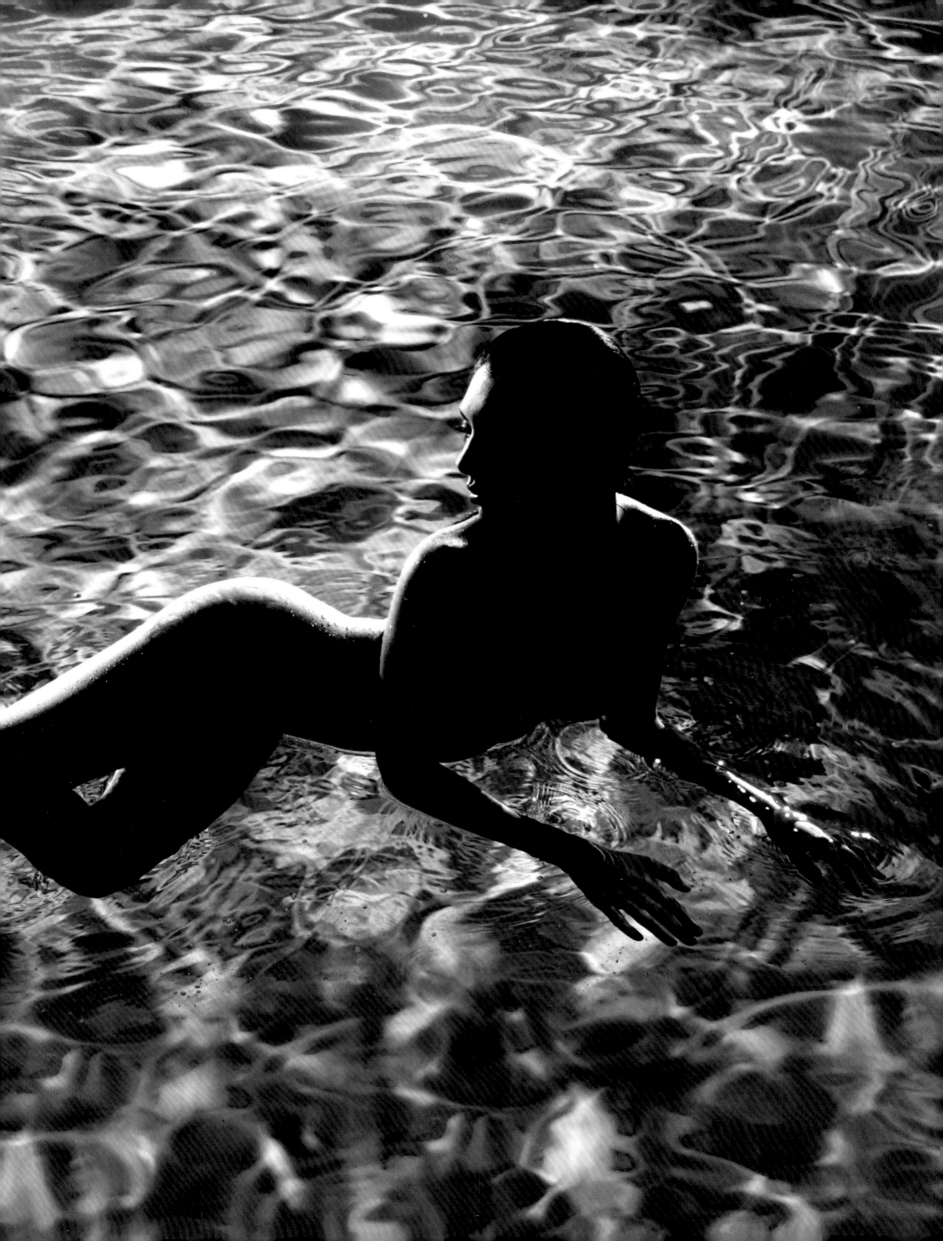

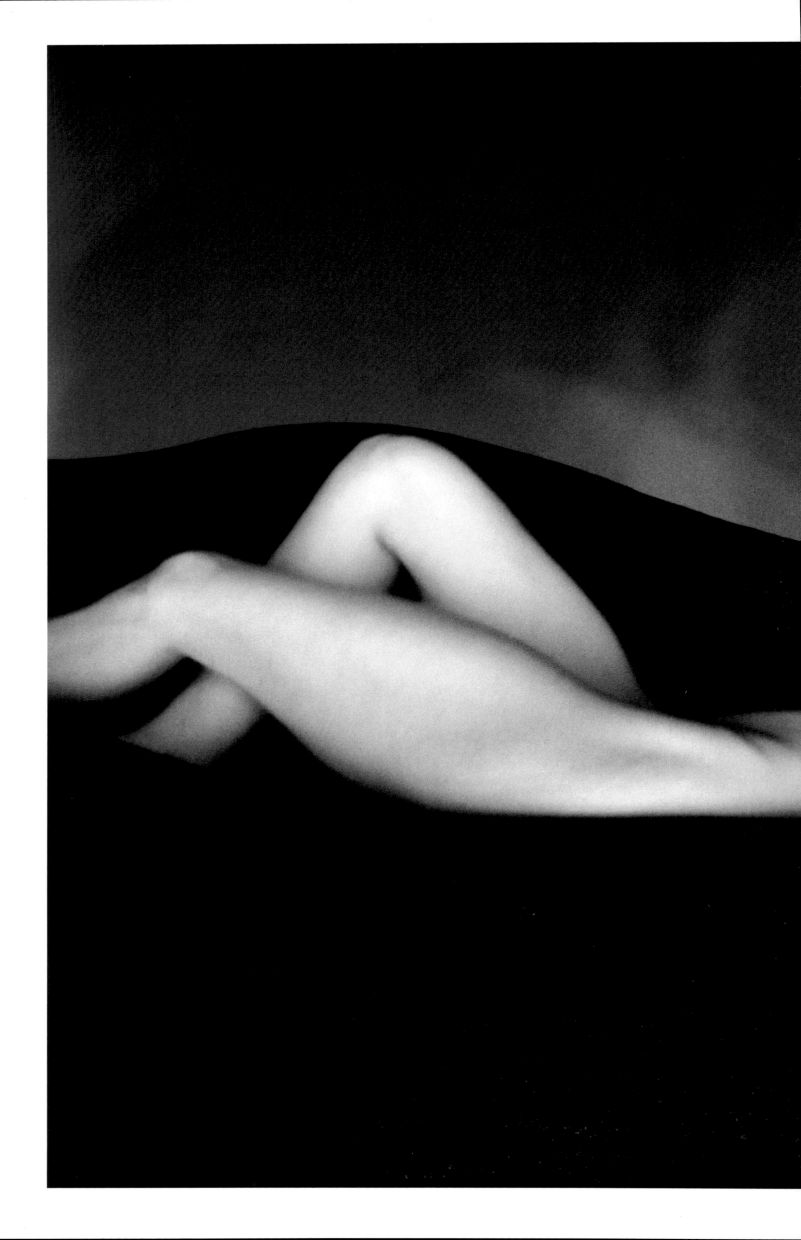

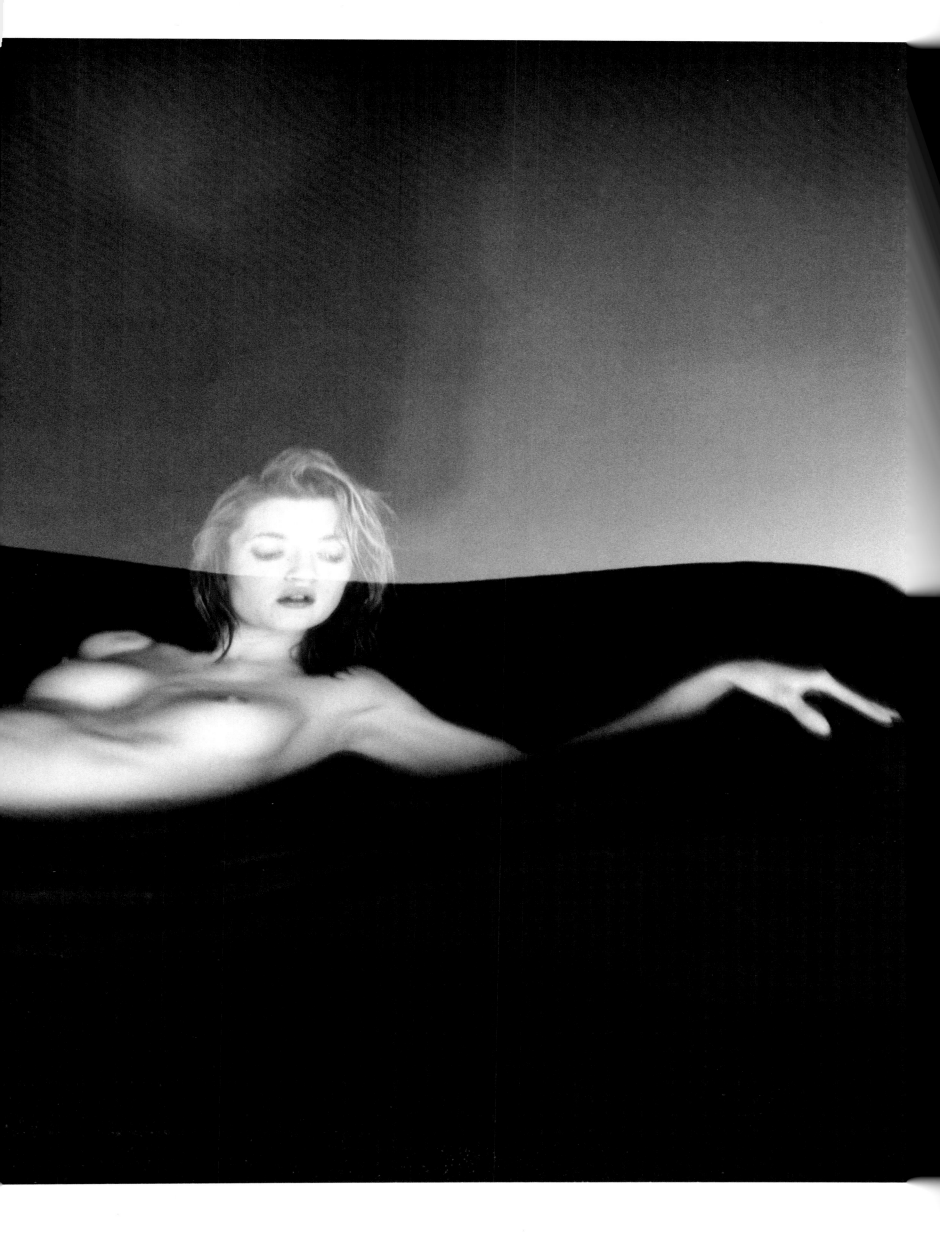

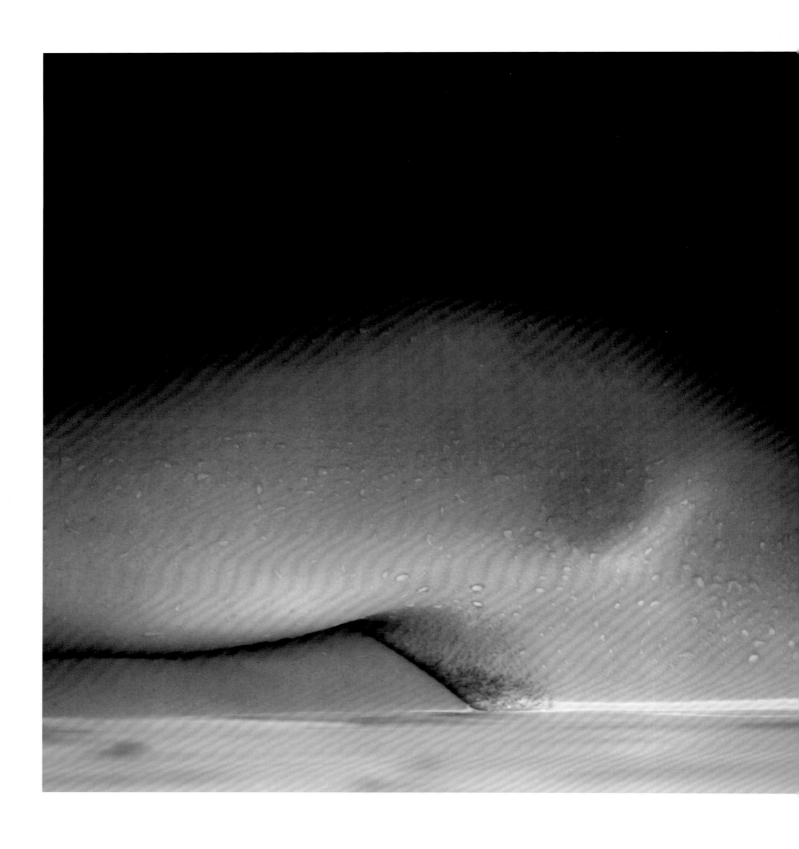

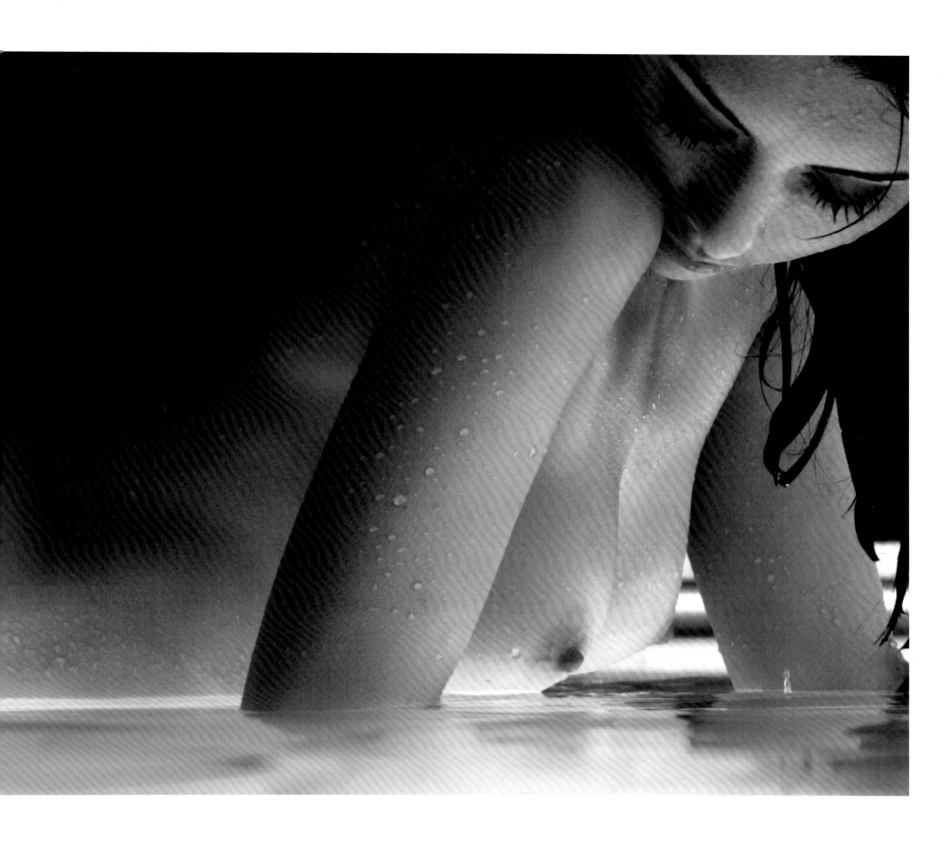

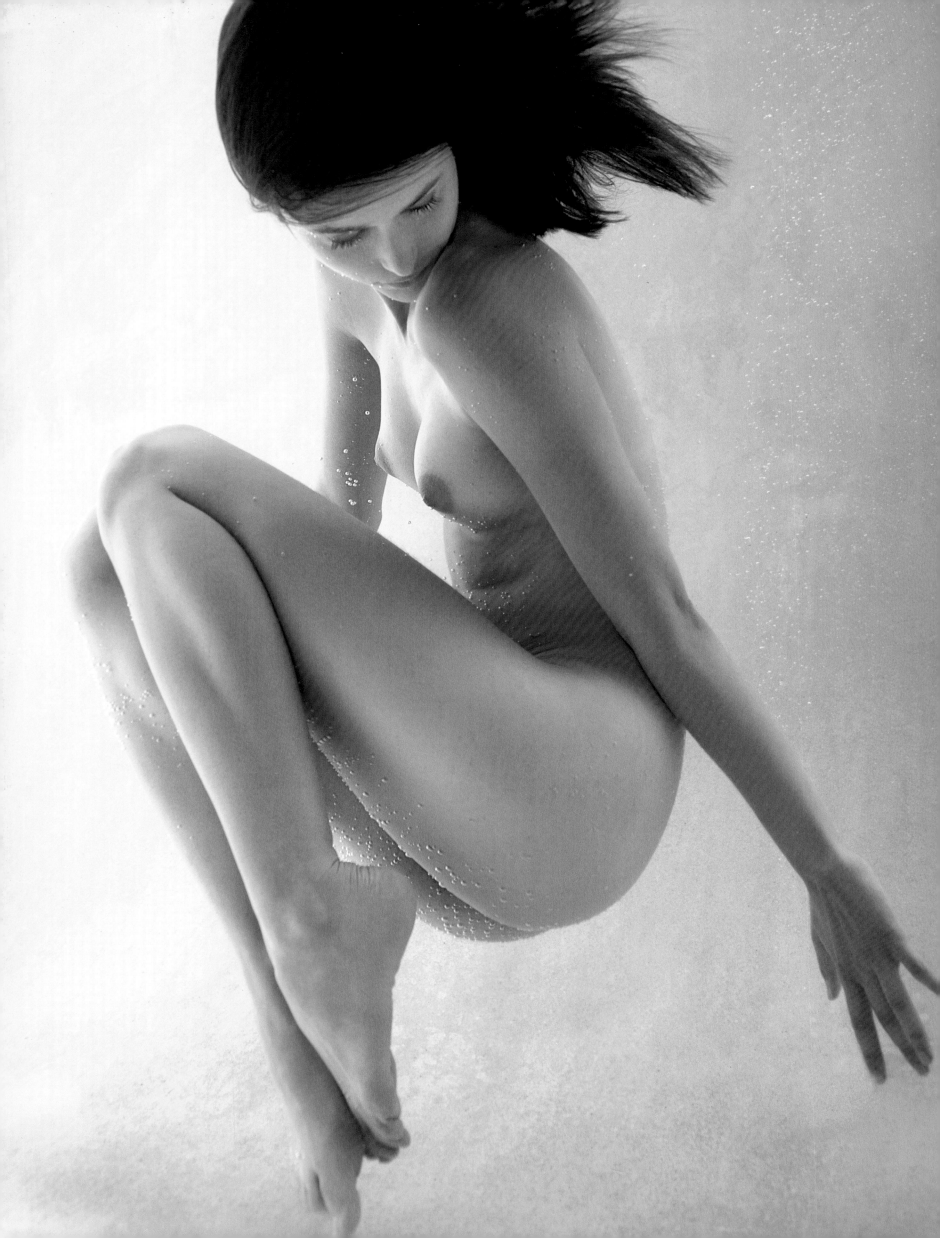

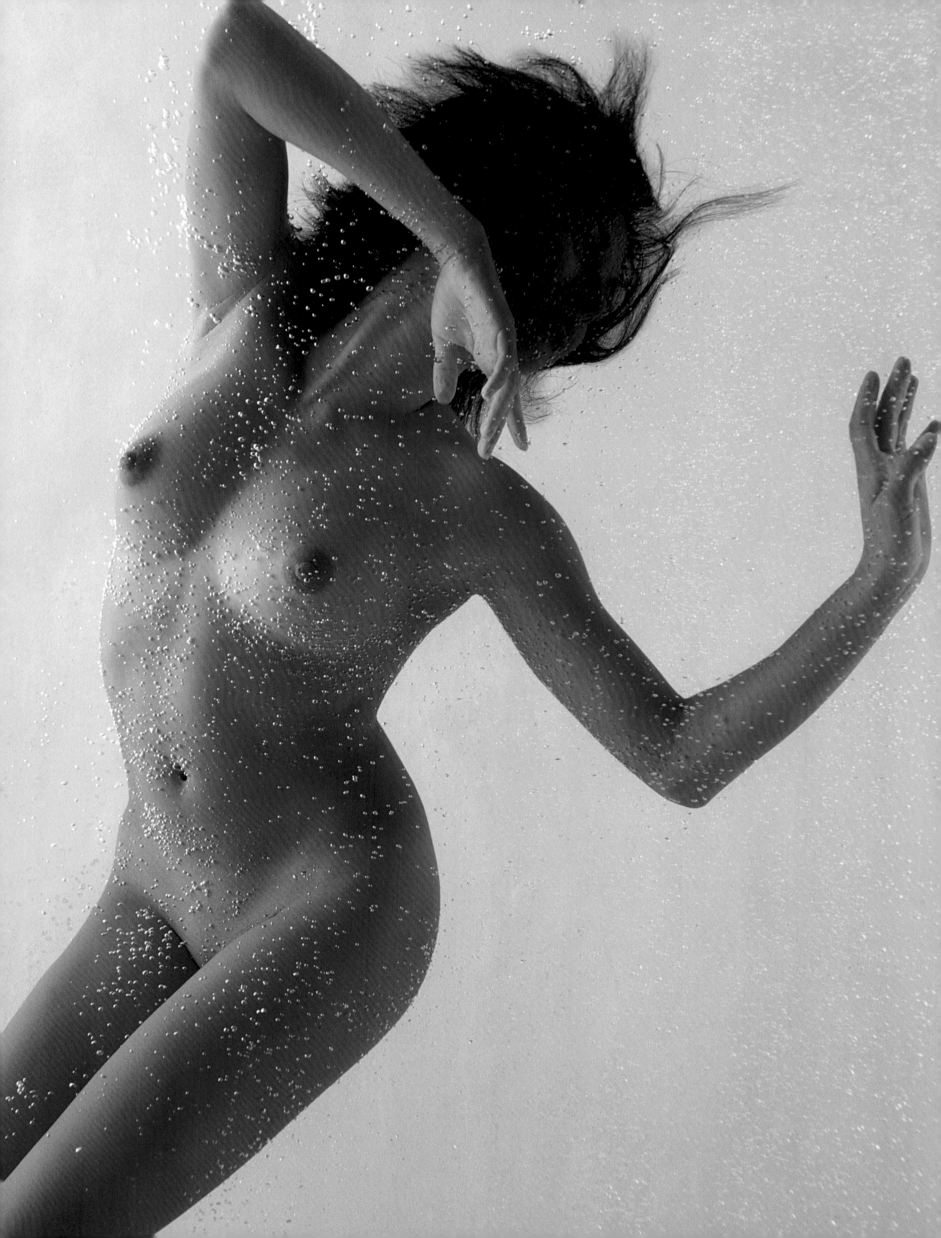

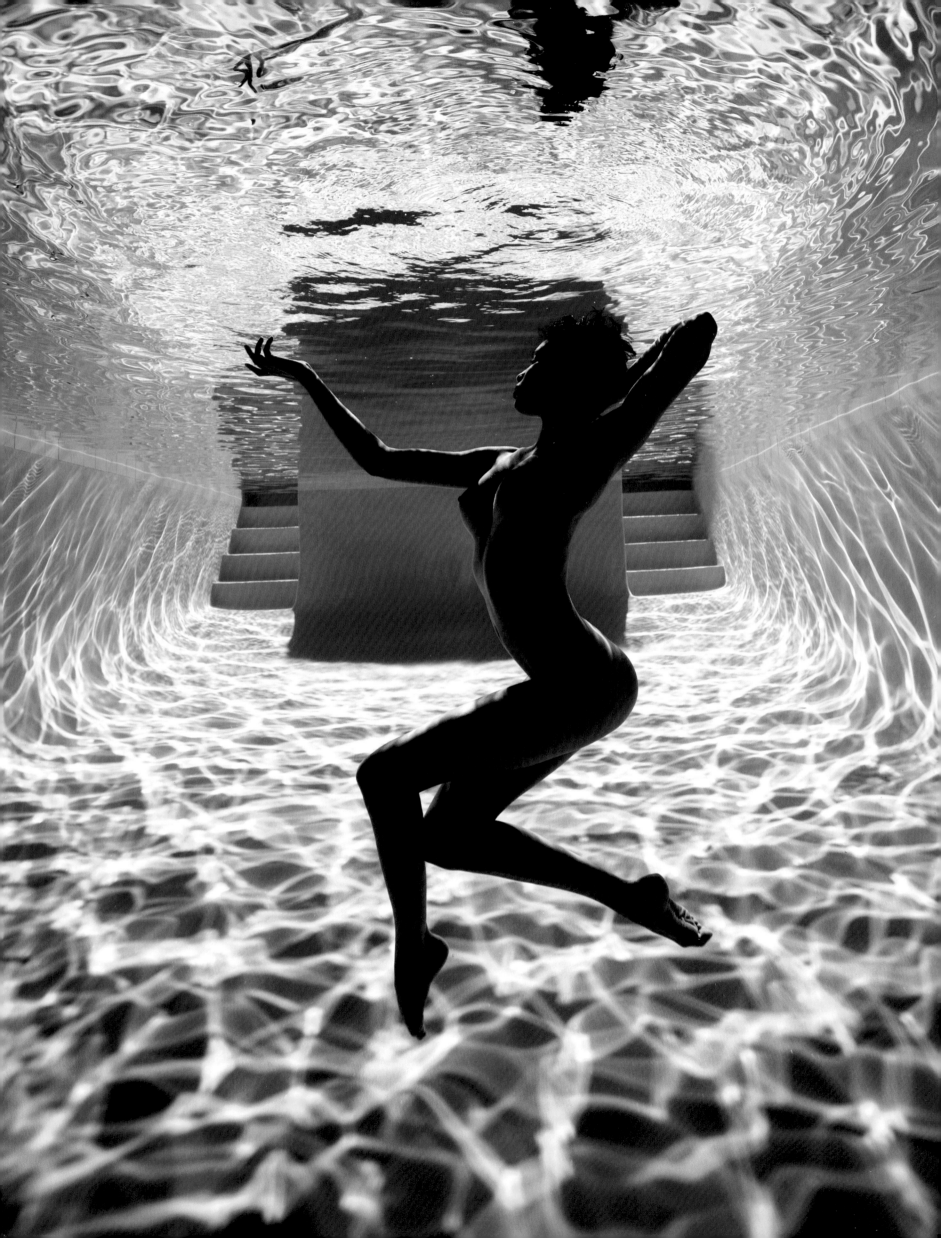

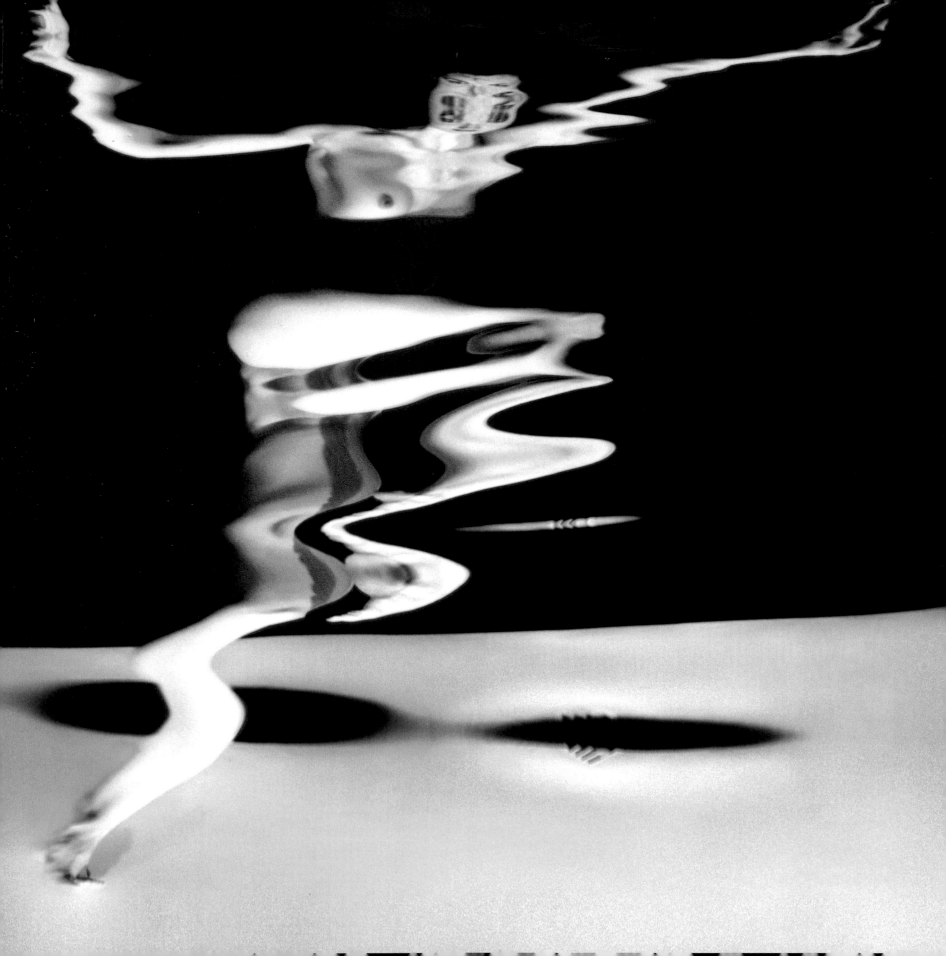

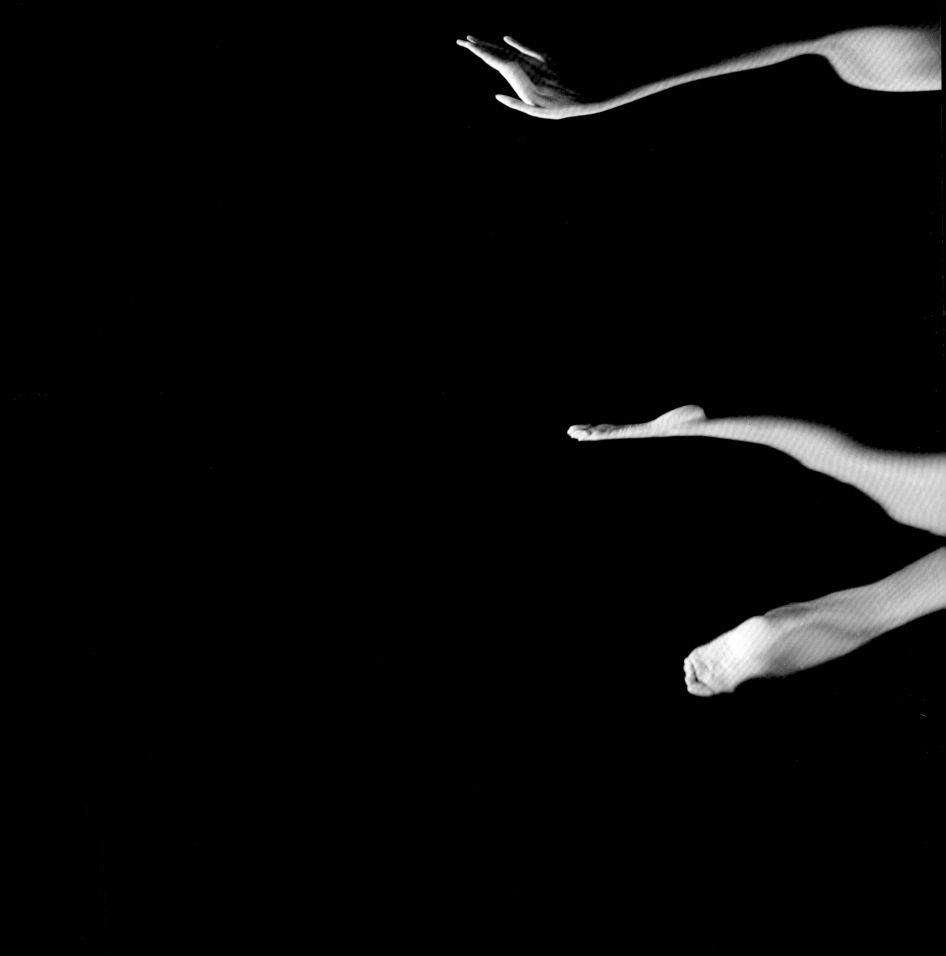

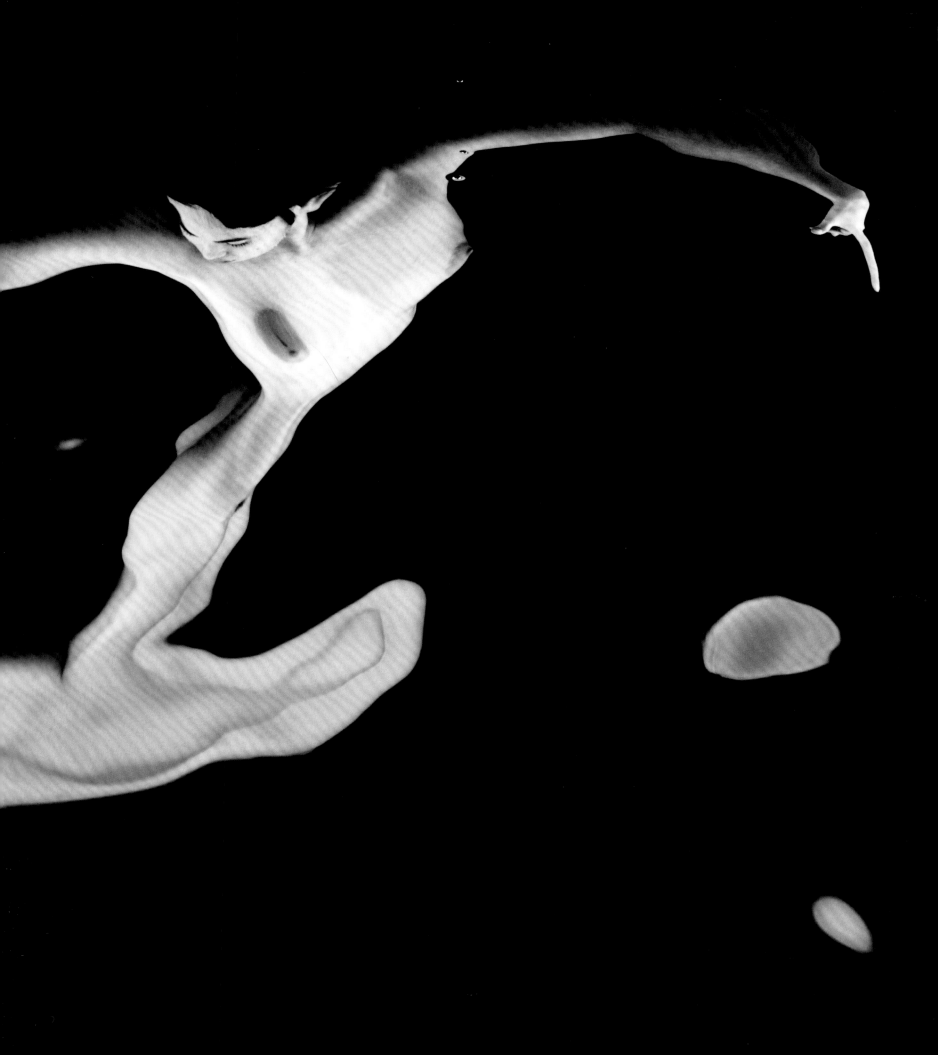

War

The lifeline of a fashion photographer is the magazine fashion director, a combination patron, promoter, mentor, and tormentor. Sometimes a fashion director is both imaginative and permissive – he or she understands exactly why a given photographer can bring an idea vividly to life. So the call is made, ideas are discussed and refined, and then the photographer is trusted to do the creating. When this kind of fashion director and a brilliant photographer collaborate, great magazine pages are usually the result.

For Schatz, a call from Kevin Stewart, then fashion director of *Gear* magazine, initiated what the photographer describes as "one of the best editorial experiences I've ever had." The assignment was to produce a feature on men's all-weather coats, in the unlikely environment of the underwater studio. Schatz had already cast his mind and eye into a fantastic future with *Atlantis* (p. 41), a vision of a tranquil feminine aquatic world. This time he saw another future in which men continue their ferocious terrestrial struggles beneath the waves. Where *Atlantis* is serene and paradisiacal, *War* is hellish, a scene of subterranean savagery right out of Bosch. "I wanted to do something visually loud," Schatz says, "to give a sense of what it is to go off to war, and the terror and ferocity of hand-to-hand combat. Yet I also wanted the water to add the elements of adventure and delight. Kevin had a way of delivering confidence, so I felt free to let myself go. He handed me the baton and let me finish the relay."

War and *Atlantis* are the bleak and bright sides of an existential coin that has flipped over and over throughout history: the violence of human nature, though improbably expressed with weightless grace, still evokes the narrative power of a kind of Homeric approach to photography – human nature seen through an underwater lens darkly. What Schatz got from Stewart was the chance to take an idea and make all he could of it. What Stewart got from Schatz was a feat of beauty and beastliness that carried the shock of the new into *Gear*'s fashion pages.

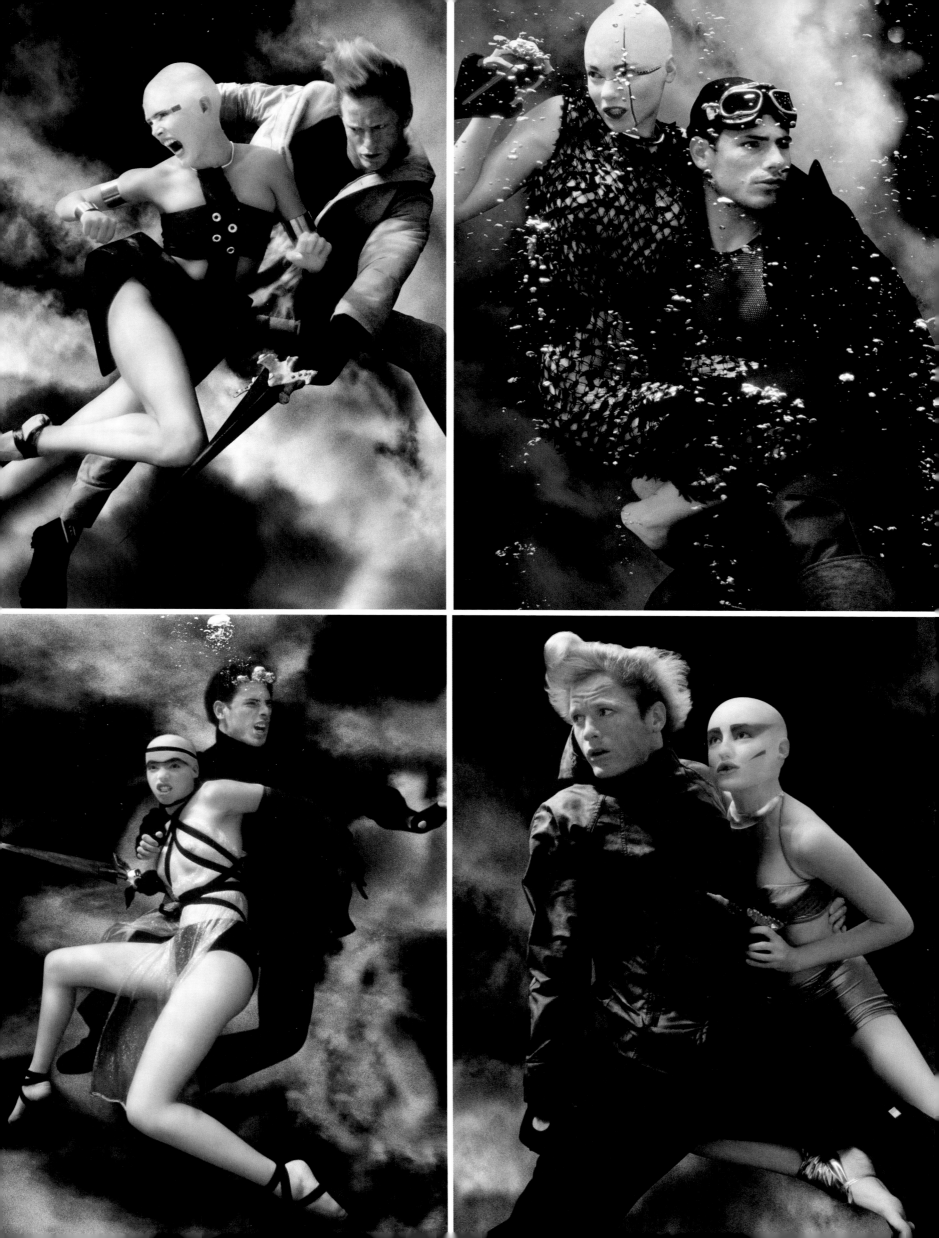

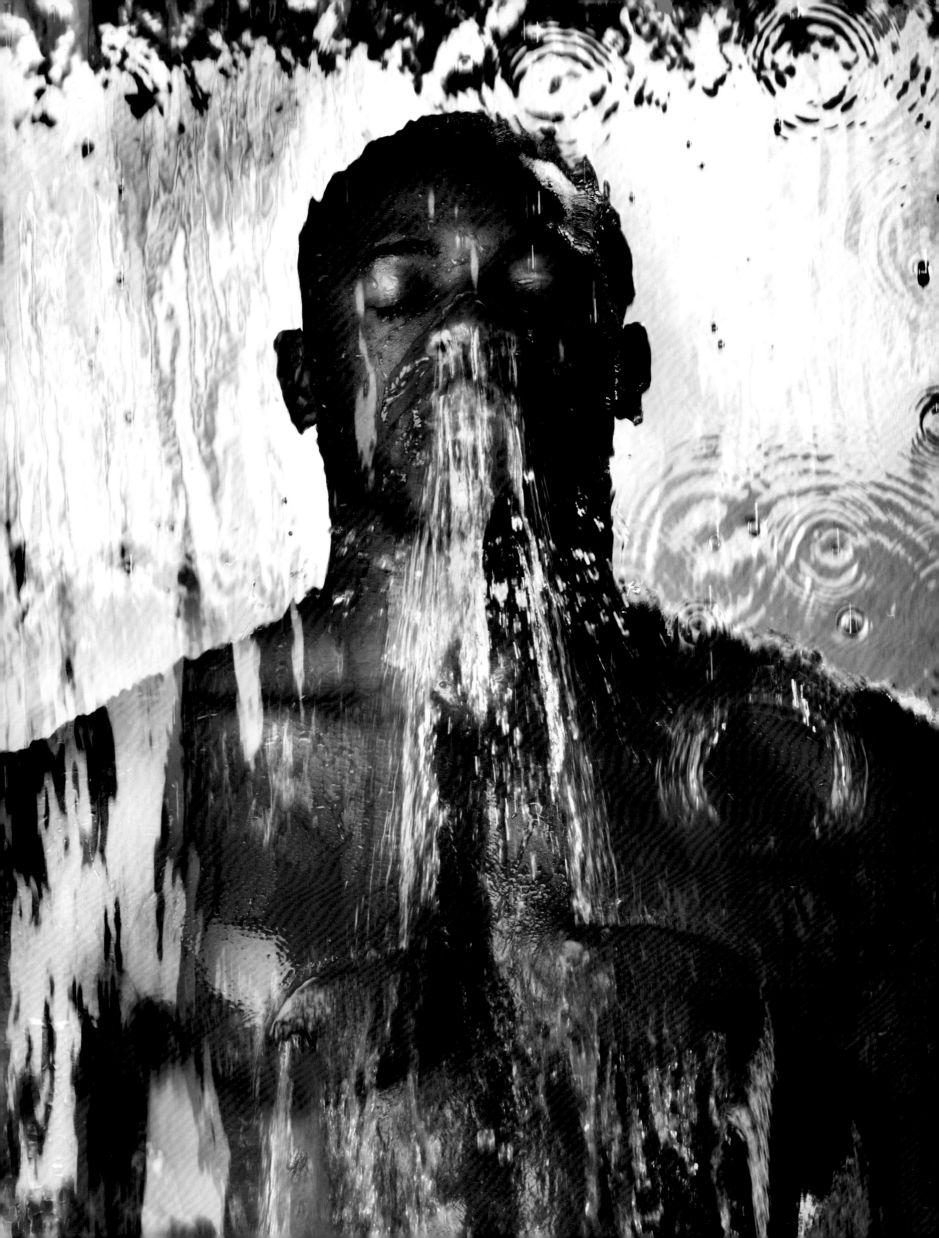

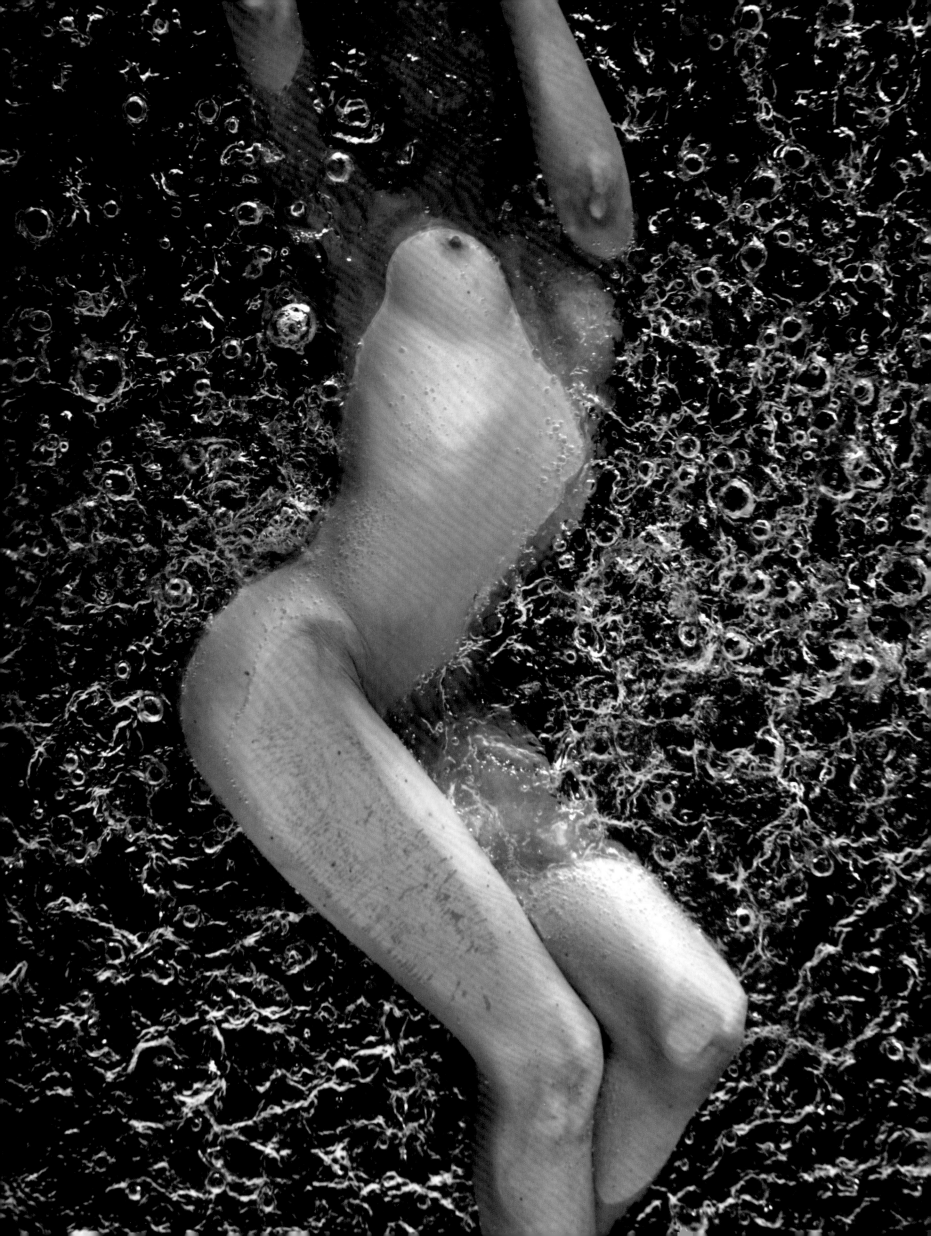

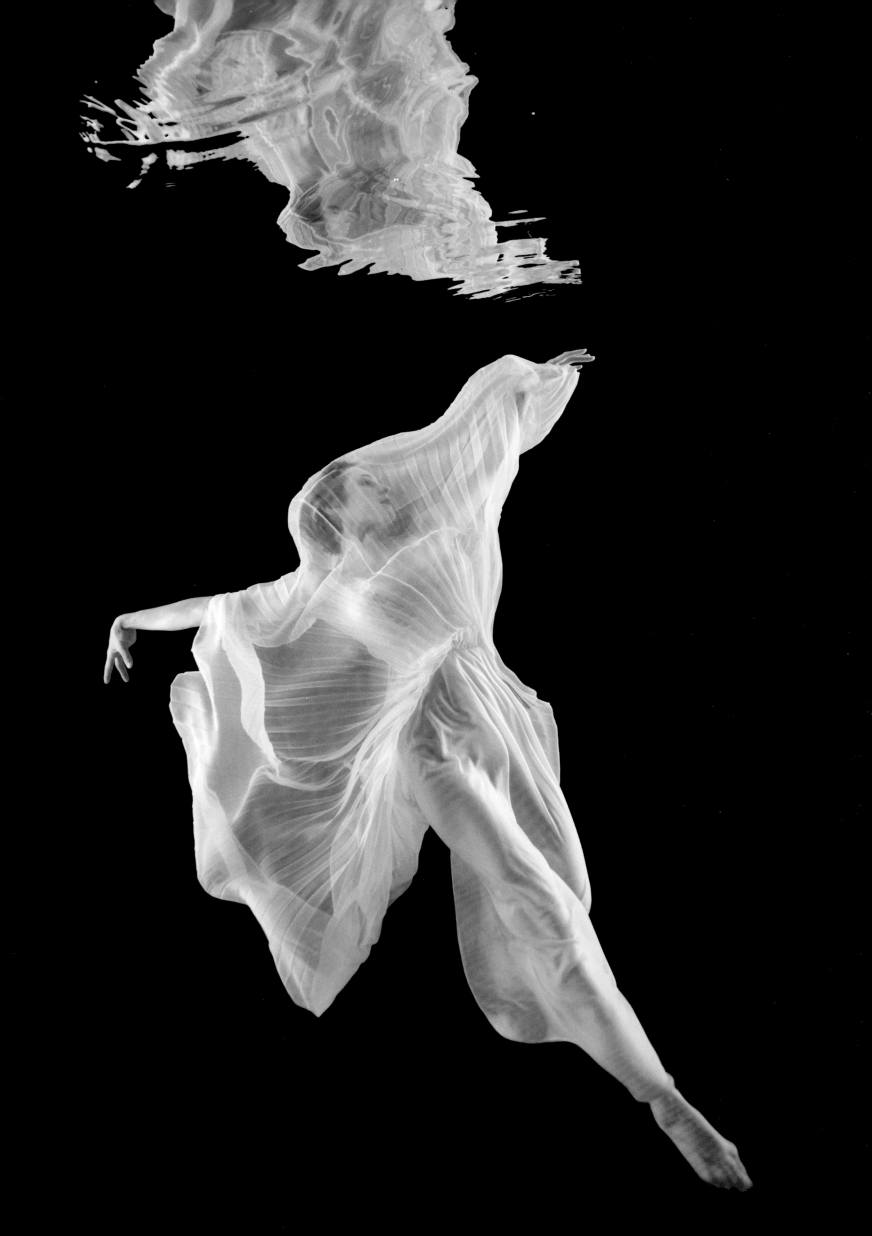

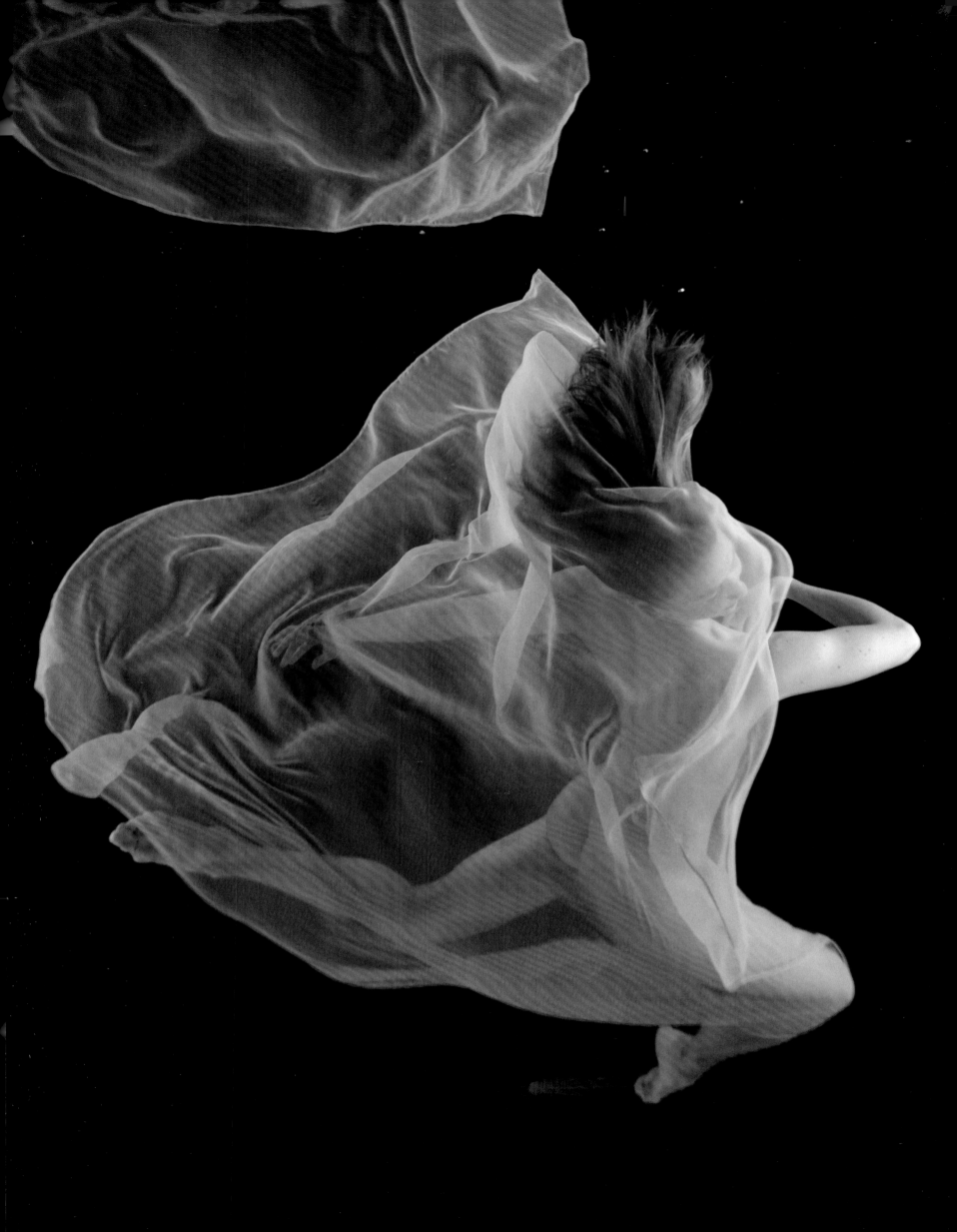

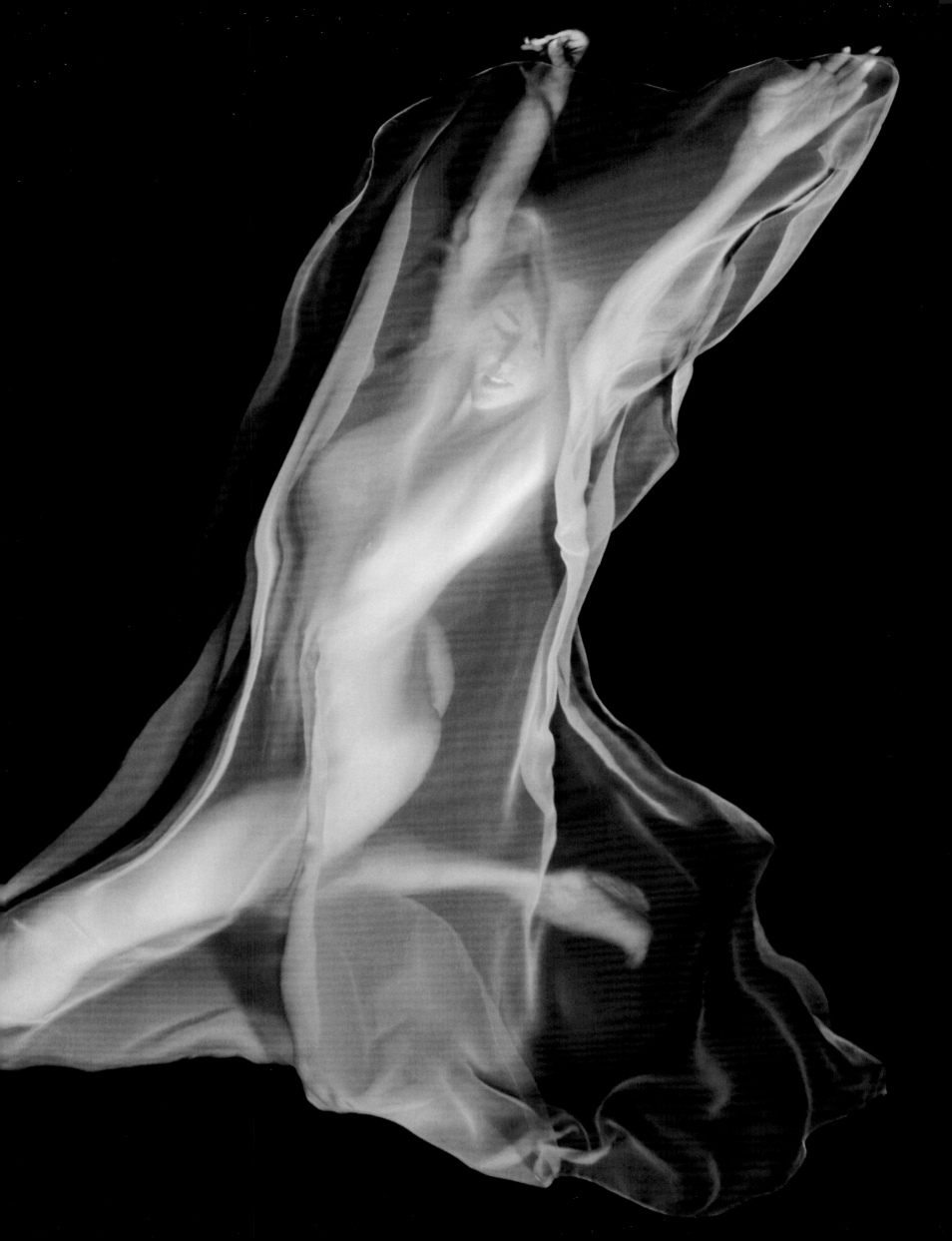

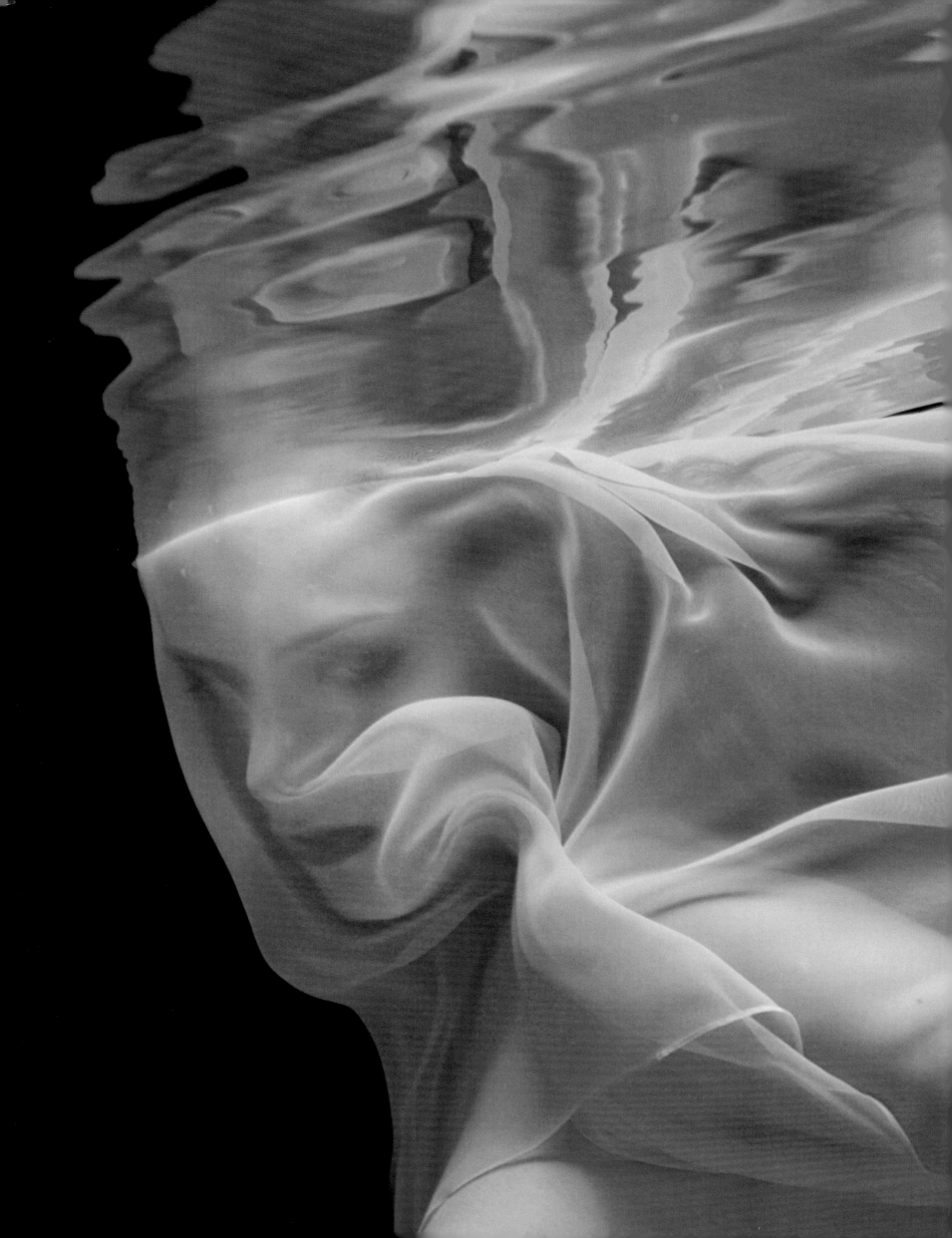

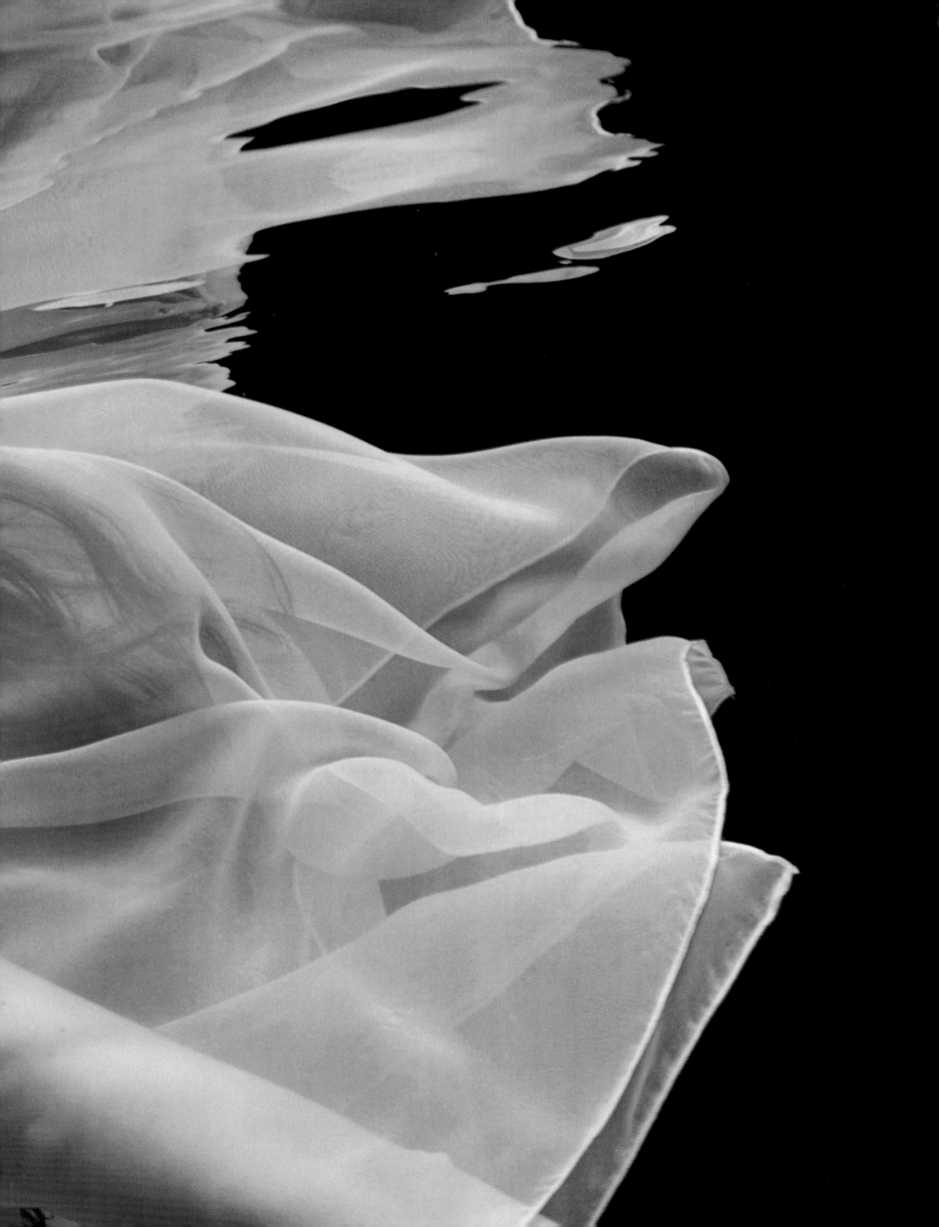

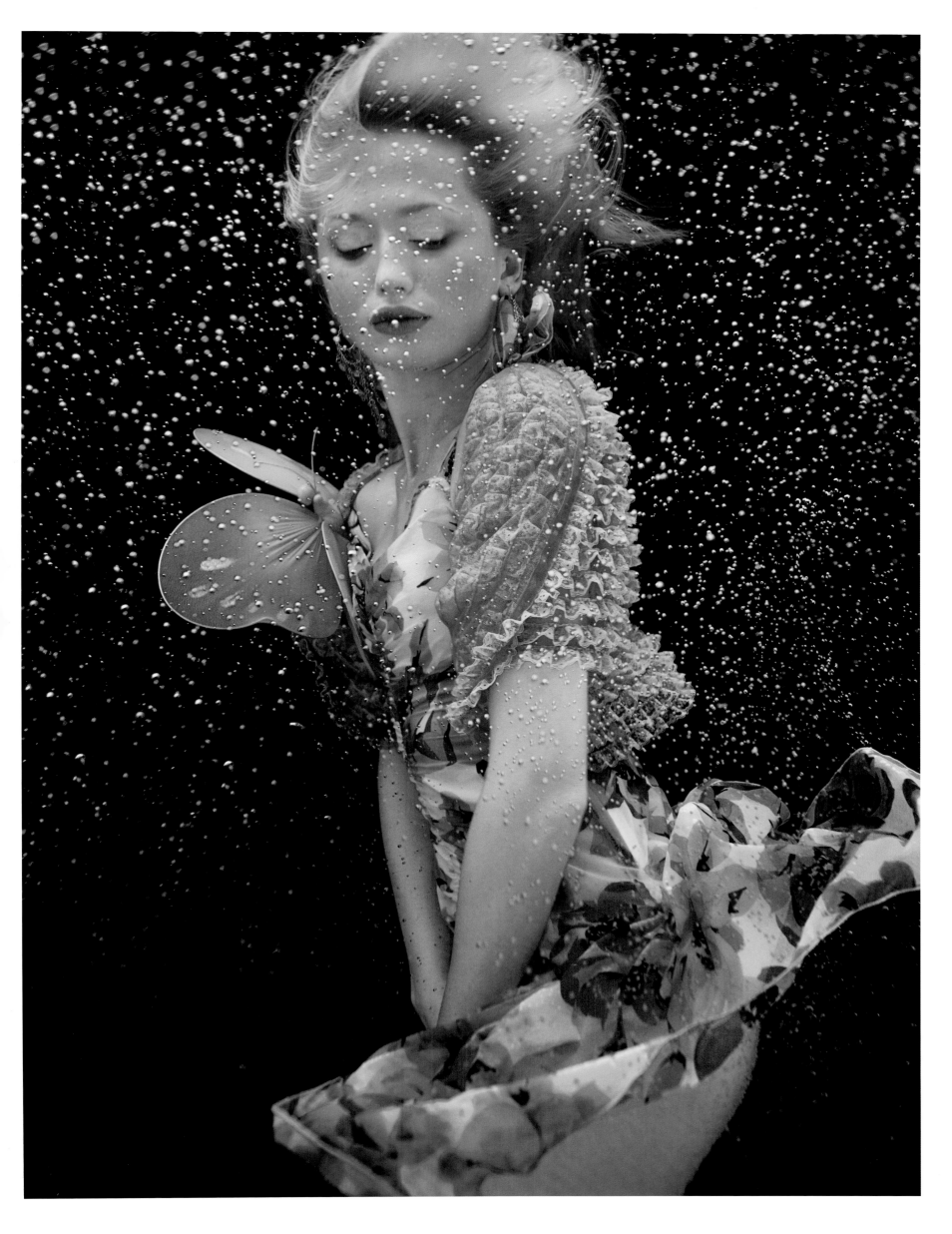

Sports Illustrated Swimsuit Issue

The art of commerce is the art of compromise — a maxim as true in art as it is in commerce. When a magazine editor or art director, or an advertising account executive, looks at a photographer's work and decides that some form of his aesthetic will energize pages or sell products, a negotiation begins between the ideals of art and the reality of media. In the summer of 2004, Schatz received a call from *Sports Illustrated*, with a request to be one of the photographers to produce six to eight pages for the magazine's hugely popular annual swimsuit issue. This was no small honor, since *Sports Illustrated* is careful to choose photographers high on the clicking order.

The photos in *Water Dance* and *Pool Light* were what inspired the magazine's interest, and the idea seemed simple enough: just take the surreal, waterborne flow of Schatz's women and fabrics and put it to work showing the latest fashion in women's bathing suits. The compromise, however, was not so simple. First of all, the swimsuit issue is a showcase for top models as well as beachwear — models who might not like the risk of being photographed in unusual ways and who don't think "deep beauty" means posing one fathom down. "I became anxious right away about whether the models would be adept and comfortable underwater," Schatz recalls. Another problem was that while *Water Dance* and *Pool Light* show nude women underwater with sinuous swaths of fabric, once models put on bathing suits, Schatz says, "the use of free-flowing chiffon no longer made the same visual sense.... I had two days to work with two models a day, and after the first day, I felt that making great images was going to be very difficult."

Schatz suggested to the editors that it would be good to add an additional day of shooting with two models he had worked with before but who were not on *Sports Illustrated*'s list. *Sports Illustrated* agreed to the third day of shooting. The photographs that the magazine published were different from the ones Schatz considered the best to come out of the sessions. On these pages the previously unpublished images have a second, and longer, life.

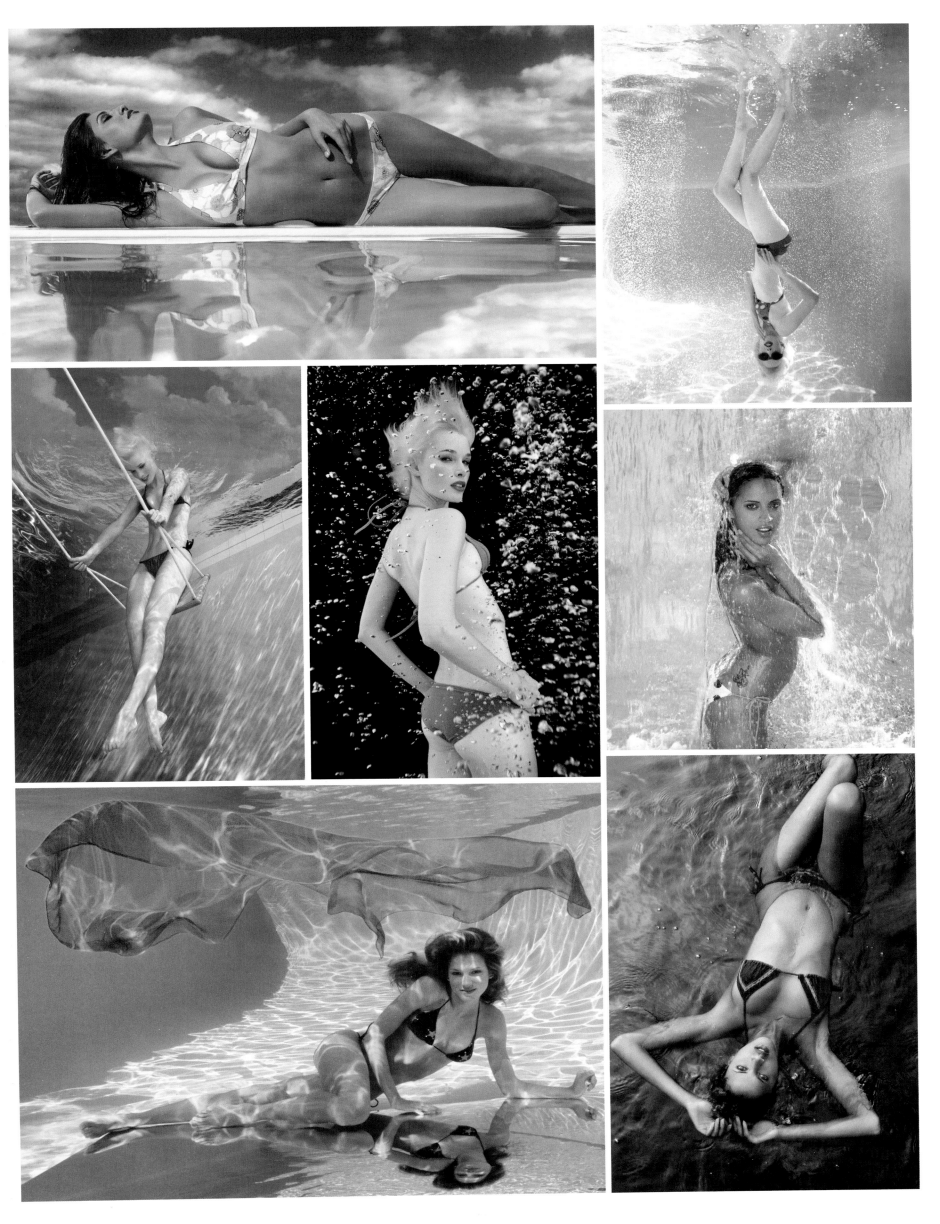

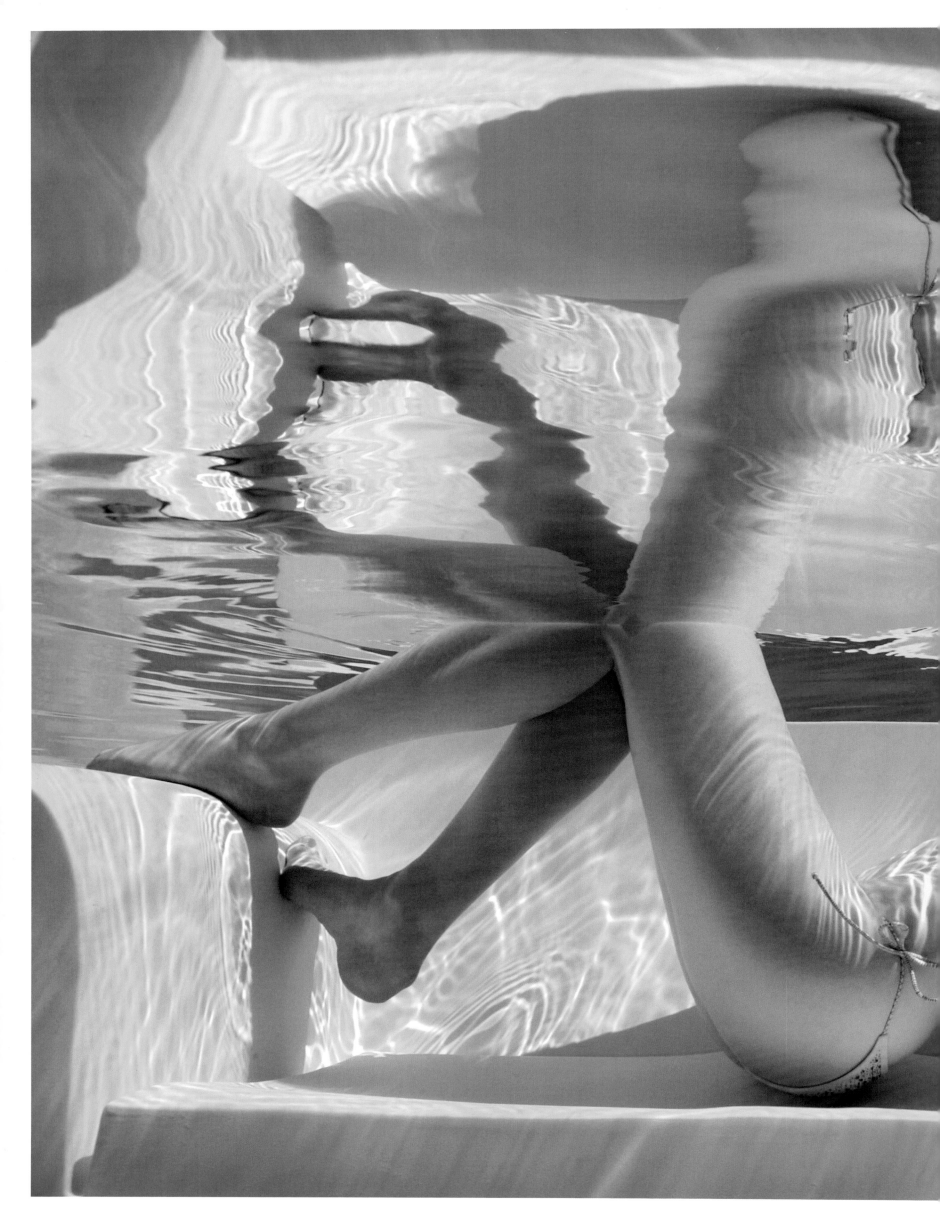

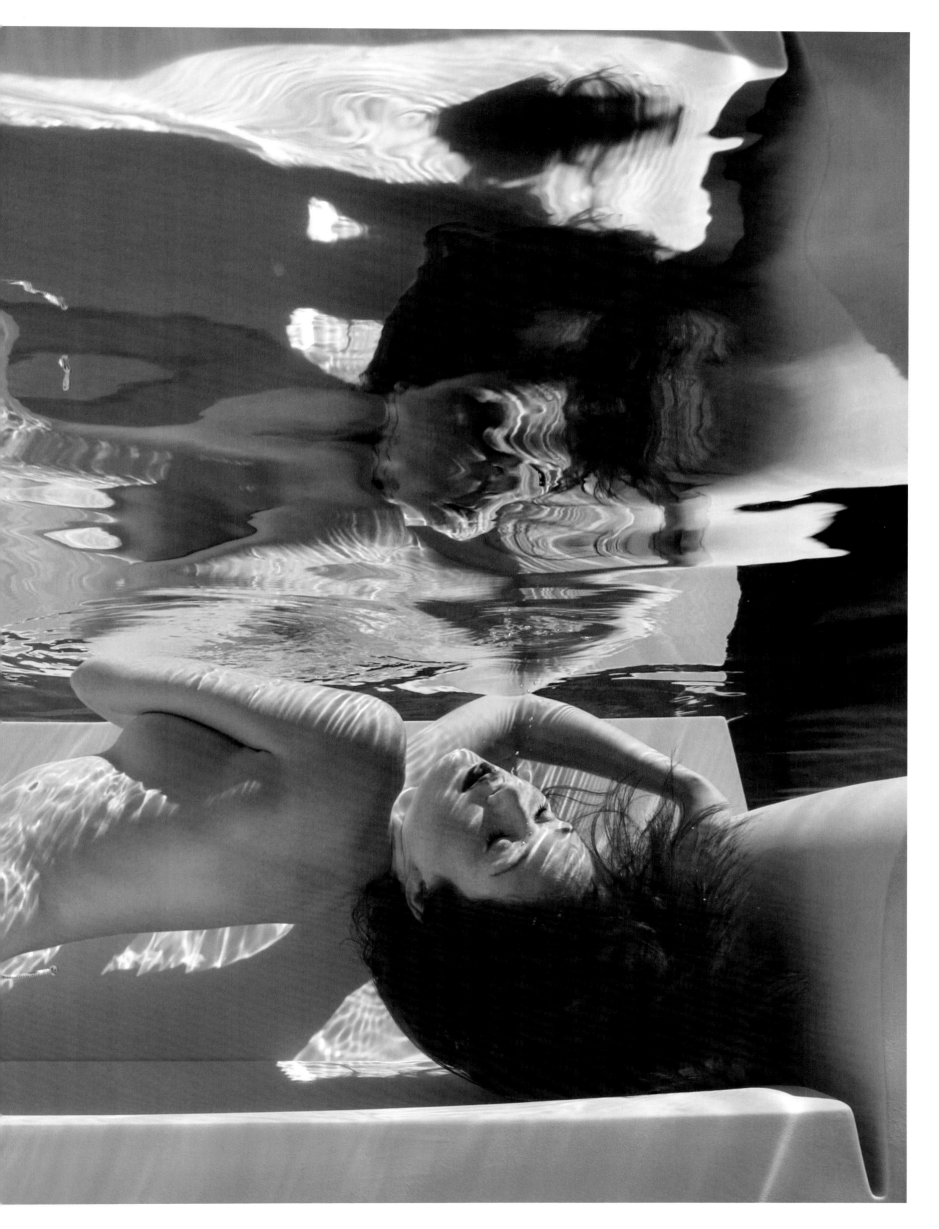

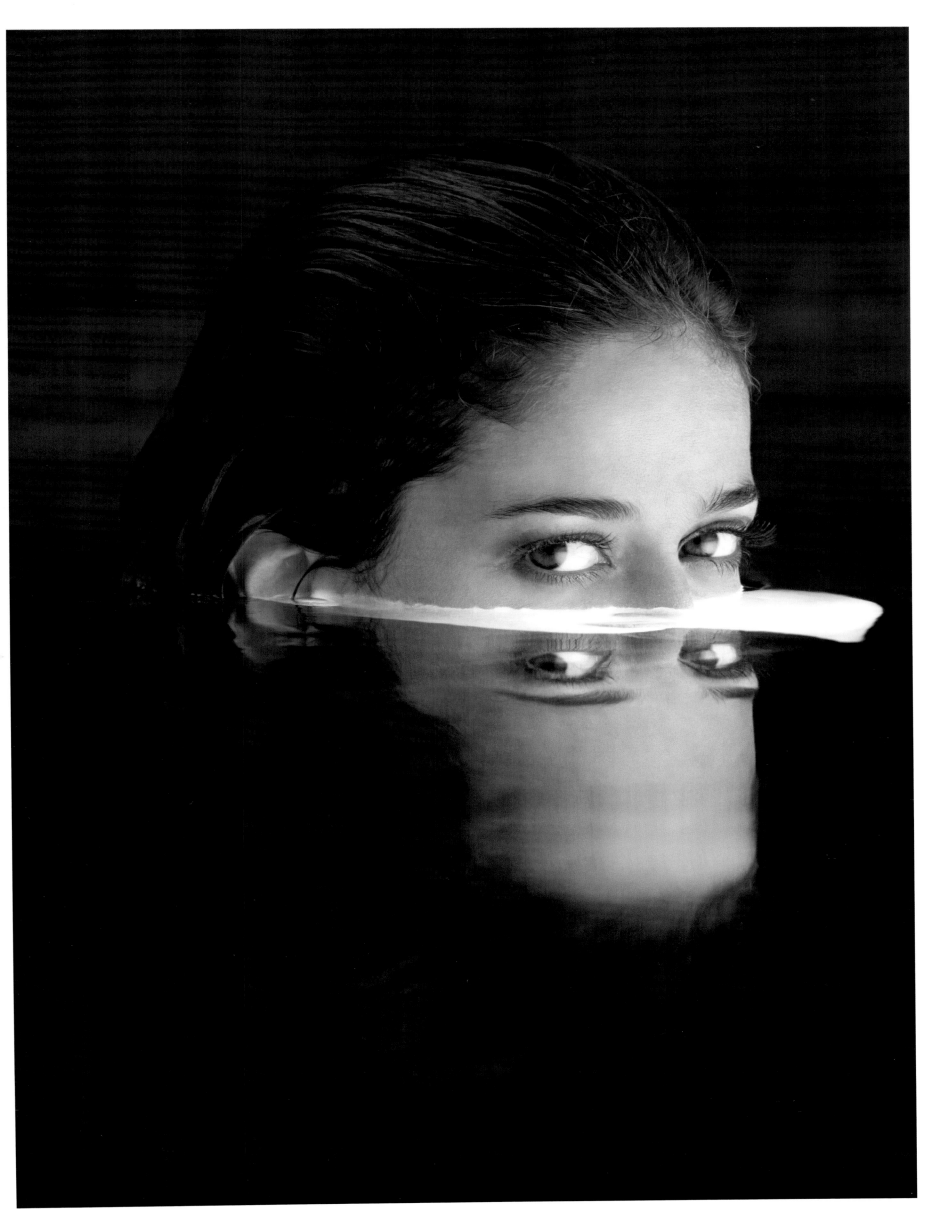

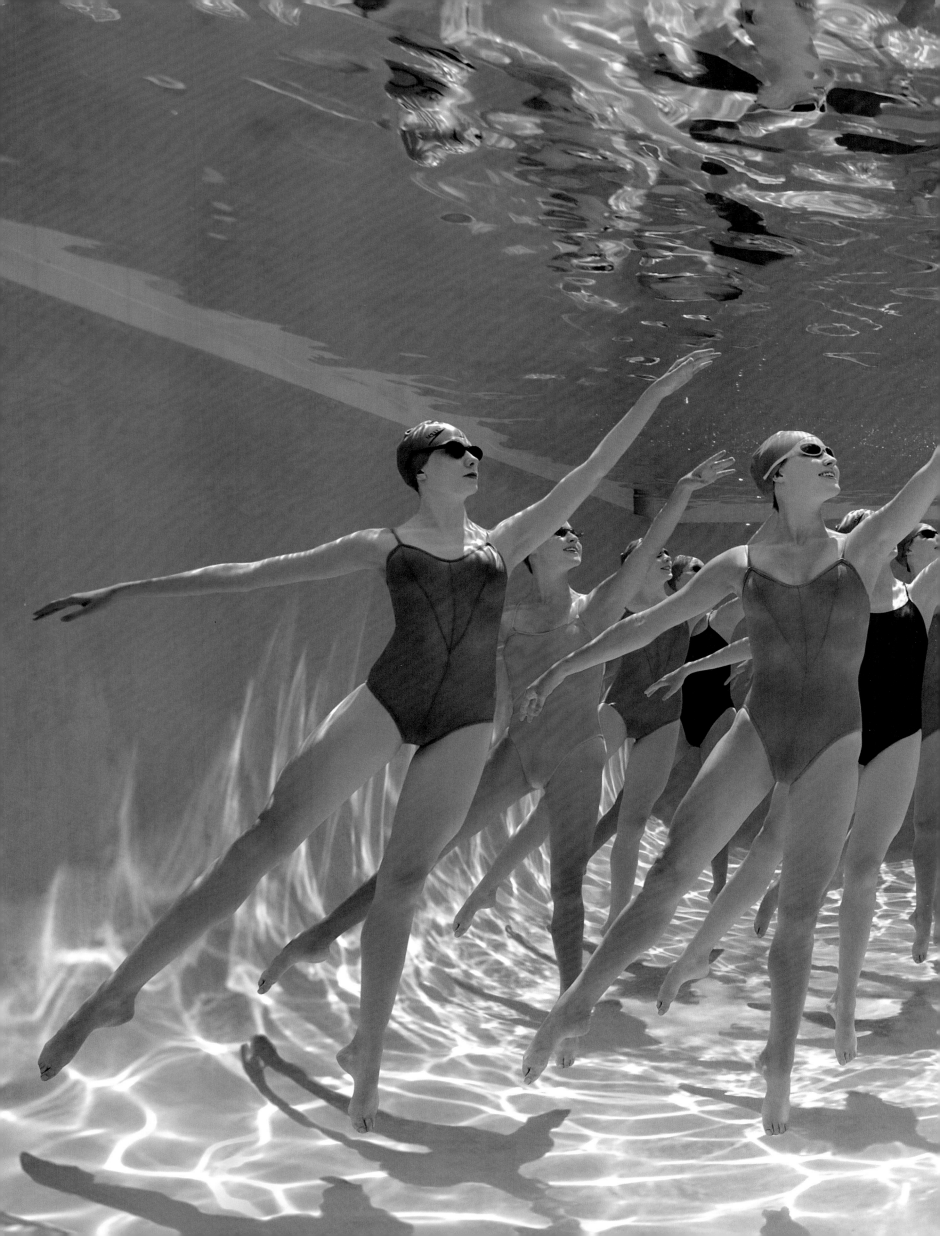

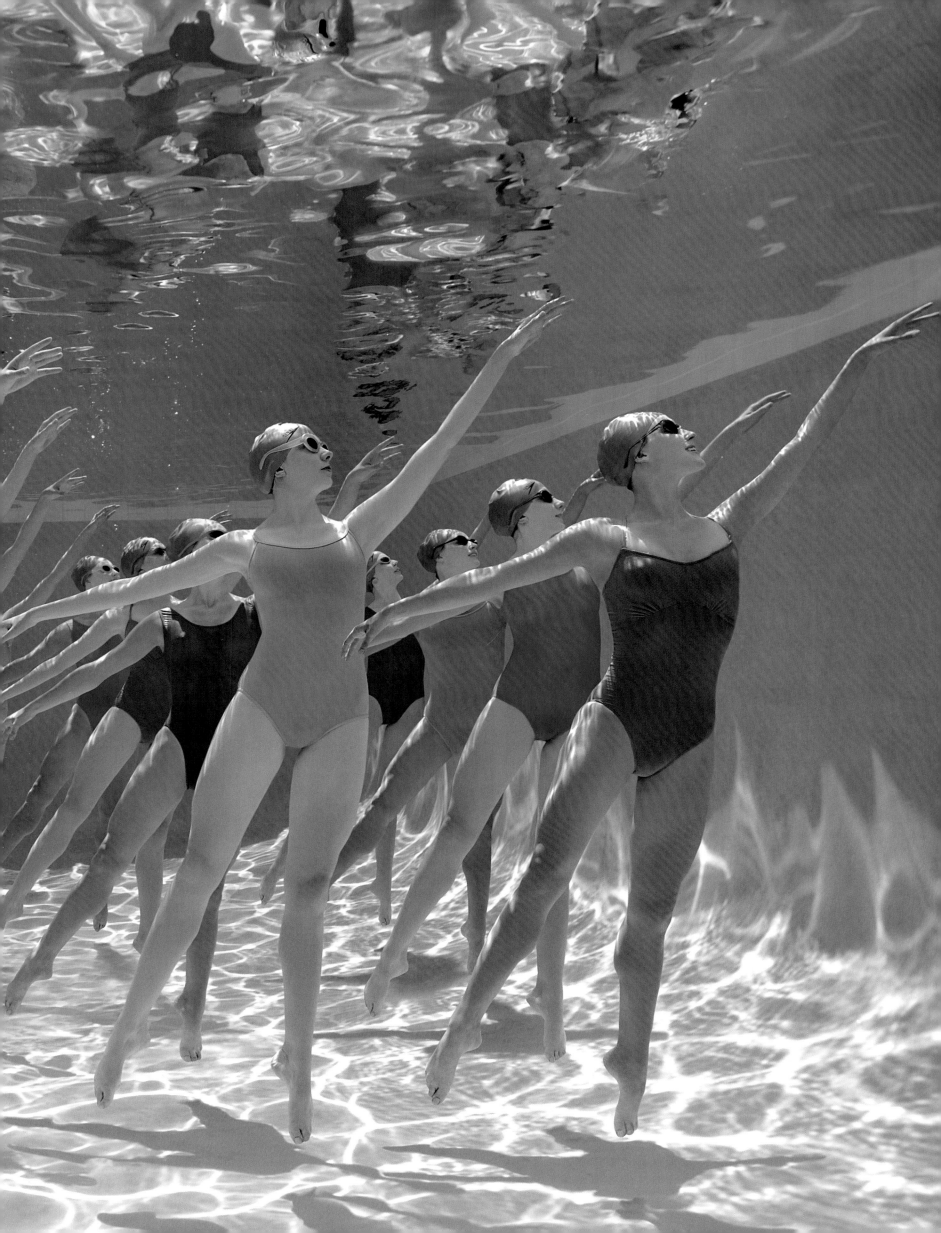

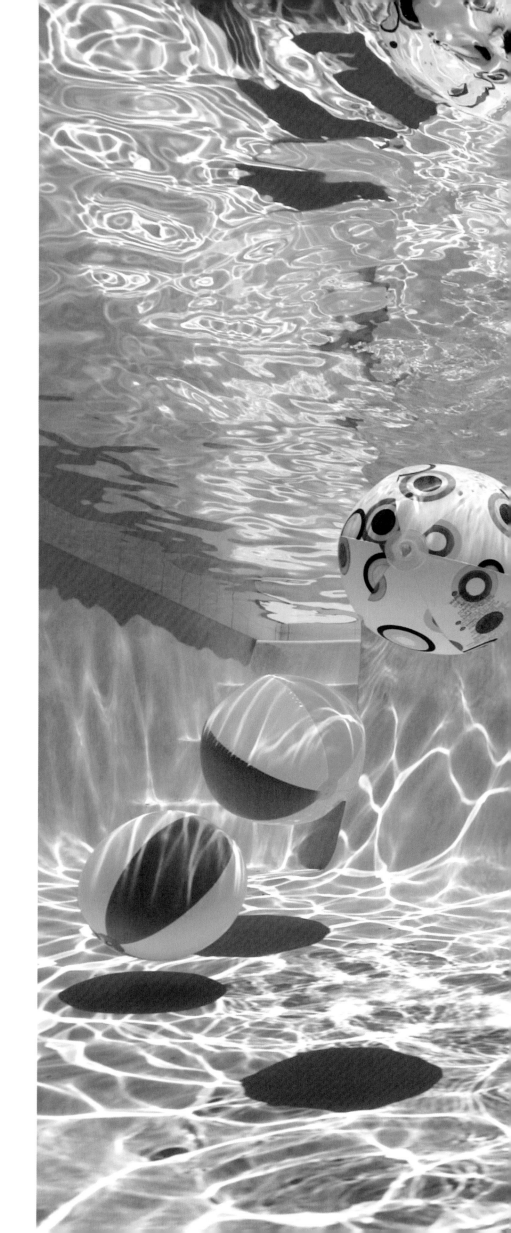

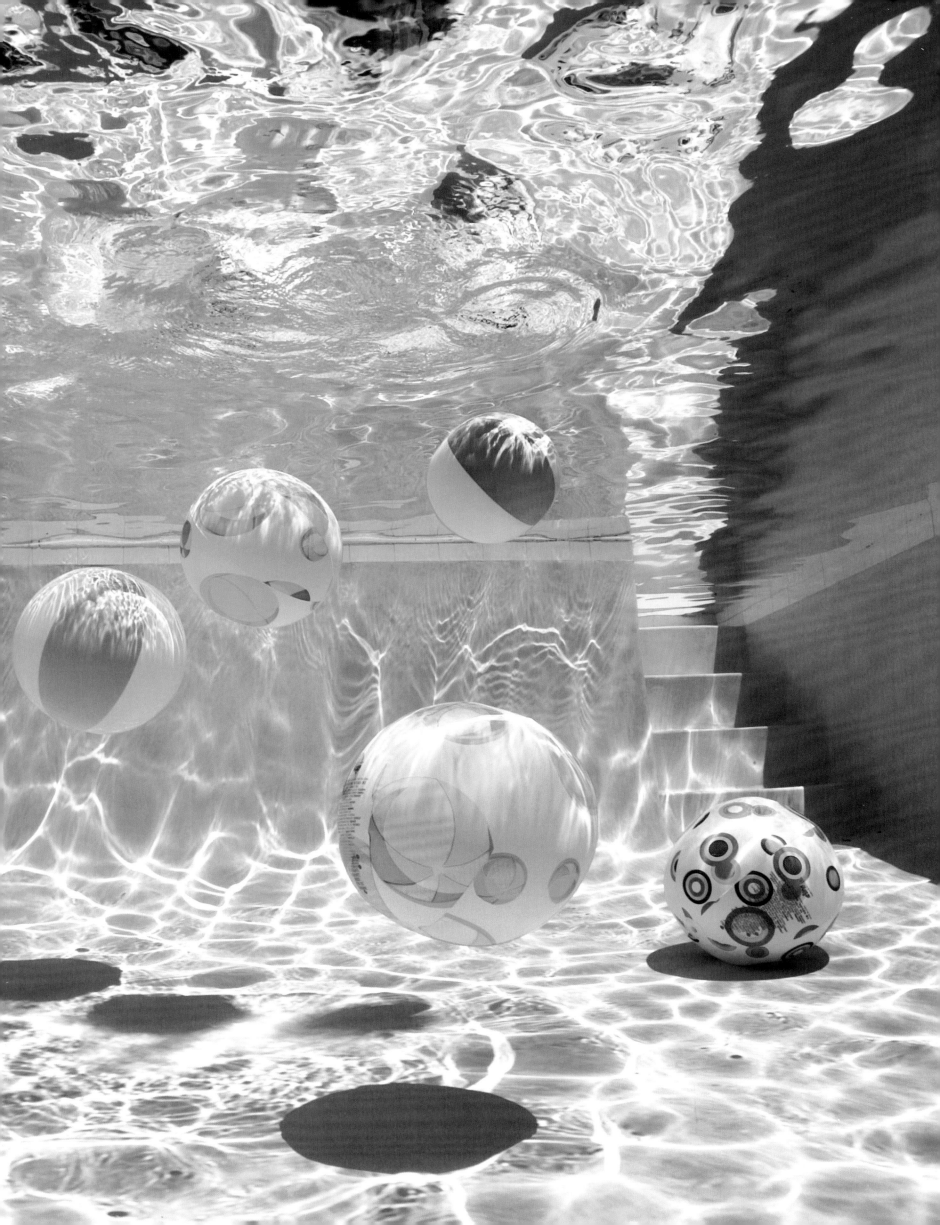

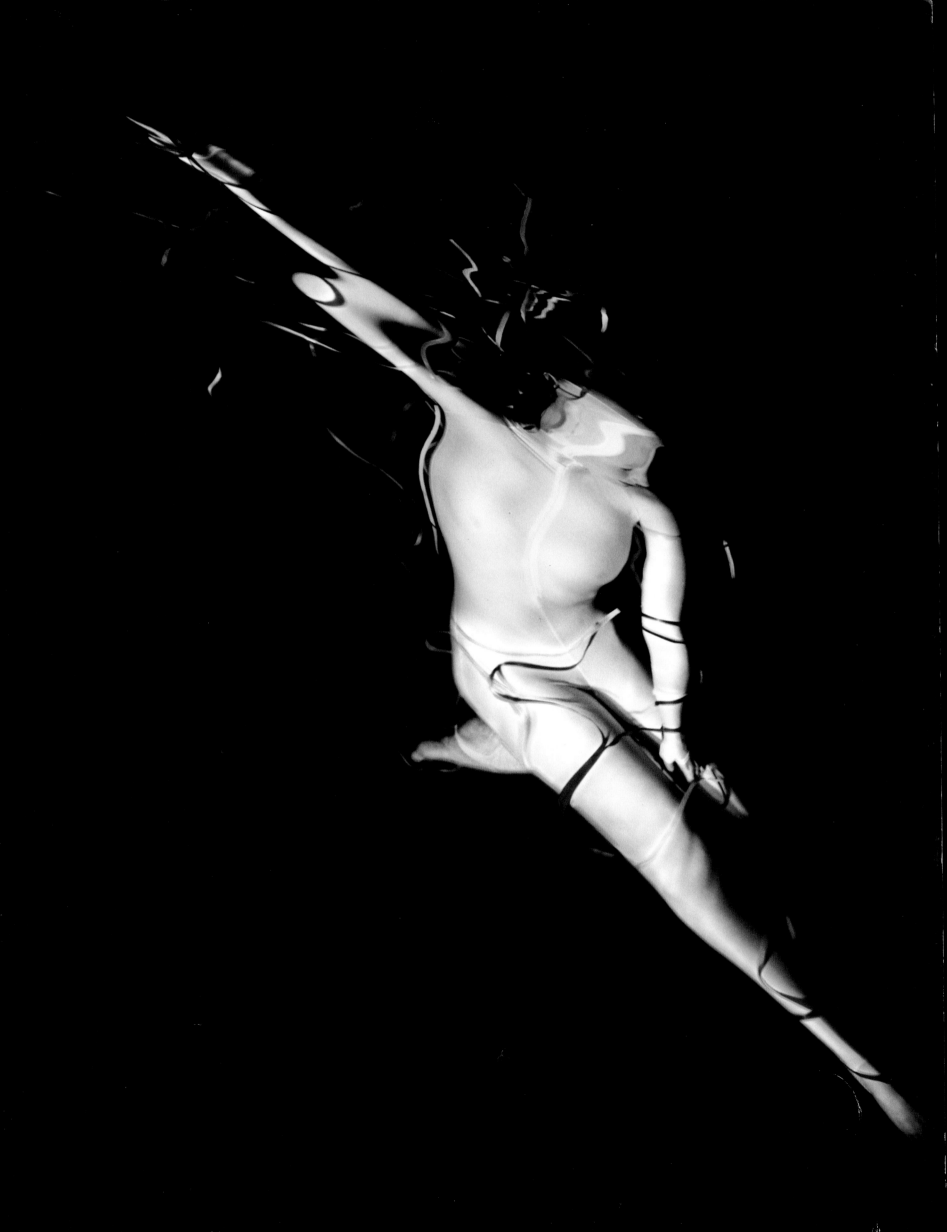

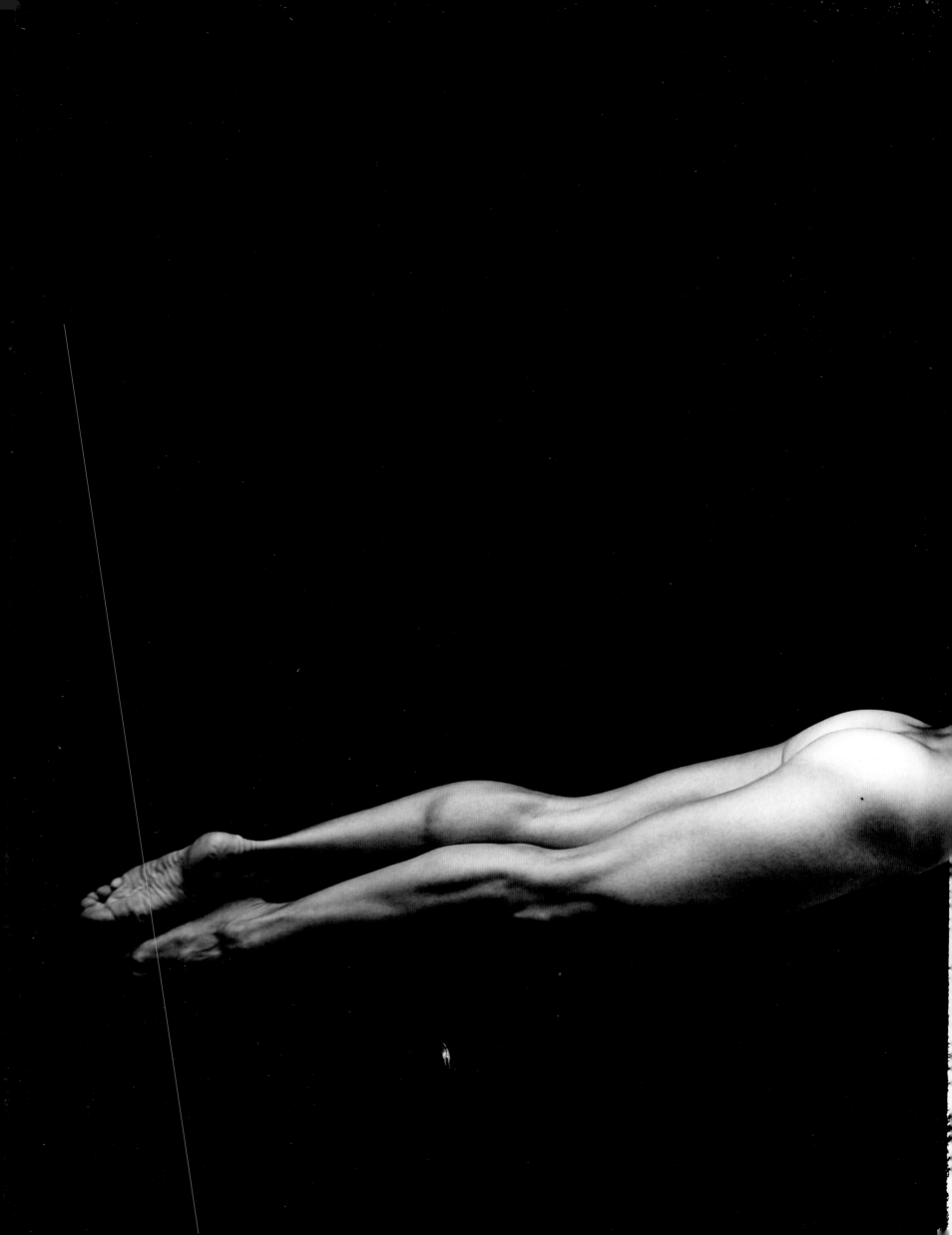

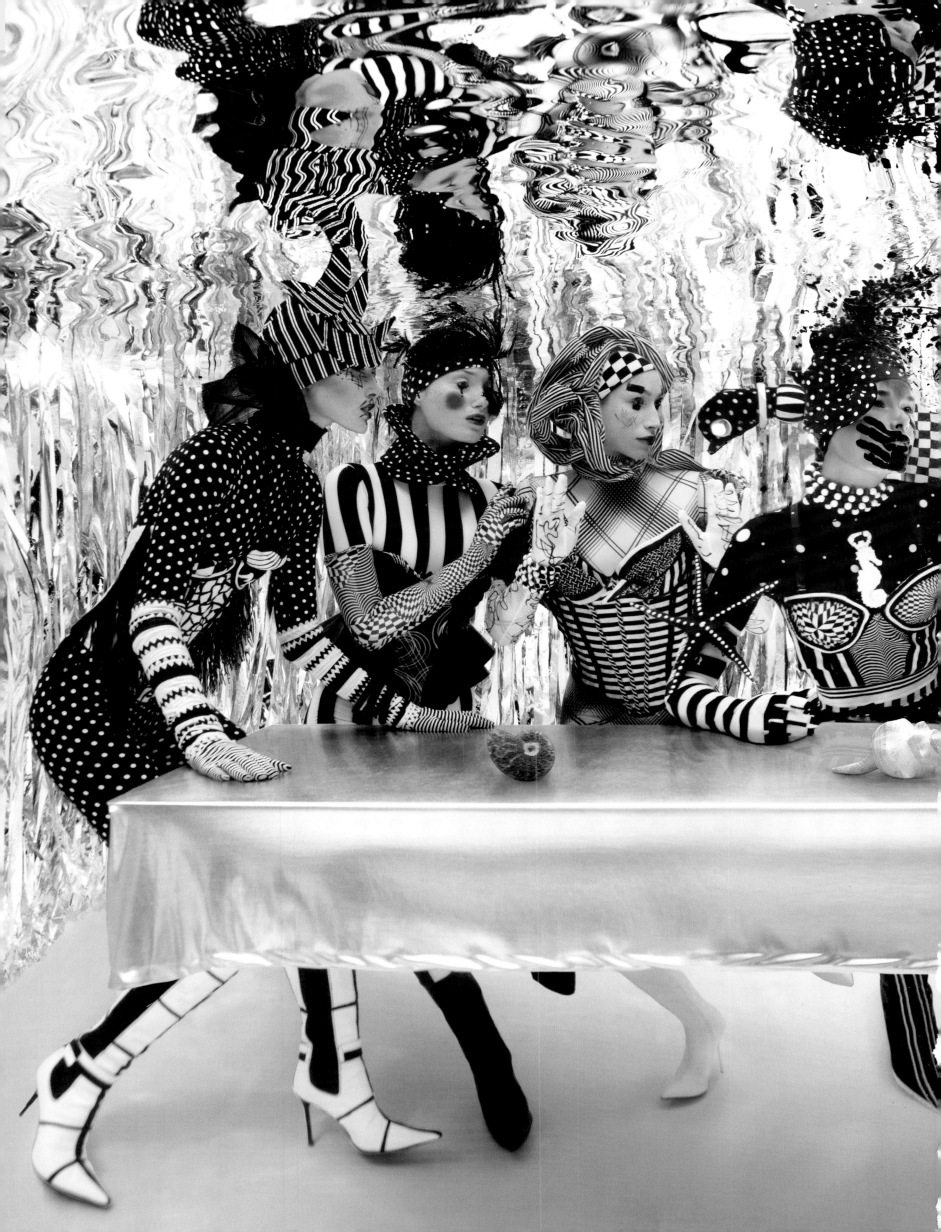

The Last Supper

The dauntless, doomed mountain climber George Mallory famously said that the reason he wanted to take on Mount Everest was "because it's there." Though Michelangelo is not known to have said the same thing about painting the ceiling of the Sistine Chapel, there are times in artists' lives when they simply get the urge to do something because it's just about impossible. So it was with Schatz's decision to become Leonardo d'Acqua and stage a re-creation at the bottom of a pool of one of the world's most renowned frescoes. What else could have motivated a modern photographer to take such liberties with *The Last Supper*?

Besides the self-challenge, Schatz says he liked the idea of making the legendary thirteen diners all women. That way, even though the composition was created expressly for this book, it would present the rigorous requirements of a fashion editorial. The project also called upon Schatz to collaborate with and direct a remarkable group of skilled artisans, and to produce a photograph in which everything started with a blank sheet of paper. "Visual art is only as good as its weakest part," Schatz says. So every aspect of the complex picture had to be perfectly worked out, from the costumes and makeup to the movie-grade computer special effects that turned five submersible models into a full house. In addition to the models, the photographer/director, and the studio assistants, the team needed to produce this wry replica consisted of one stylist, the stylist's assistant, one makeup artist with two assistants, one hair stylist, and a milliner – to create twelve original hats, using some of the four yards of spandex from which each model's black-and-white outfit was made. As an example of the detailed preparation for the sessions that resulted in the complex composition, Schatz asked the makeup artist to do fifty drawings of possible looks for the models, with instructions to "include red in the palette, because, in part, the story is about betrayal." In the end, he chose twelve of the makeup artist's inspired schemes for apostle makeovers. In creating the images that merged to form the elongated shape of Leonardo's masterpiece, Schatz used the costume designs in a kind of syncopation and gave the central figure – a Second Coming in the form of a ravishing redhead (harking back to his early book *Seeing Red: The Rapture of Redheads*) – the only color, with scarlet gloves and a rainbow spatter on her clothes. Given the context, the swirling reflections above add a kind of spectral aura.

As it happens, no one is eating supper in this *Last Supper*; the feast is for the eyes.

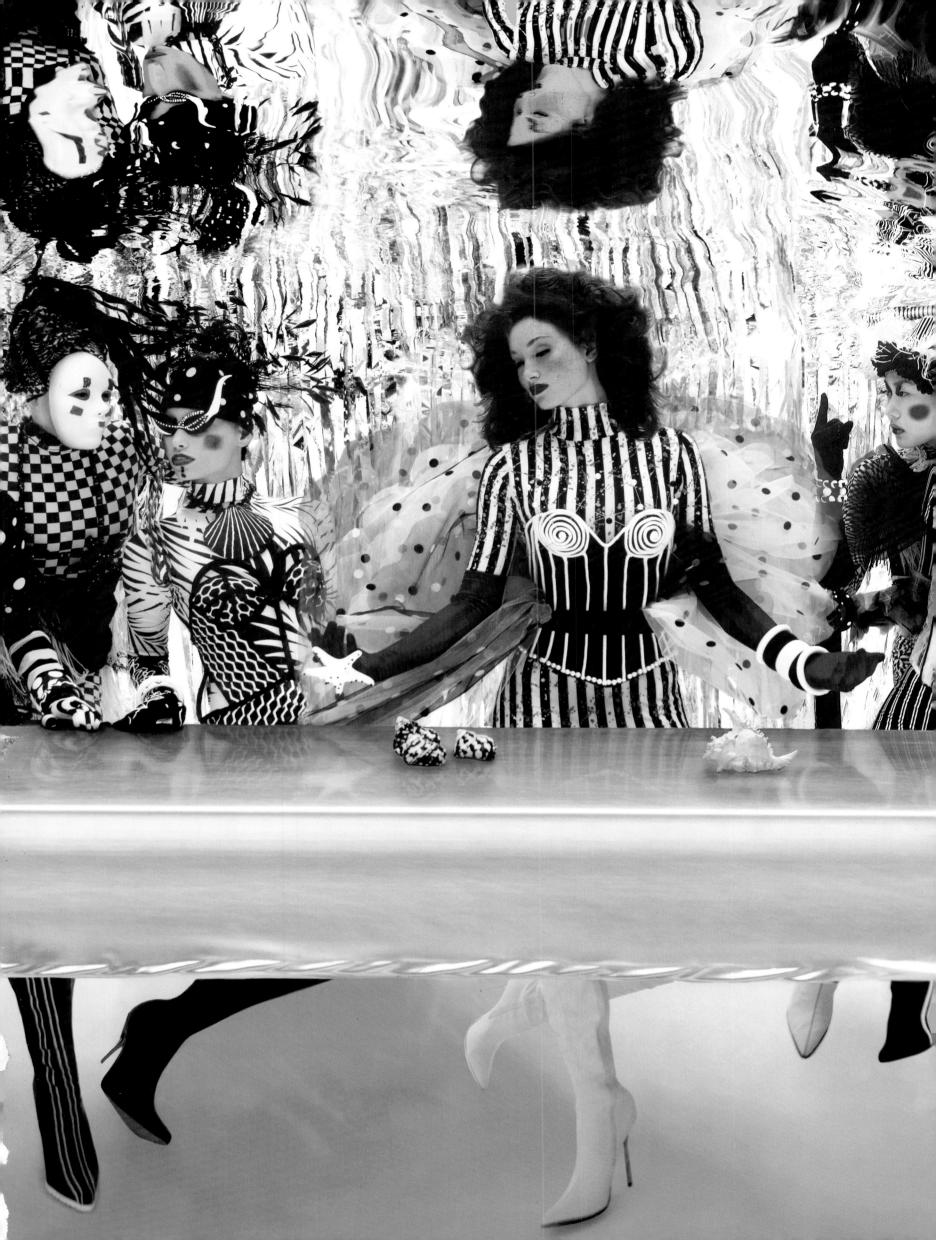

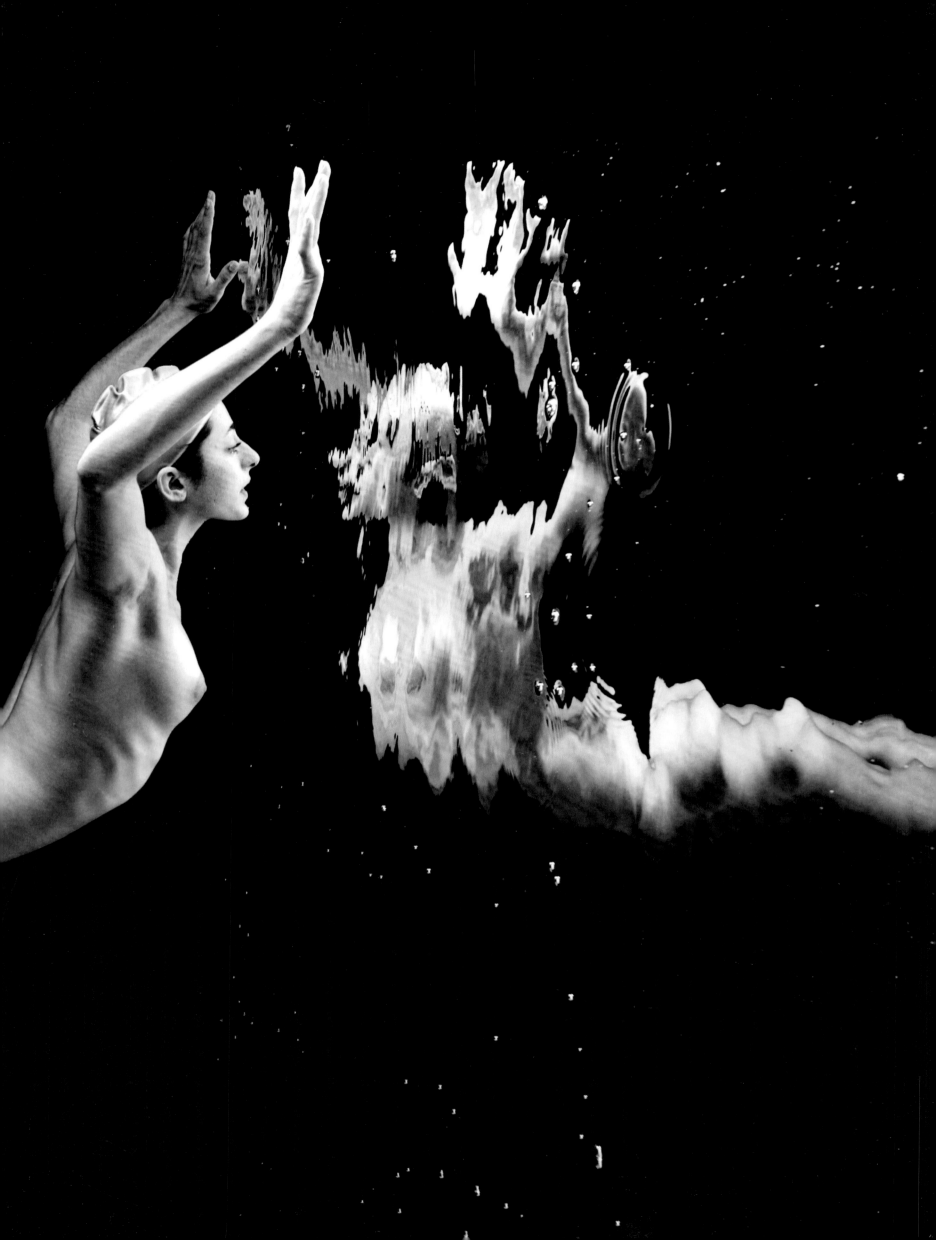

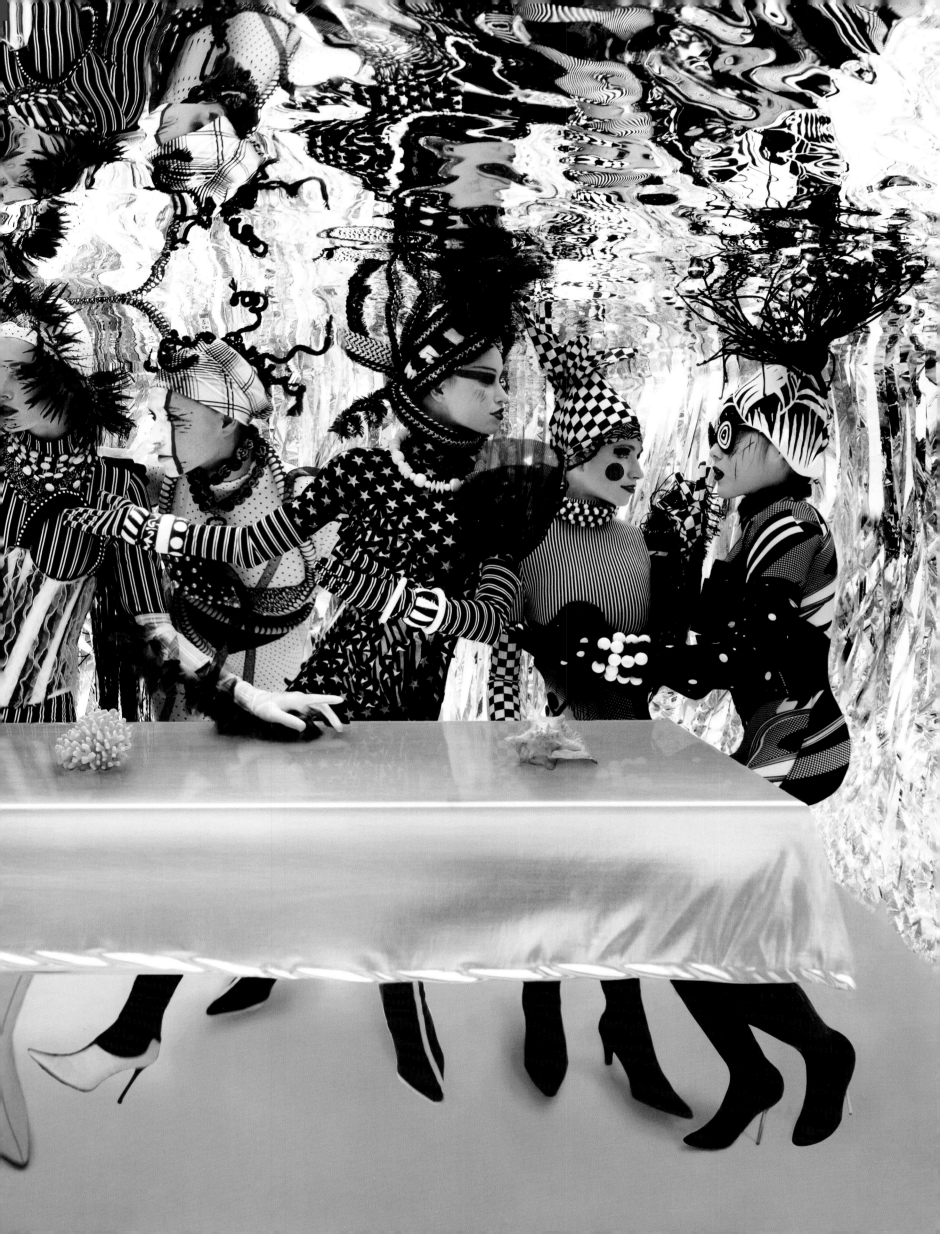

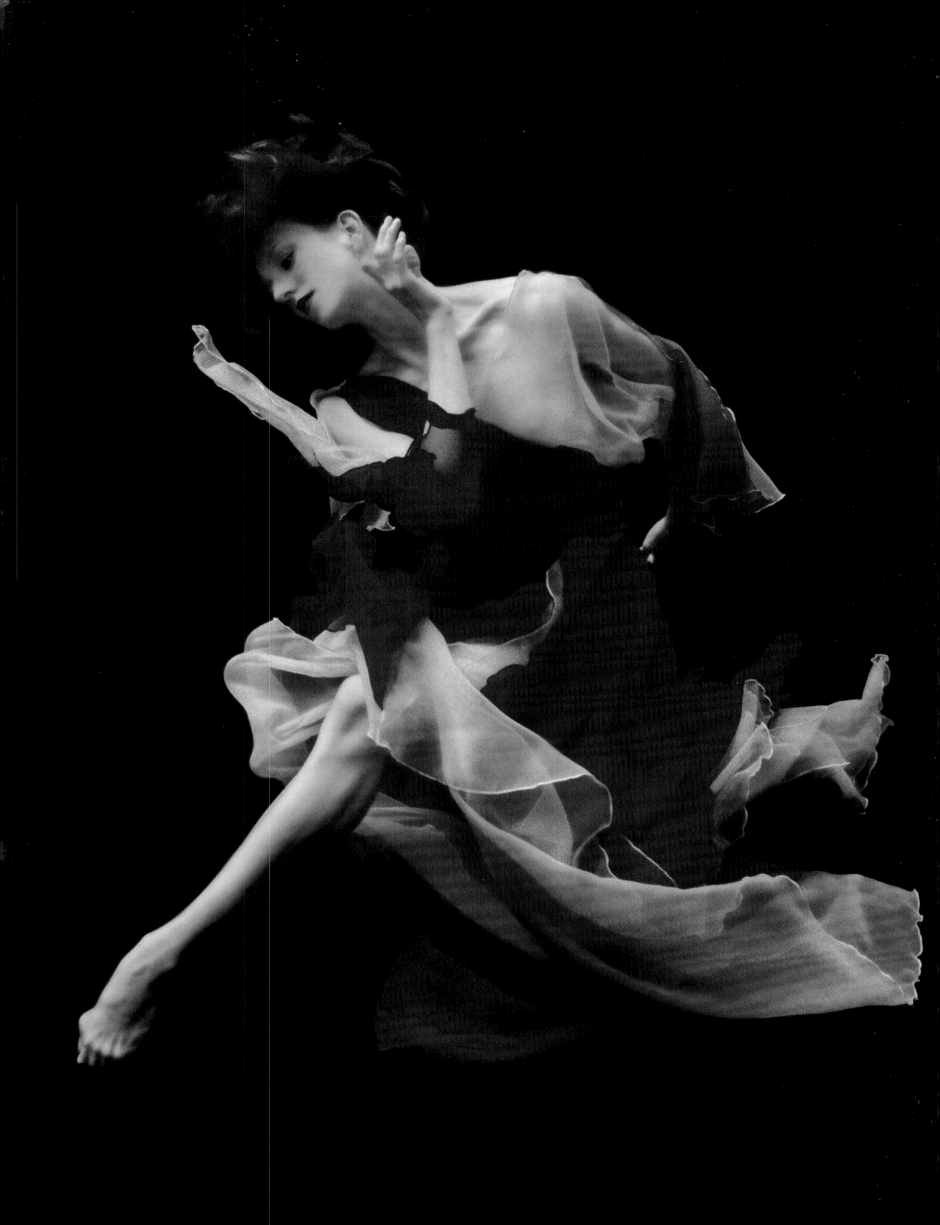

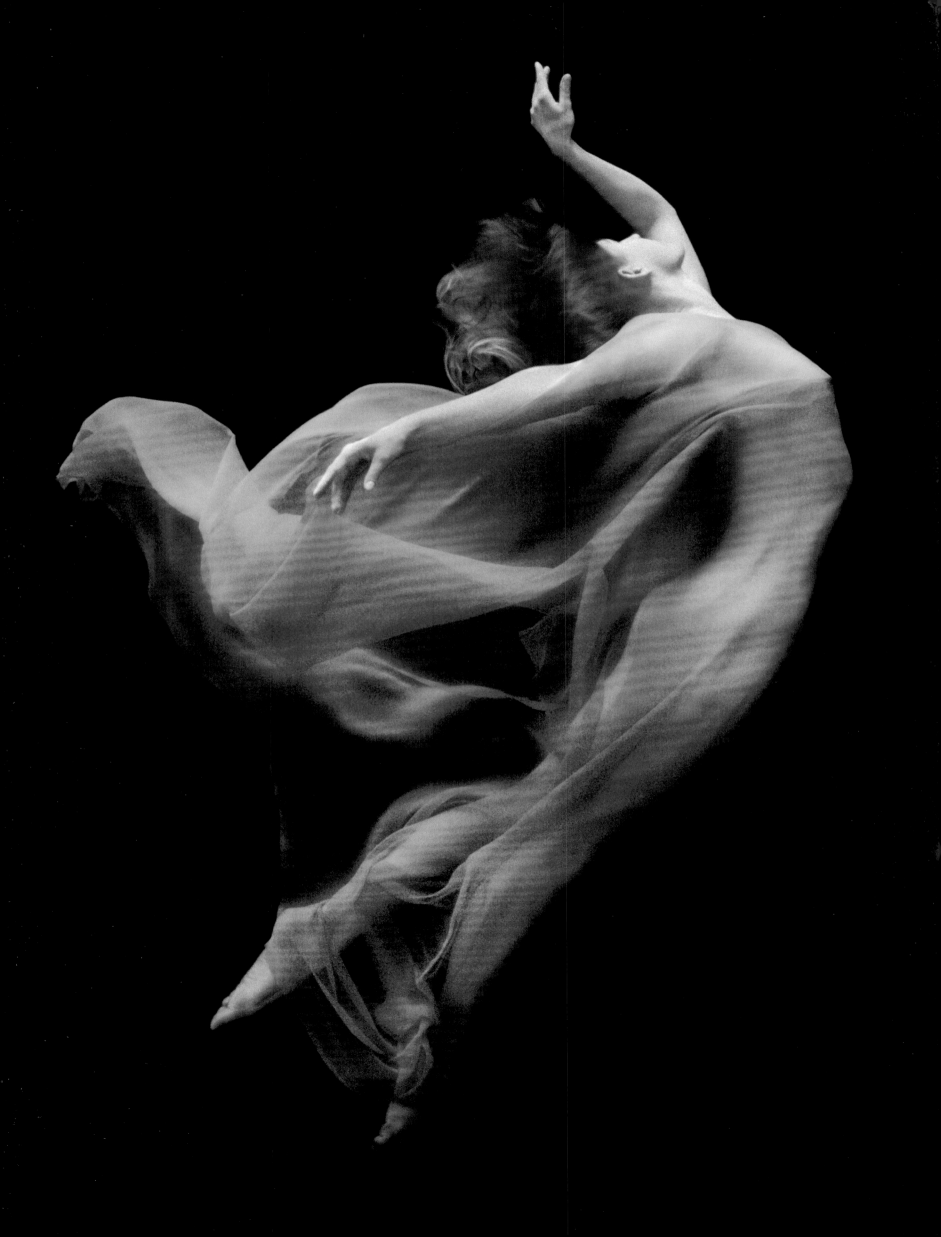

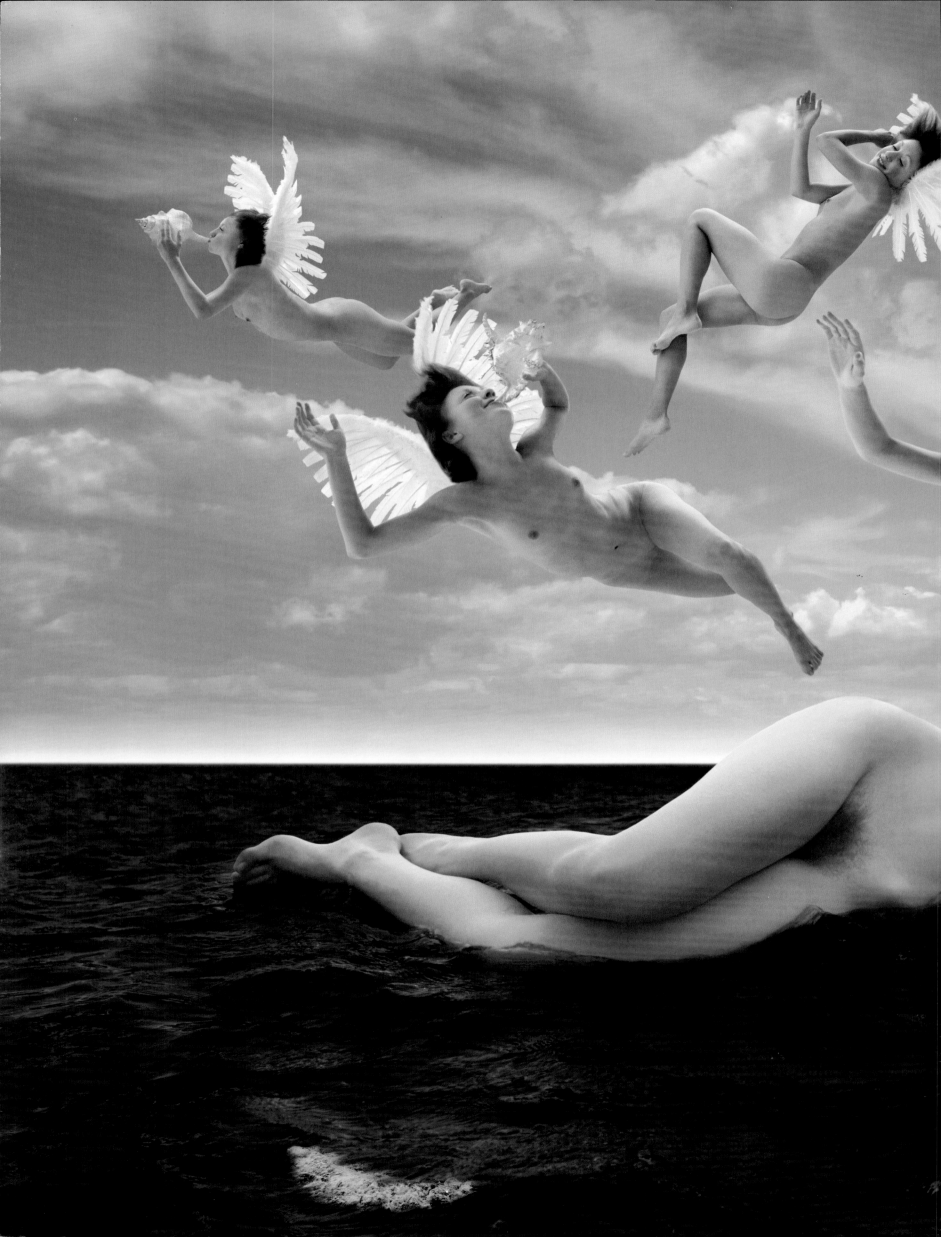

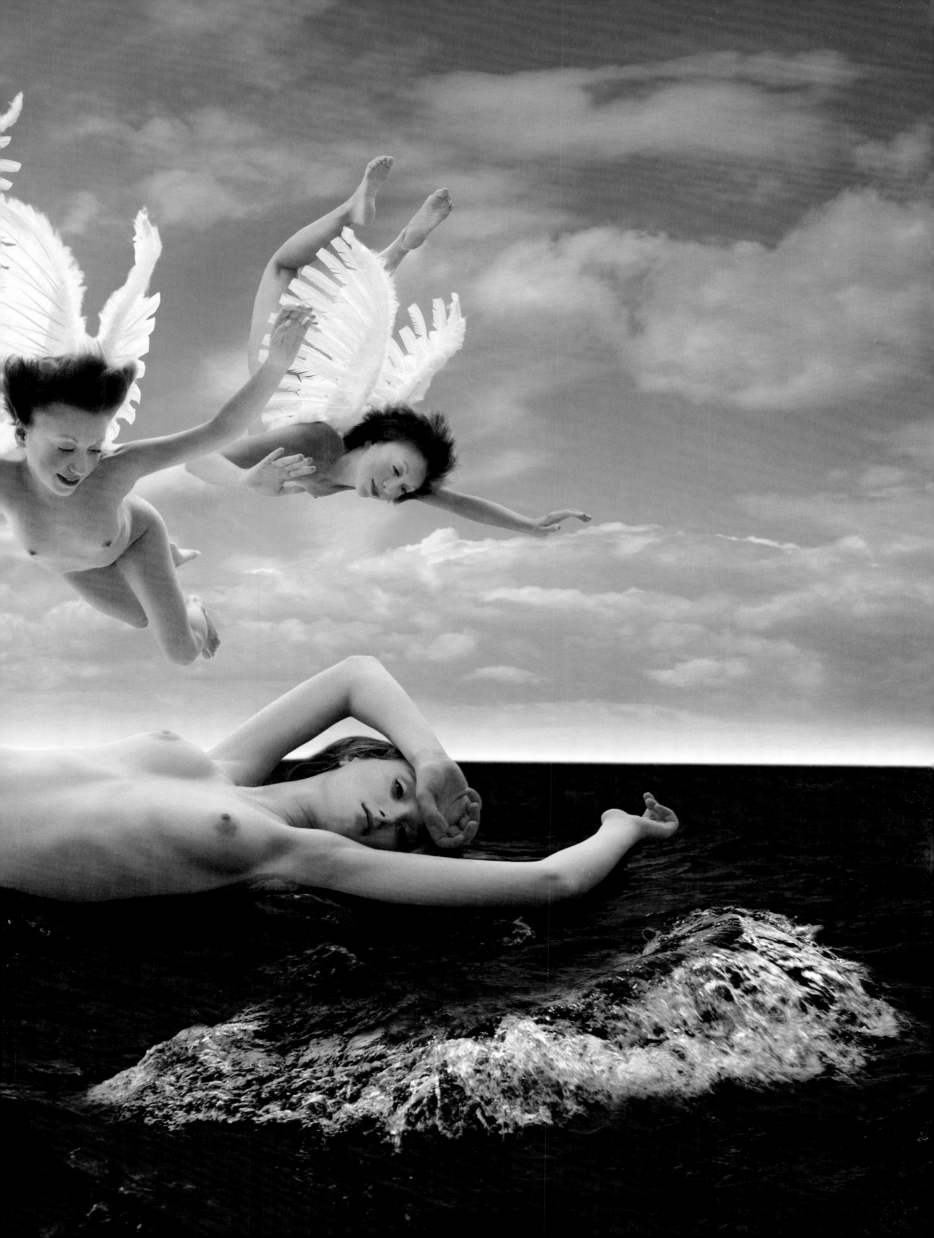

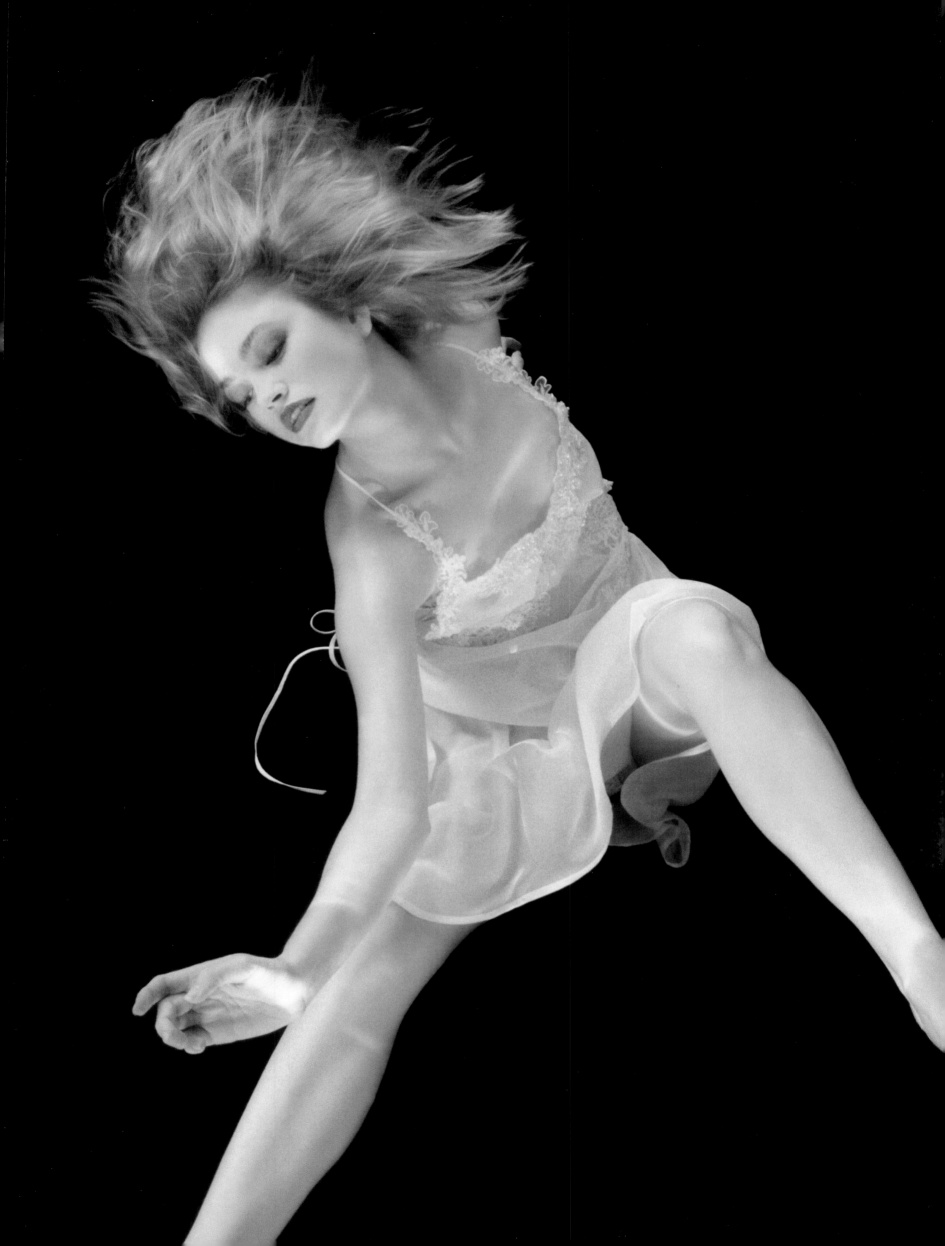

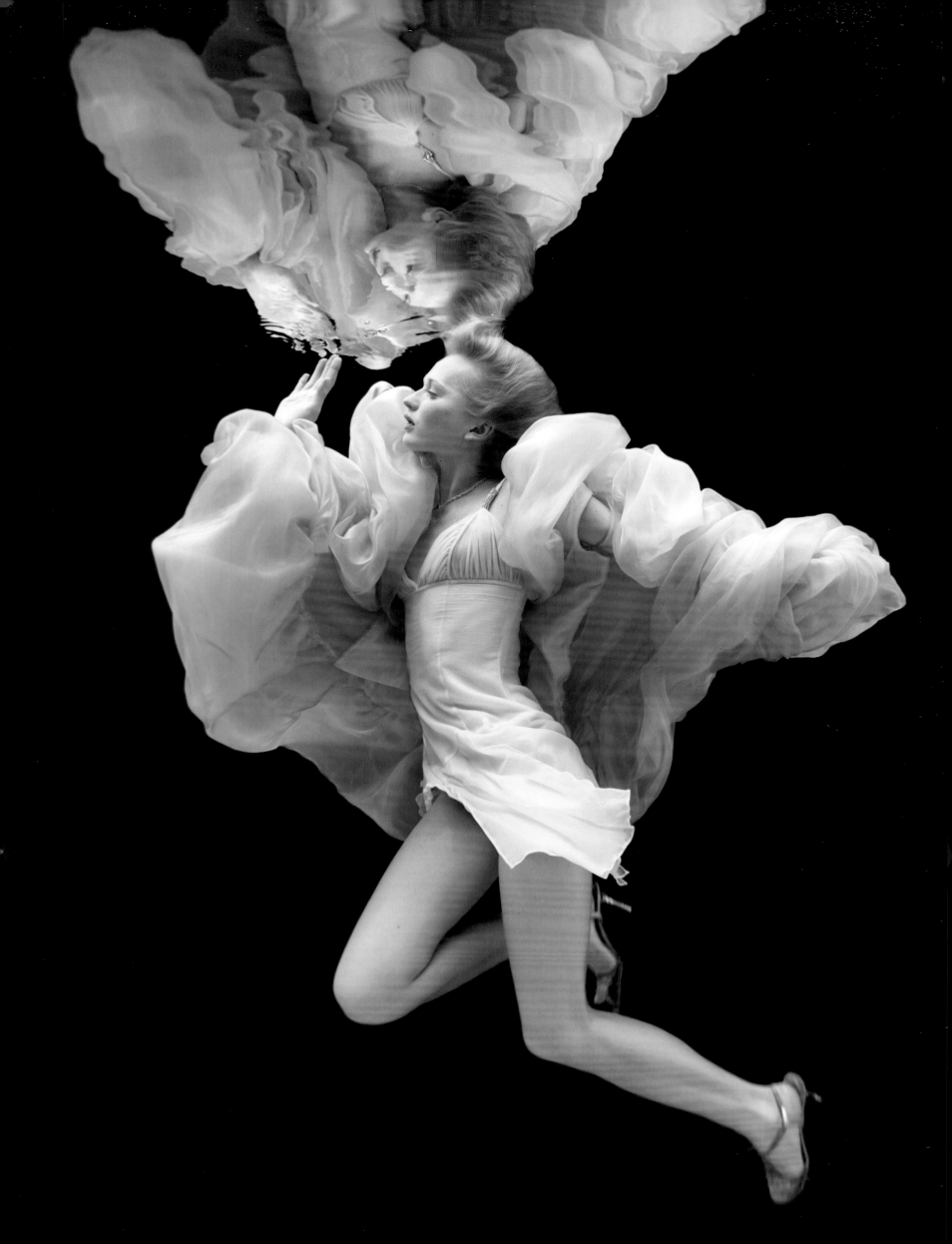

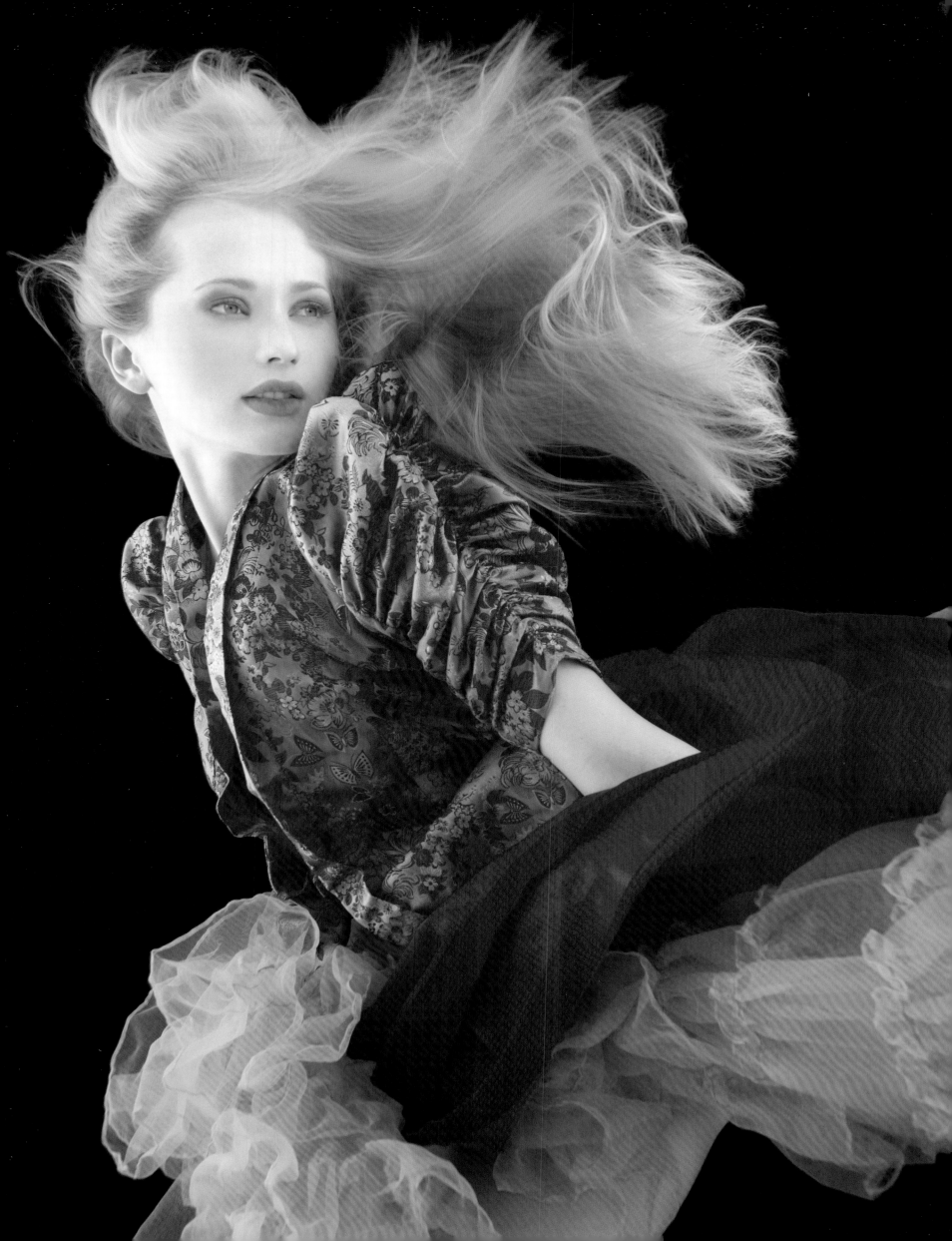

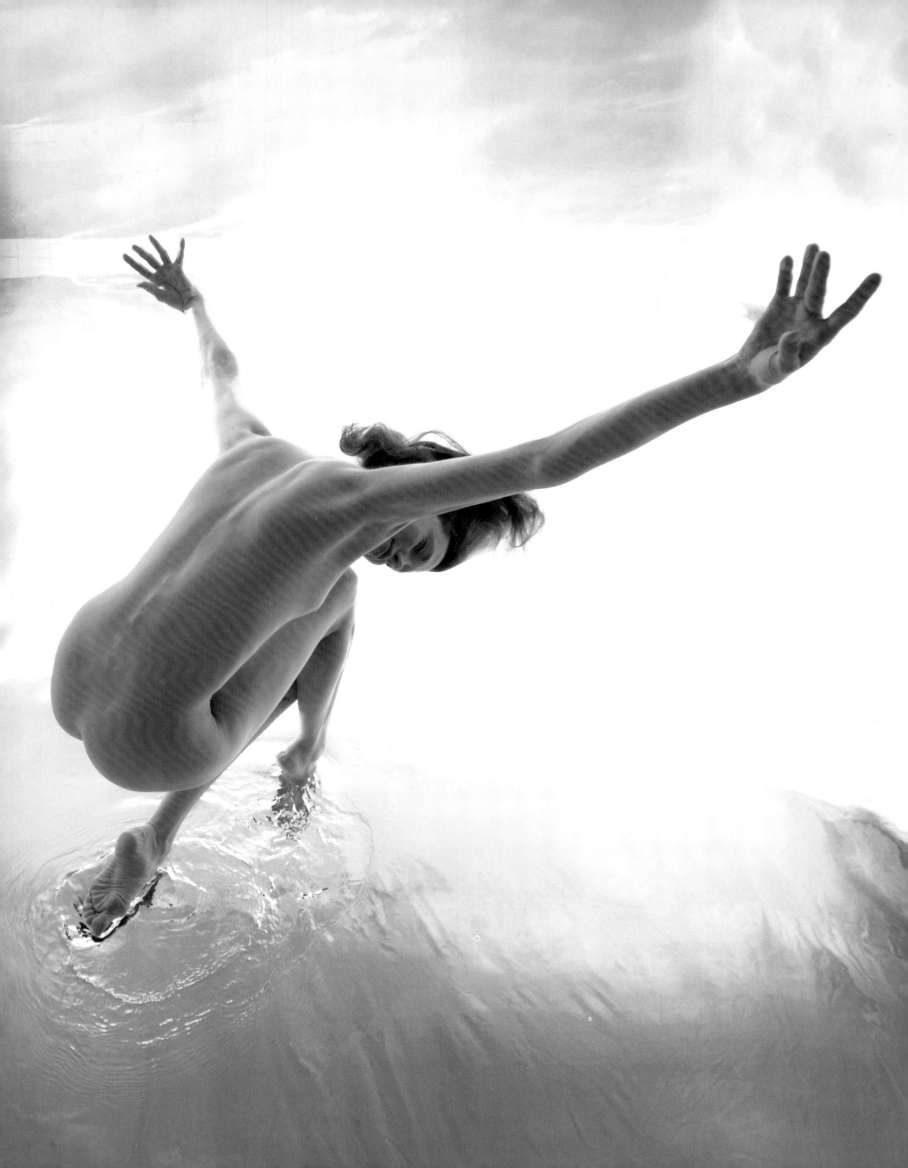

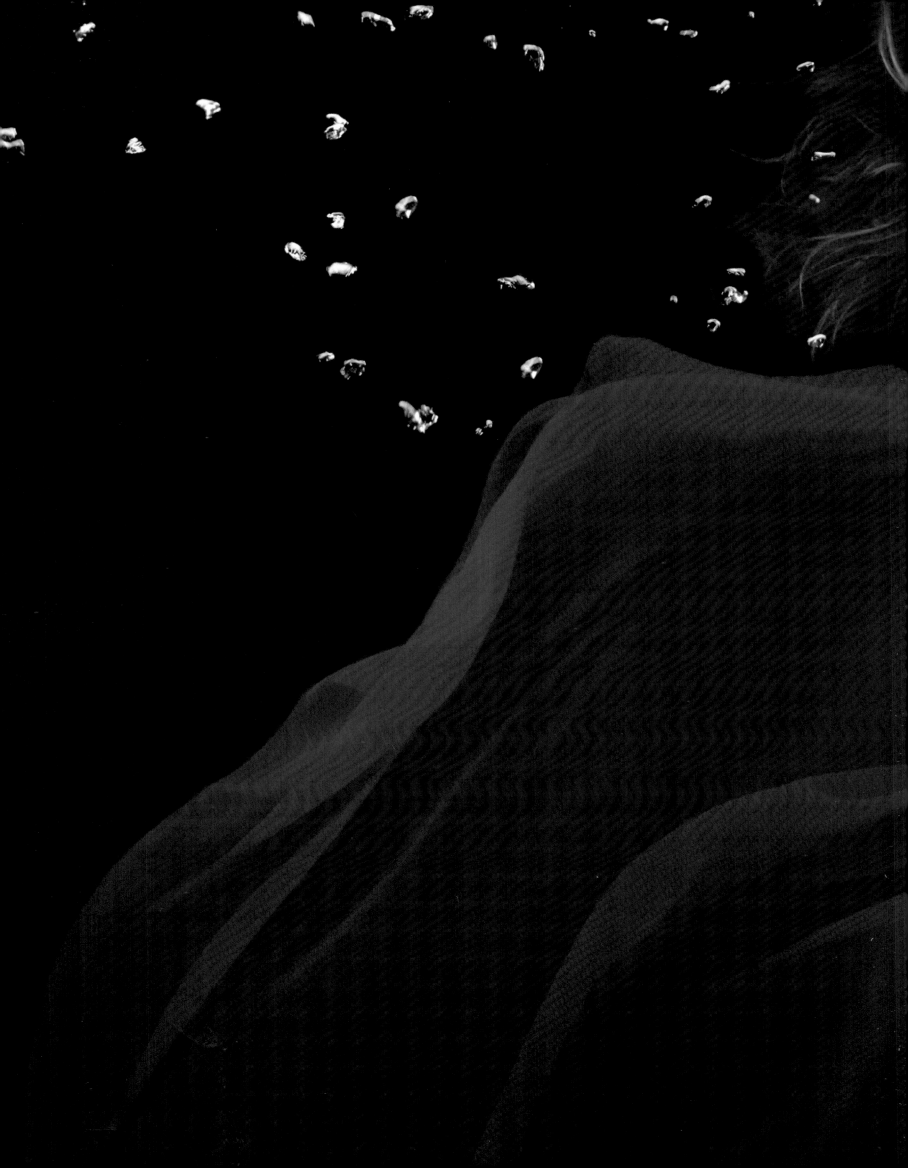

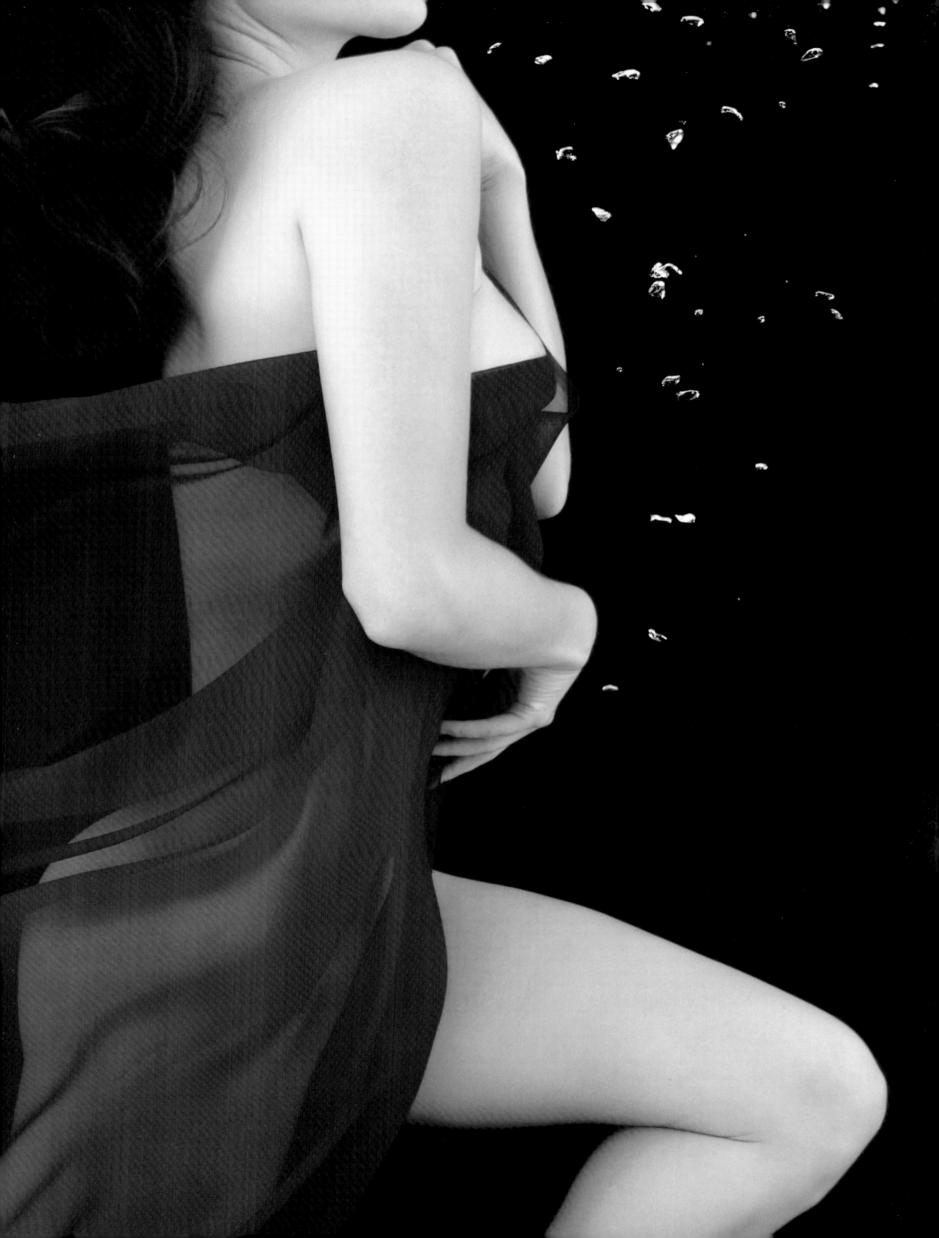

Acknowledgments

We are most grateful to a wonderful group of companies and individuals who have provided us with the technical expertise and support that have allowed us to do our work without interruption.

Epson America: Dan Steinhardt

MAC Group: Jan Lederman, Cliff Hausner, Kevin Stuts, Rick Adshead, Pat Buono; Leaf/Creo: Ilan Carmi

Sinar Bron Imaging, Inc.: Claude Bron, Jim Reed, Gregory King, Cathy Strobel

Lexar: John Omvik, Demaris Williams

Canon: David Metz, Alyssa Cohen, David Sparer

Chimera: Eileen Healy

Tim Ambrose, LPA Design, for his expertise with PocketWizard

Glenn Thorp, Precision Pools, for keeping our underwater stage in top working form

Waterfall courtesy of Custom Cascade, Bloomington, CA

We also extend our gratitude to our agent, John Campbell, who has always championed our work; to Jill Cohen, who first opened the doors of Bulfinch to us; to our editor at Bulfinch, Michael Sand; and to Pam Schechter, production manager.

Pete Romano, owner and chief guru of HydroFlex, Inc., generously allowed us to use his underwater lighting for some very special shoots. Stephen Frink made it easy for us to keep our underwater housings in good working order.

Editorial/Fashion Credits

The Last Supper (underwater): Costumes by Nikko Kefalas; hats by Kokin; makeup by Alberto Luengo for Bernstein & Andriulli

The Birth of Venus Homage to Alexandre Cabanel: Hair design by Algene Wong for Sally Harlor; makeup by Patrycja Korzeniak for igroup

Atlantis: Stylist: Nikko Kefalas

War: Fashion director: Kevin Stewart; props by Courtney Walsh, Jon Lucca, Gib

Sports Illustrated swimsuit issue: Stylists: Diane Smith, Jennifer Kaplan, MJ Fiegel; makeup by Richard Keogh, Jorge Serio for JGK

Escada: Into the Blue: Stylist: Nikko Kefalas; makeup by Alberto Luengo for Bernstein & Andriulli; hair by Algene Wong for Sally Harlor

O™ from Cirque du Soleil™: Photographed at the Bellagio Hotel in Las Vegas, Nevada, 2005; costumes by Dominique Lemieux

Additional styling: Jaja Brandt

Additional makeup artists: Marina Andersson for igroup; Sylvester Castellano for Bernstein & Andriulli; Jane & Elizabeth Choi, Diane da Silva, Landy Dean, Anthony Isambert for Q Management; Amy Komorowski for Art House Management; Patrycja Korzeniak for igroup; Tara Meadows, Jehan Radwan for ArtWing; Jorge Serio for JGK; Bernadine Bibiano, Jon Lucca, Gib, Wallet for Artists Untied

Special thanks: Betsey Johnson and Wolford, US, for providing wonderful wardrobe and accessories for a number of our shoots

Production Staff for H_2O

Producers: Molly Nee, McKenna Lebens, Jonna Mattingly, Patti Harris-Zarkin

Archivist: Monique Reddington

First assistants: Ben Law-Viljoen, Lauren Bilanko

Assistants: Virginie Blachere, Todd Williams, Mike Meken, Scott Clinton

Post-production supervisor: Richard Romagnoli

Typographic design and page layout: Allison Malcolm Carroll

Retouchers: Diego Alvarez, Aaron Epstein, Geoff Green, Bart Babinski, Yann Todedano

Interns: Brian Offidani, Jennifer Askew, Will Haddad, Erica Upshaw, Lara Kahan, Aaron Jones

Production assistants: Heather Christensen, Stephanie Colley

Editors: Aoife Wasser, Steve Fine, Owen Edwards

Design consultant: Aoife Wasser

The modeling agencies and the agents with whom we work in New York have been generous and enthusiastic in allowing their models to participate in this personal project, and we're most grateful for all their help.

APM Model Mgt.: Penny Basch
Bella Agency: Ray Volant, Susan Weinberg
CESD Model Mgt.: Stephanie Bellarosa, Oscar Garnica
Click Model Mgt.: Nancy Menis, Paul Blascak
Code Model Mgt.: Lorraine Ospedales, Regina Kim
DNA Model Mgt.: Christiana Tran
Elite Model Mgt.: Mary Ann Publisi
Ford Model Mgt.: Liz Edelstein, Jackie, Glena Marshall, Patty Sicular
ID Models: Kirsten Weaver
Ikon Model Mgt.: Chantelle Fraser
Images Mgt.: Kathy Geraghty, Kate Gold, Brit Mazzola
IMG Model Mgt.: Tricia Freeman, Jessica DeJesus
Karin Models: Judy Gos
Look Model Mgt.: Jay O'Dell
Madison Model Mgt.: Eduard Pesch, Rosmarie Chalem
Major Model Mgt.: Christian Paris
Marilyn Model Mgt.: Chris Kiely, Michael Ross, Daniel Kershaw, Greg Christenson, Sheri Bowen
New York Model Mgt.: Jackie Hall, Lisa Berenberg, Cory Bautista, Melissa Previdi
Next Model Mgt.: Nikolina Dosen, Mia Lolordo, Maria Cognata
Planit M Model Mgt.: Rene Gonzales
Q Mgt.: Jeff Kolsrud
Reich New York: Sharon Reich
SVM Mgt.: Rachel Mitchel, Maguy Gagnaire-Stein, David Grilli, Victoria Korina
Stars, the Agency: Aj, Kris, and Scott Claxton
Vision Model Mgt.: John Babin
Wilhelmina Models: Judy Linton, Cherie Portabib, Pink, Anita Norris, Peter King
Women Mgt.: Helena Suric, Mohammed Fajar, Miguel Avalos

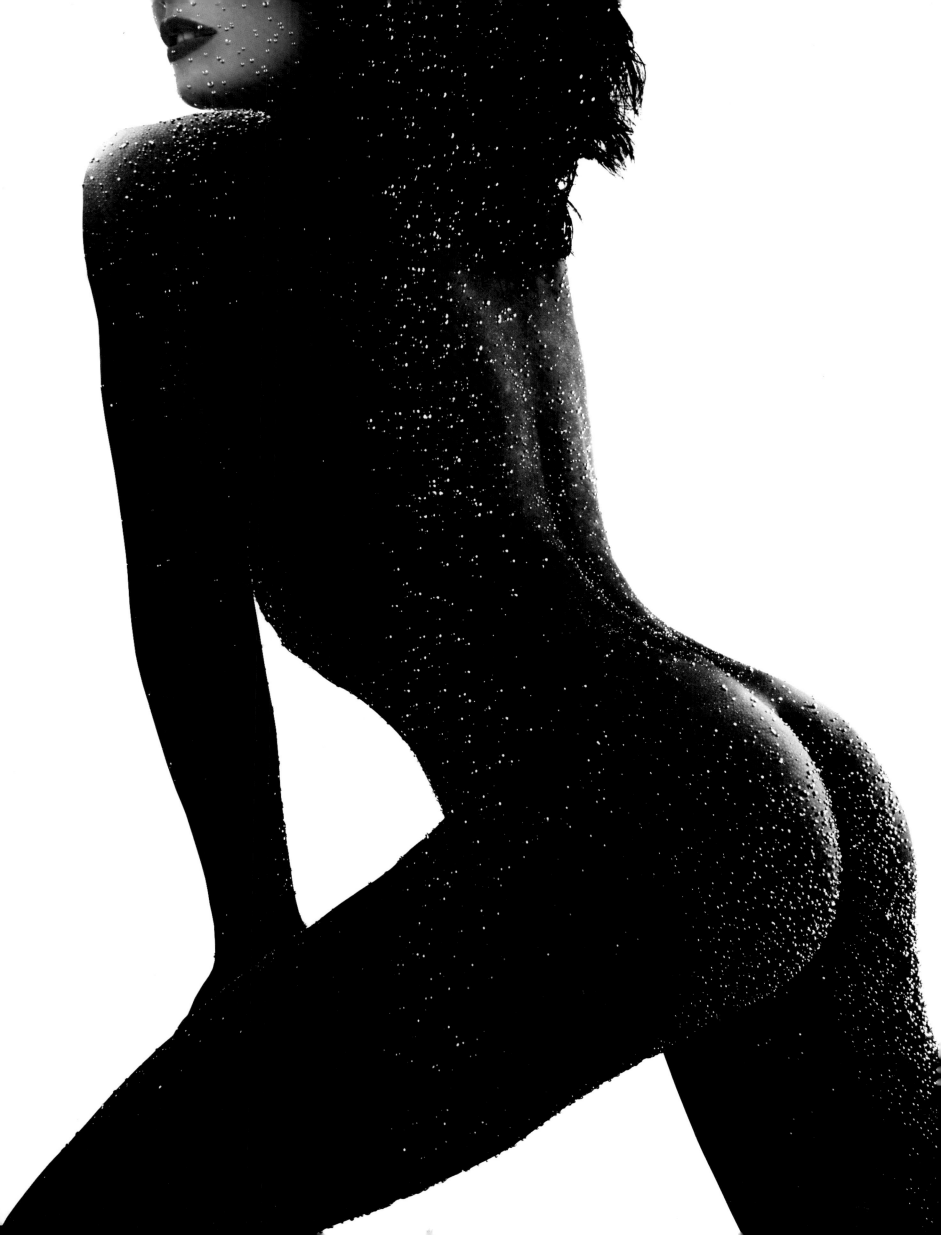

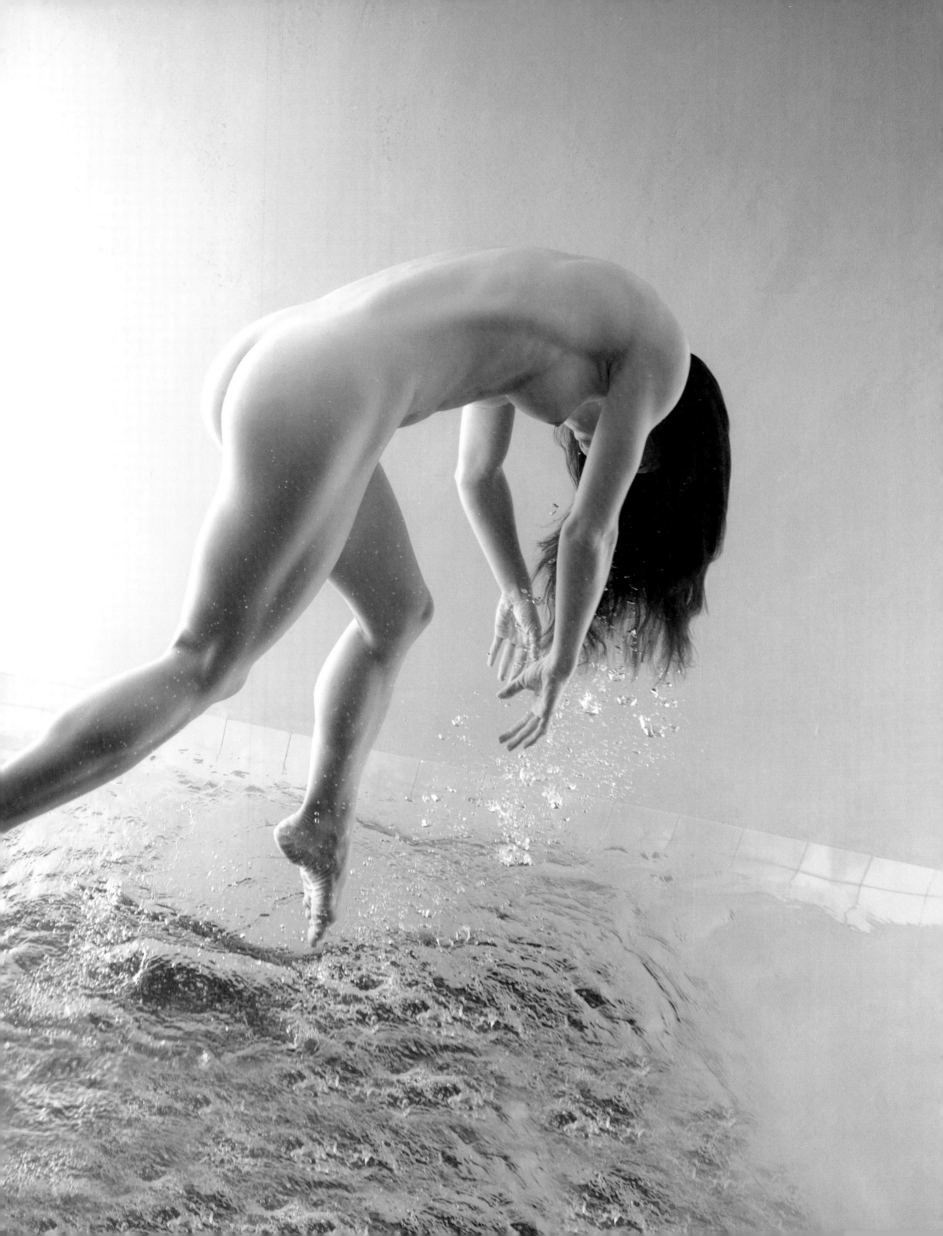

Dancers and Models

The dancers and models who worked with us made this book possible. We extend our heartfelt gratitude to each and every one of them.

Abdur-Rahim Jackson
Adrienne Doe
Alexandra Beller
Alex English, Ford Model Mgt.
Alhia Chacoff, CESD
Alia Crutcher
Alina Puscau, Karin Models
Alison Clancy
Amanda Cobb, American Ballet Theatre
Anne Marie Kortright, Next Model Mgt.
Annie Henley, SVM Mgt.
Anuschka Von Oppen
Ari Loeb, Momix
Ayo Janeen Jackson
Belinda Baidoo, Ikon Model Mgt.
Briana Reed
Brian Simerson, Momix
Brooke Baker, Images Mgt.
Camila Dubay, Q Mgt.
Carrie Berkey O'Brien
Casha Warner, Q Mgt.
Cherina Scott, Code Model Mgt.
Chia Ying Kao
Christina May
Cristen Elmore, Ikon Model Mgt.
Dana Stackpole
Dante Cernobori
Dara Adler
Dasniya Sommer
David Berridge
Deirdre Chapman
Denni Parkinson, Women Mgt.
Diane M. Boyle
Edward Matthews
Elizora Olivier, Wilhelmina Models
Emilie Adams, Q Mgt.
Emma Stein
Eric Hoisington
Eric Jeffers
Erika Singer, Code Model Mgt.
Erika Sutter

Florence Faivre, Karin Models
Francesca Tedeschi, Q Mgt.
Francesco Guglielmino
Frances Ortiz
Gary Hall
Ginna Ortiz
Glyn Scott, American Ballet Theatre
Gosia Kos, Q Mgt.
Greta Campagnollo, Code Model Mgt.
Guadalupe Tomic, NY Model Mgt.
Gus Torlidakis
Hamden Heronettes
 Brittany Pollio
 Erica Courtmanche
 Jenna Swinkin
 Jieyoni Vaughn
 Kristeena Griggs
 Melissa Bruhn
 Sarah Swinkin
 Stacey Amodio
Heather Magee, Momix
Heather Nahser Uicker
Hildur Isabella Boylston,
 American Ballet Theatre
Isis Valdes, NY Model Mgt.
Izabel Goulart, Karin Models
Jenean Baylor, Q Mgt.
Janicke Askevold, Ford Model Mgt.
Jared Kennedy, City Models
Jeannine Kaspar, APM Model Mgt.
Jenifer Wymore
Jennifer Beaty, Q Mgt.
Jennifer Doidge
Jennifer Kulz
Jenny Fletcher, Next Model Mgt.
Jessica Bohl, NY Model Mgt.
Jill Childress Munden
John Michael Schert,
 Alonzo King's Lines Ballet
Jordanna Dworkin
Julie Henderson, NY Model Mgt.

Julie Montgomery, Look Model Mgt.
Kara Oculato
Karen Carissimo
Kathleen McNulty
Katita Waldo
Kevin Scarpin
Kim Jones
Krista Coyle, Bella Agency
Krista LeBeau, Code Model Mgt.
Kristen Hollinsworth
Lauren Alzamora
Lee Pappas, Look Model Mgt.
Linzie Sullivan, NY Model Mgt.
Lisa Wymore
Lorena Giaquinto, NY Model Mgt.
Luke Wiley
Lydia Tetzlaff
Madison Garton, Next Model Mgt.
Maria Yakovenko, Code Model Mgt.
Marie Meyer, Viva Models
Marlene Landauer, Q Mgt.
Mary Arnett
Megan LeCrone, New York City Ballet
Meghan Lowther, Q Mgt.
Melanie Scheriau, Wilhelmina Models
Melanie Scholz, Ford Model Mgt.
Melissa Re, Flaunt Models
Michael Hendricks
Moneera Tawfik, Boom Models
Nadedja, ID Models
Nadia Kazakova, Q Mgt.
Narelle Payne, Q Mgt.
Natasha Shearer, ID Models
Nilmarie, Elite Model Mgt.
Nina Goldman
Nina Stotler
Ocean Dull
Olga Pikhienko
Olivia Bowman
Paul Treacy, Ford Model Mgt.
Penny Saunders, Momix

Rieko Yamanaka
Samantha Randall, Code Model Mgt.
Sara Joel
Sara Sessions
Shannon Lilly
Shawnee Free Jones
Sophie Meister, Q Mgt.
Sports Illustrated Swimsuit Shoot
 Emilie Adams, Q Mgt.
 Francesca Tedeschi, Q Mgt.
 Mallory Snyder, Elite Model Mgt.
 Michelle Lombardo,
 Next Model Mgt.
 Noemie Lenoir, Ford Model Mgt.
 Yamila Diaz-Rahi,
 Next Model Mgt.
Stefanie Kirchner, Next Model Mgt.
Tabitha Garza
Tara Stiles, Ford Model Mgt.
Terri Wolfe
Tetyana Kuzmishcheva, NY Model Mgt.
Tiffany Heft
Tina Baltzer, Q Mgt.
Tina Casciani, NY Model Mgt.
Tina LeBlanc
Todd Davis, Mitchell Model Mgt.
Tricia Nasser, Major Model Mgt.
Tyree Washington
US 2000 Olympic Synchronized
 Swim Team Members
 Anna Kozlova
 Becky Jasontek
 Erin Dobratz
 Kendra Zanotto
 Lauren McFall (captain)
 Tammy Crow
Veronica Dunlap
Virginia Horne

Fine Art Prints

A small selection of the images in this book are available as fine art Ilfochrome prints in a numbered series of eight, with three artist's proofs.

Staley-Wise Gallery
New York, NY 10012

Robert Klein Gallery
Boston, MA 02116

Gallery M
Denver, CO 80206

Galerie Gora
Montreal, Quebec, Canada

David Gallery
Culver City, CA 90232

Photography West Gallery
Carmel, CA 93921

Monroe Gallery
Santa Fe, NM 87501

Photo-Eye Gallery
Santa Fe, NM 87501

The work of Howard Schatz can be found at www.howardschatz.com.

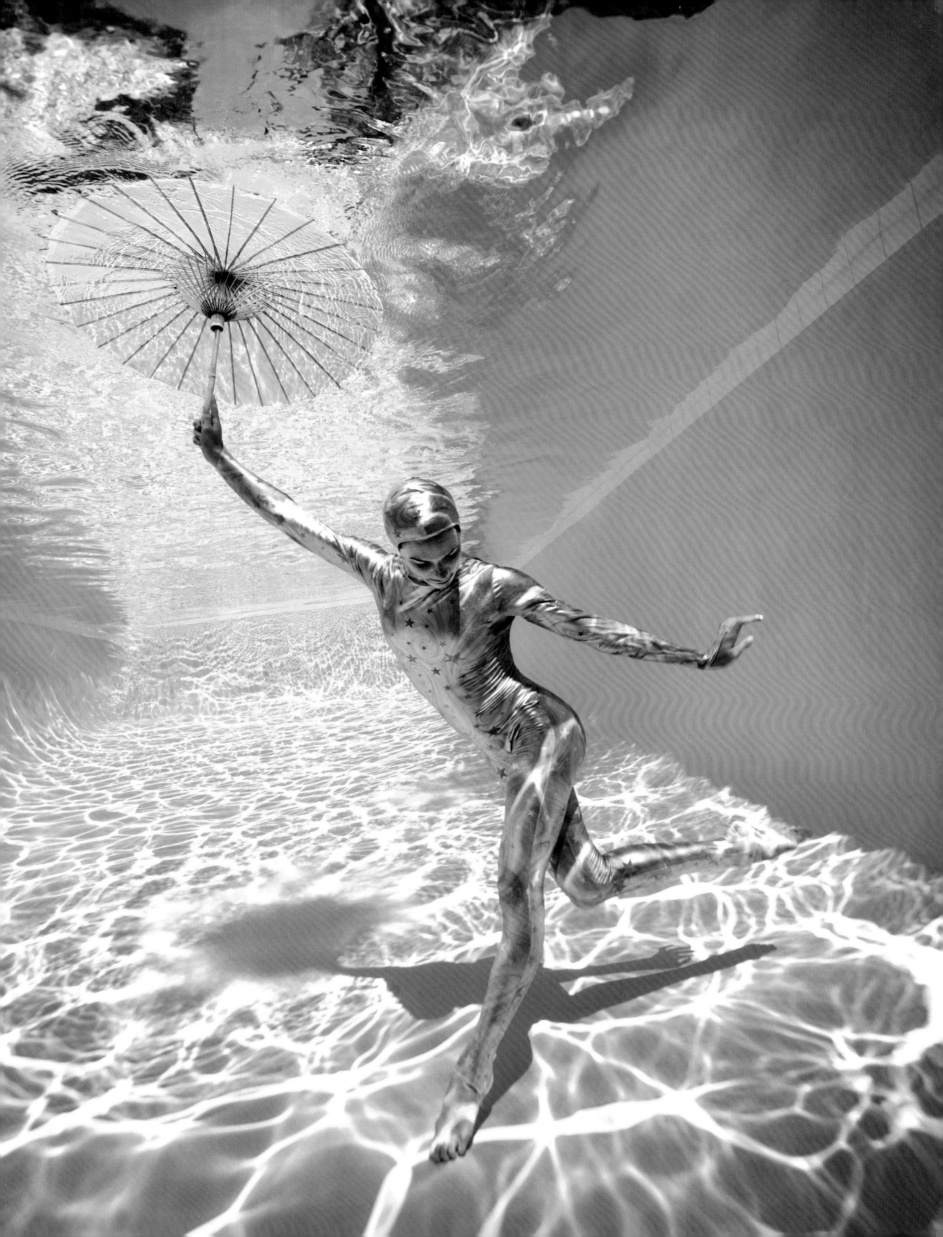

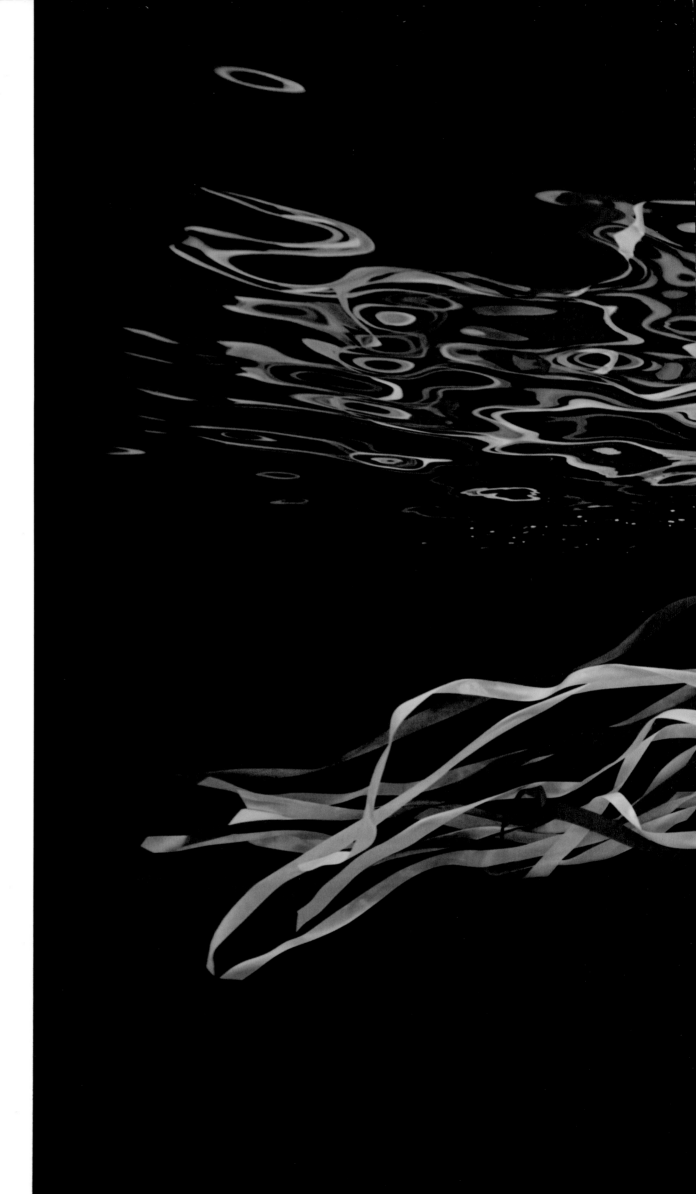

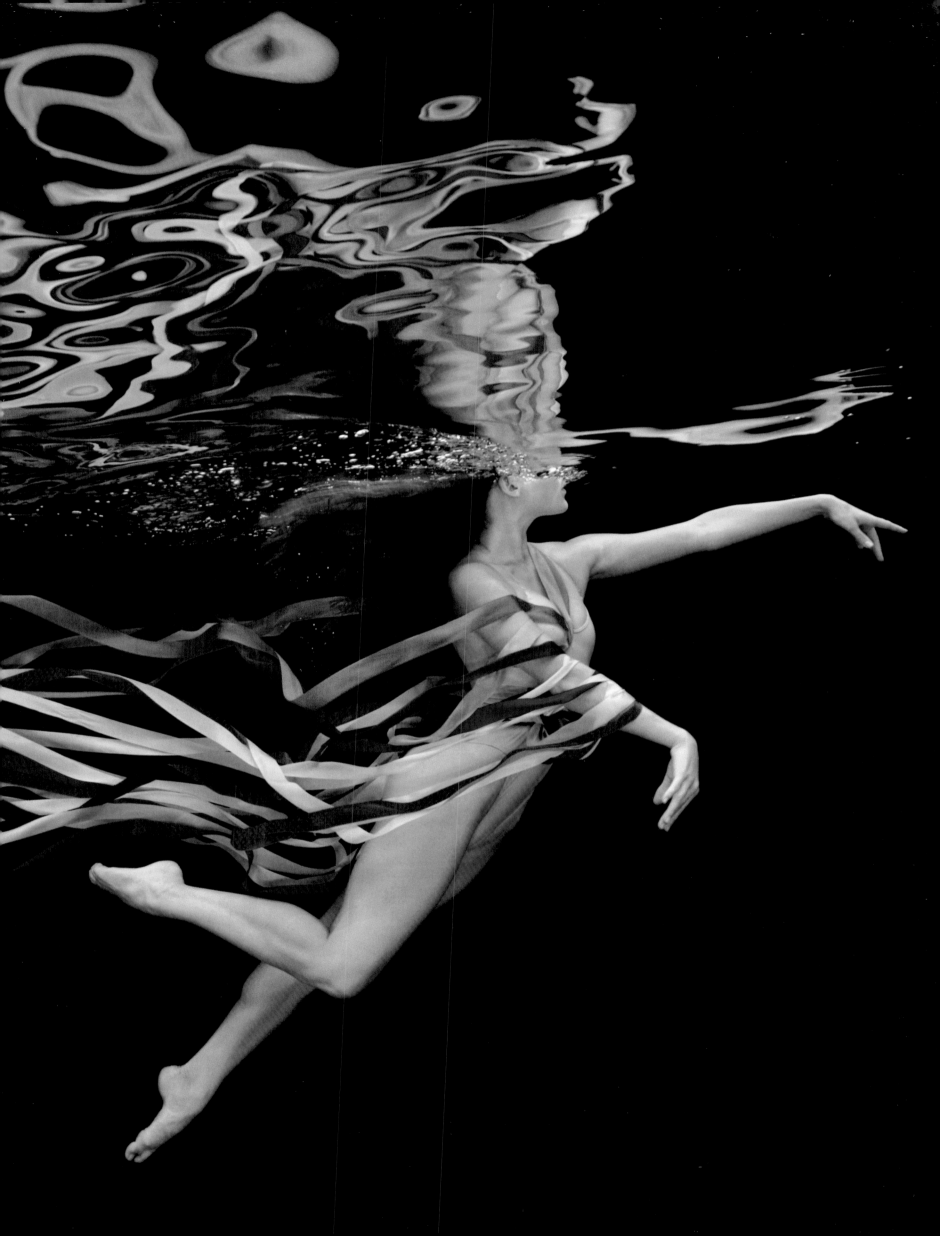

Endpapers *Underwater Study 3147*

Underwater Study 2411

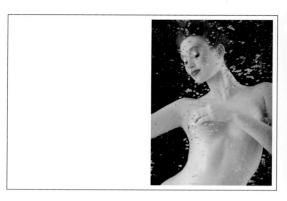

5 *Underwater Study 2381*

Of the hundreds of models and dancers who tried out for *H₂O*, we met a few gifted women who were both models and dancers, and could perform underwater as well. Here is one of that rare group.

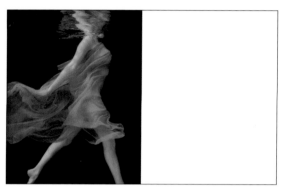

6 *Underwater Study 132*

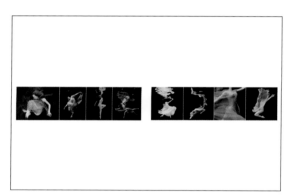

8 *Underwater Study 1*
Underwater Study 161
Underwater Study 19
Underwater Study 1605

9 *Underwater Study 208*
Underwater Study 960
Underwater Study 477
Underwater Study 49

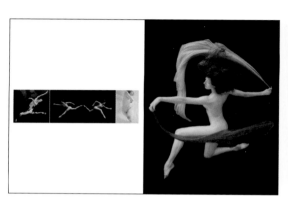

10 *Underwater Study 1608*
Underwater Study 1601
Underwater Study 22

11 *Underwater Study 41*
The cover of *Water Dance*

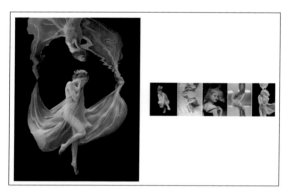

12 *Underwater Study 980*

13 *Underwater Study 1595*
Underwater Study 1647
Underwater Study 1624
Underwater Study 1342
Underwater Study 1336

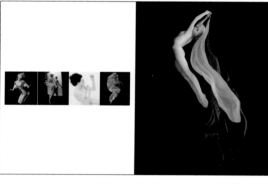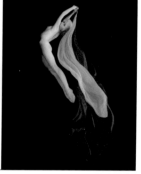

14 *Underwater Study 1453*
Underwater Study 1431
Nude Study 1167
Underwater Study 1293

15 *Underwater Study 1335*
The cover of *Pool Light*

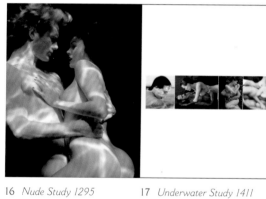

16 *Nude Study 1295*

17 *Underwater Study 1411*
Nude Study 1253
Underwater Study 1454
Nude Study 1277

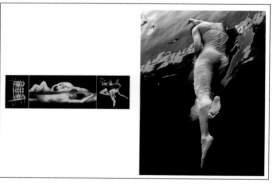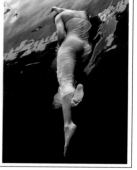

18 *Underwater Study 1687*
Nude Study 1155
Underwater Study 1459

19 *Underwater Study 1612*

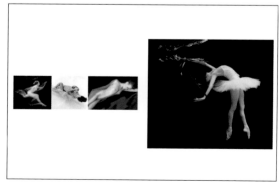

20 *Underwater Study 225D*
Nude Study 572
Nude Study 1137

21 *Underwater Study 1657*

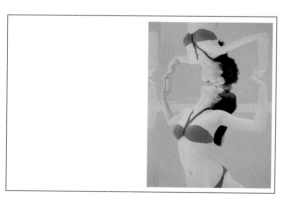

23 *Underwater Study 2481*

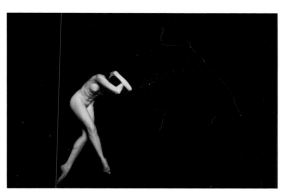

24 *Underwater Study 2617*

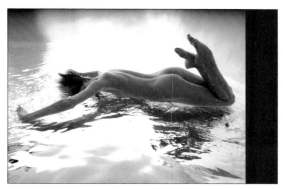

26 *Underwater Study 3026*

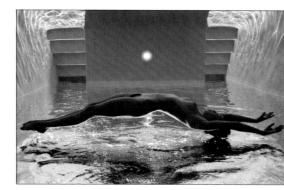

28 *Underwater Study 2846*

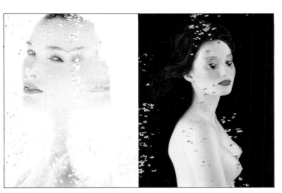

30 *Underwater Study 2663* 31 *Underwater Study 2380*

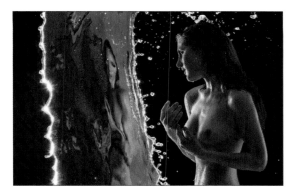

32 *Underwater Study 3020*

When water meets air, the interface reflects like a mirror. We've learned to throw water in a sheet to mirror a model adjacent to it. The only trick is learning to throw the water into the correct shape.

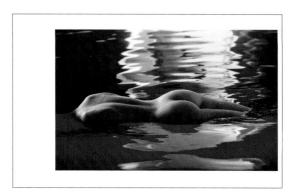

34 *Underwater Study 3083*

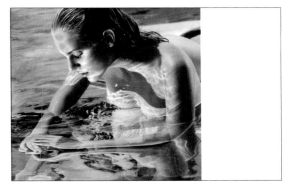

36 *Underwater Study 3085*

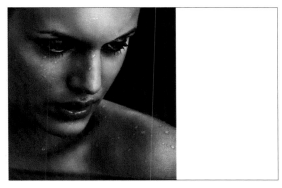

38 *Underwater Study 3119*

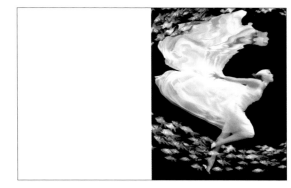

41 *Atlantis 1*

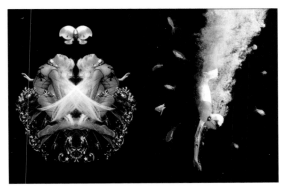

42 *Atlantis 2* 43 *Atlantis 9*

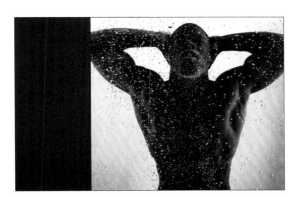

44 *Underwater Study 2752*

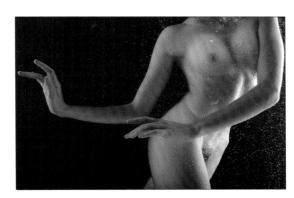

46 *Underwater Study 2844*

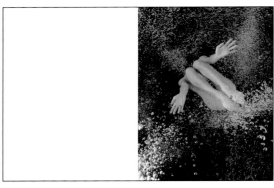

49 *Underwater Study 2154*

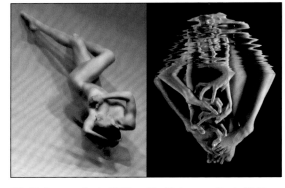

50 *Underwater Study 2055* 51 *Underwater Study 2845*

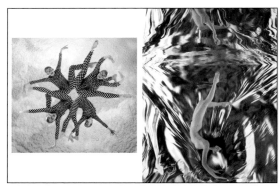

52 *Underwater Study 2608* 53 *Underwater Study 2883*

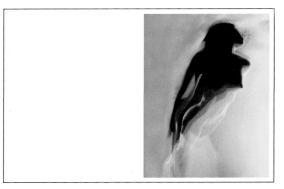

55 *Underwater Study 2326*

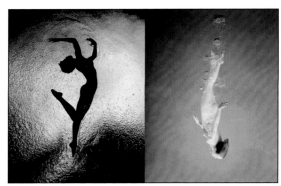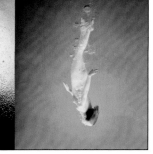

56 *Underwater Study 2696* 57 *Underwater Study 2250*

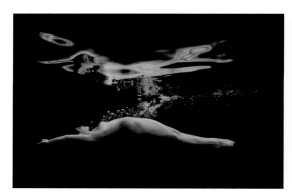

58 *Underwater Study 2896*

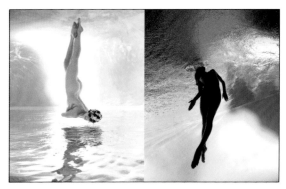

60 *Underwater Study 3126* 61 *Underwater Study 2967*

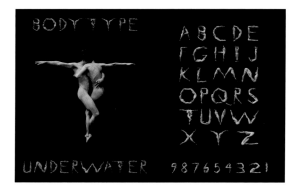

62 *Body Type*
Eric Hoisington and Tiffany Heft worked with me on making letters
underwater. Both are trained dancers and gymnasts. We worked on the
letters in the studio first, and then we went to the pool. Each letter
took an hour of shaping, refining. Some were easier (L, P, T, V, X, and
Y) and some were very challenging (B, G, M, O, Q, S, U, and W).

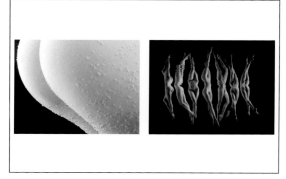

64 *Underwater Study 3064* 65 *Underwater Study 3146*

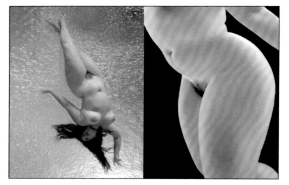

66 *Underwater Study 2917* 67 *Underwater Study 2905*
Alexandra Beller is a professional dancer and dance teacher in
New York. She danced for many years with the Bill T. Jones / Arnie
Zane Dance Company.

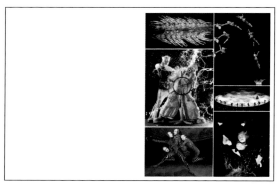

69 *Clockwise from upper left: Cirque du Soleil*™ ○™ *82*
Cirque du Soleil™ ○™ *186*
Cirque du Soleil™ ○™ *95*
Cirque du Soleil™ ○™ *26*
Cirque du Soleil™ ○™ *159*
Cirque du Soleil™ ○™ *93*

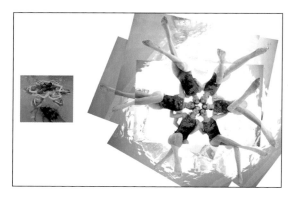

70 *Underwater Study 2580* 71 *Underwater Study 2588*
These six members of the US 2000 Olympic Synchronized Swim Team
came to the pool to work with me. On the left, I am on the bottom of the
pool, shooting upward at them. On the right is the resulting photograph.

174

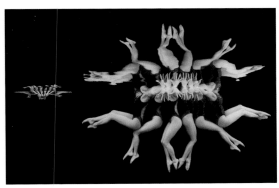
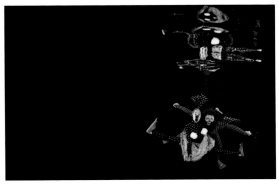
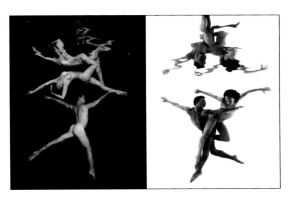

72 *Underwater Study 2505*
On the left, the six members of the US 2000 Olympic Synchronized Swim Team are photographed from above the water, their torsos half out of the water, holding on to the pool deck. The image on the right was taken at the same moment, photographed from under the water, with the reflection seen on the underneath surface (the "ceiling") of the water.

75 *Underwater Study 2894*
Ari Loeb and Heather Magee dance for the Momix Dance Company. Natural clowns.

76 *Underwater Study 2876* **77** *Underwater Study 2727*

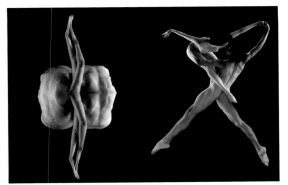
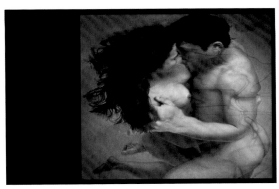
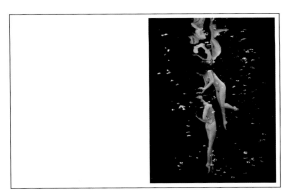

78 *Underwater Study 2830* **79** *Underwater Study 2843*

80 *Underwater Study 2301*

83 *Underwater Study 2517*
When two dancers work in the studio, each can see what the other is doing and adjust to create a complementary position. Underwater, without goggles, this is not possible, and working with pairs is very challenging. These two dancers are identical twins and have an instinctive ability to create complementary positions without being able to see each other.

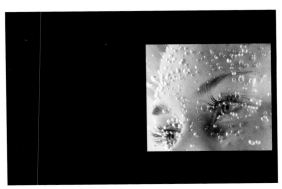
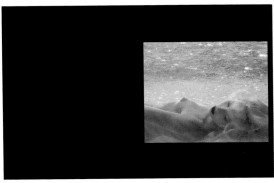
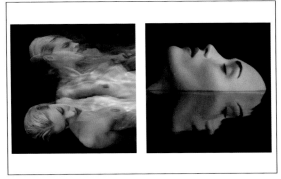

85 *Underwater Study 2822*

87 *Underwater Study 2586*

88 *Underwater Study 2859* **89** *Underwater Study 3120*

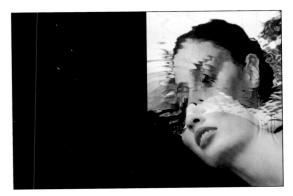

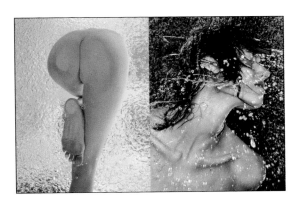

91 *Underwater Study 2691*
In this photograph, the model has brought her lower face under the surface of the water, leaving her eyes out of the water. The underwater camera has a clear view of her mouth and nose, and "sees" her eyes and the top of her head through the rippling surface of the water.

93 *Underwater Study 2981*

94 *Underwater Study 2020* **95** *Waterproof Editorial 2*

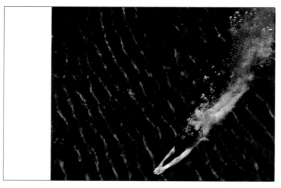

96 *Underwater Study 3024*

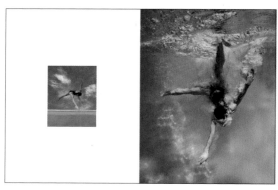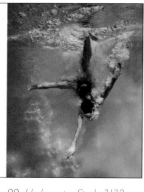

98 *Underwater Study 3133* 99 *Underwater Study 3132*

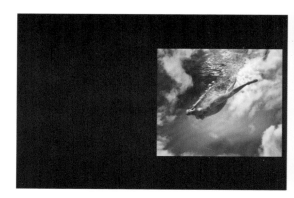

101 *Underwater Study 2923*

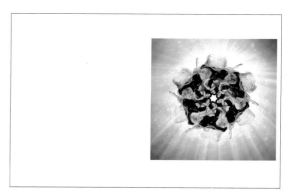

103 *Escada: Into the Blue*

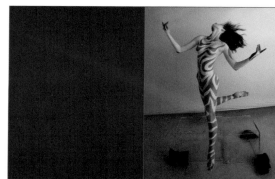

105 *Underwater Study 2417*
Using body paint, the makeup artist drew this pattern, which I had created, on the body of our model, seen here underwater. At the bottom of the pool, clear plastic boxes filled with water serve as a place for the model to stand with her head above the surface between shots; the boxes are held in place with underwater lead-filled "sandbags."

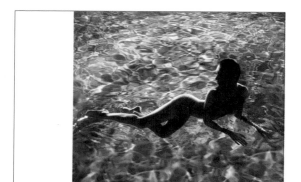

108 *Underwater Study 2855*

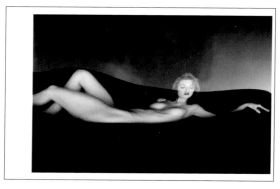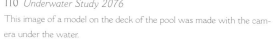

110 *Underwater Study 2076*
This image of a model on the deck of the pool was made with the camera under the water.

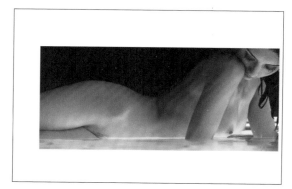

112 *Underwater Study 2704*

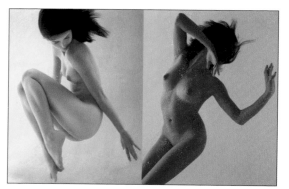

114 *Underwater Study 3036* 115 *Underwater Study 2799*

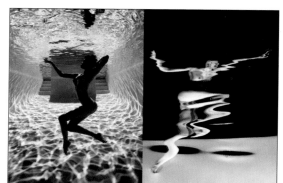

116 *Underwater Study 2826* 117 *Underwater Study 2064*

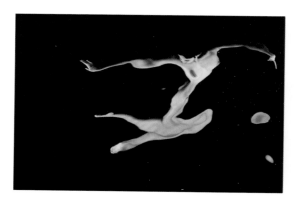

118 *Underwater Study 2968*

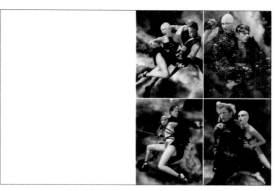

121 *Clockwise from upper left:* *War Fashion Editorial 1*
War Fashion Editorial 7
War Fashion Editorial 3
War Fashion Editorial 6

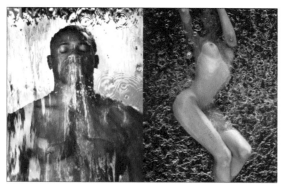

122 *Underwater Study 2803* 123 *Underwater Study 2742*

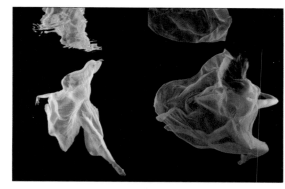

124 *Underwater Study 3058* 125 *Underwater Study 2755*

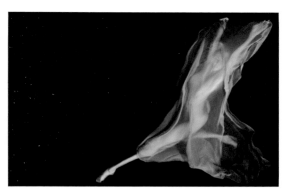

126 *Underwater Study 3059*

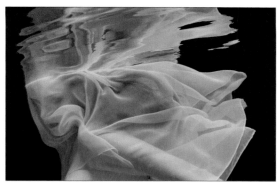

128 *Underwater Study 3127*

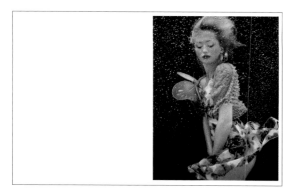

131 *Underwater Study 2615*
Betsey Johnson loaned us a beautiful, fanciful dress for this fashion image.

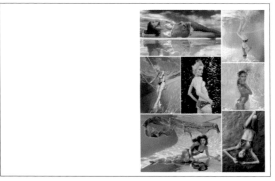

133 *Clockwise from upper left:*
Swimsuit Editorial YD16 *Swimsuit Editorial MS12*
Swimsuit Editorial EA3 *Swimsuit Editorial EA4*
Swimsuit Editorial NL16 *Swimsuit Editorial EA1*
Swimsuit Editorial NL14

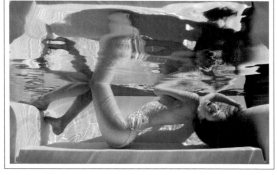

134 *Swimsuit Editorial: Underwater Study 2482*

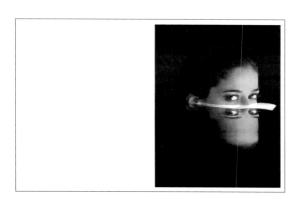

137 *Underwater Study 2688*

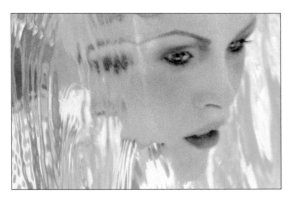

138 *Nude Study 1148*

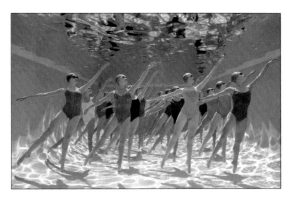

140 *Corps de Ballet*

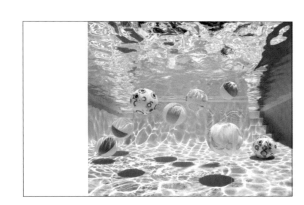

142 *Underwater Study 2434*

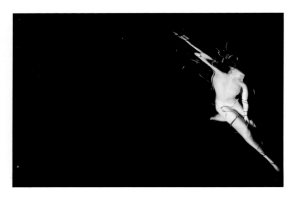

144 *Underwater Study 2054*

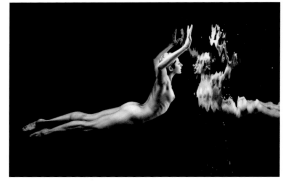

146 *Underwater Study 2465*

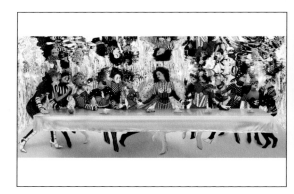

149 *The Last Supper (Underwater)*

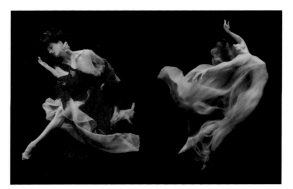

152 *Underwater Study 2010* 153 *MGM Grand Spa*

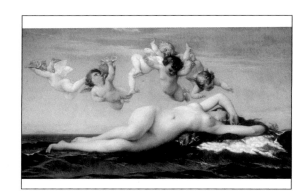

The Birth of Venus by Alexandre Cabanel (1863)
French artist Alexandre Cabanel (1823–1889) painted *The Birth of Venus* in 1863. It was shown in Paris and bought by Napoleon III for his own personal collection. It now resides in the Museé d'Orsay in Paris.

This smaller version, painted by Cabanel in 1875, is in The Metropolitan Museum of Art, Gift of John Wolfe, 1893 (94.24.1), Photograph © 1988 The Metropolitan Museum of Art

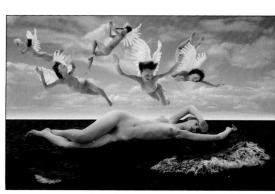

154 *The Birth of Venus Homage to Alexandre Cabanel*
To make the "angels," we photographed a dancer with feathered wings underwater. For the main figure, we photographed another dancer on the surface of the pool, in a few inches of water.

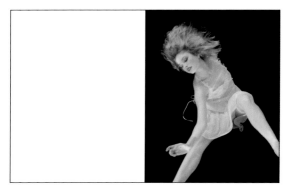

157 *Underwater Study 2009*

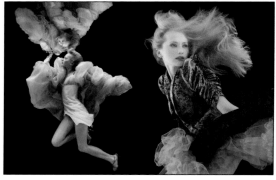

158 *Underwater Study 2657* 159 *Underwater Study 2616*

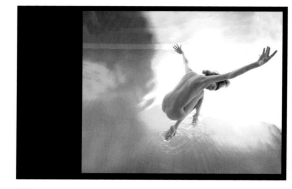

160 *Underwater Study 3025*

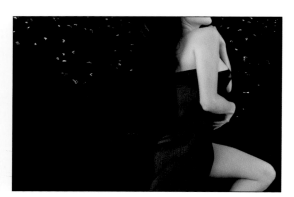

162 *Underwater Study 2461*

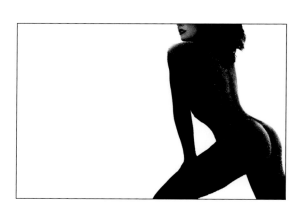

165 *Underwater Study 3028*

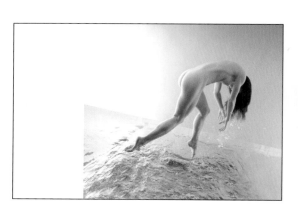

166 *Underwater Study 3145*

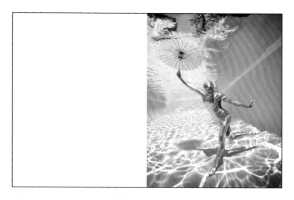

169 *Underwater Study 2778*
Megan LeCrone, who dances for the New York City Ballet, was able to
"perform" underwater as though she were onstage.

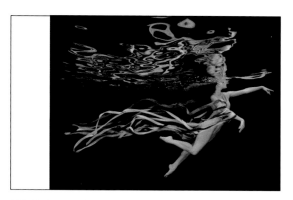

170 *Underwater Study 3093*
Amanda Cobb, who dances for the American Ballet Theatre, came to
the pool for many, many shoots.

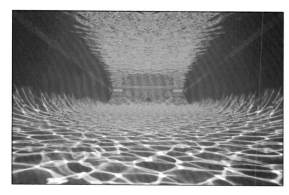

Endpapers *Underwater Study 3147*

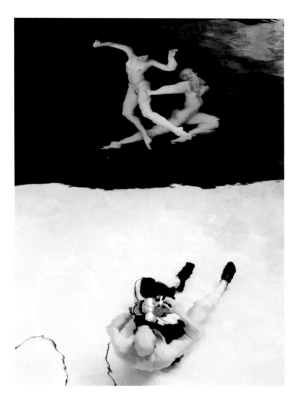

Howard Schatz, New York, NY 2007

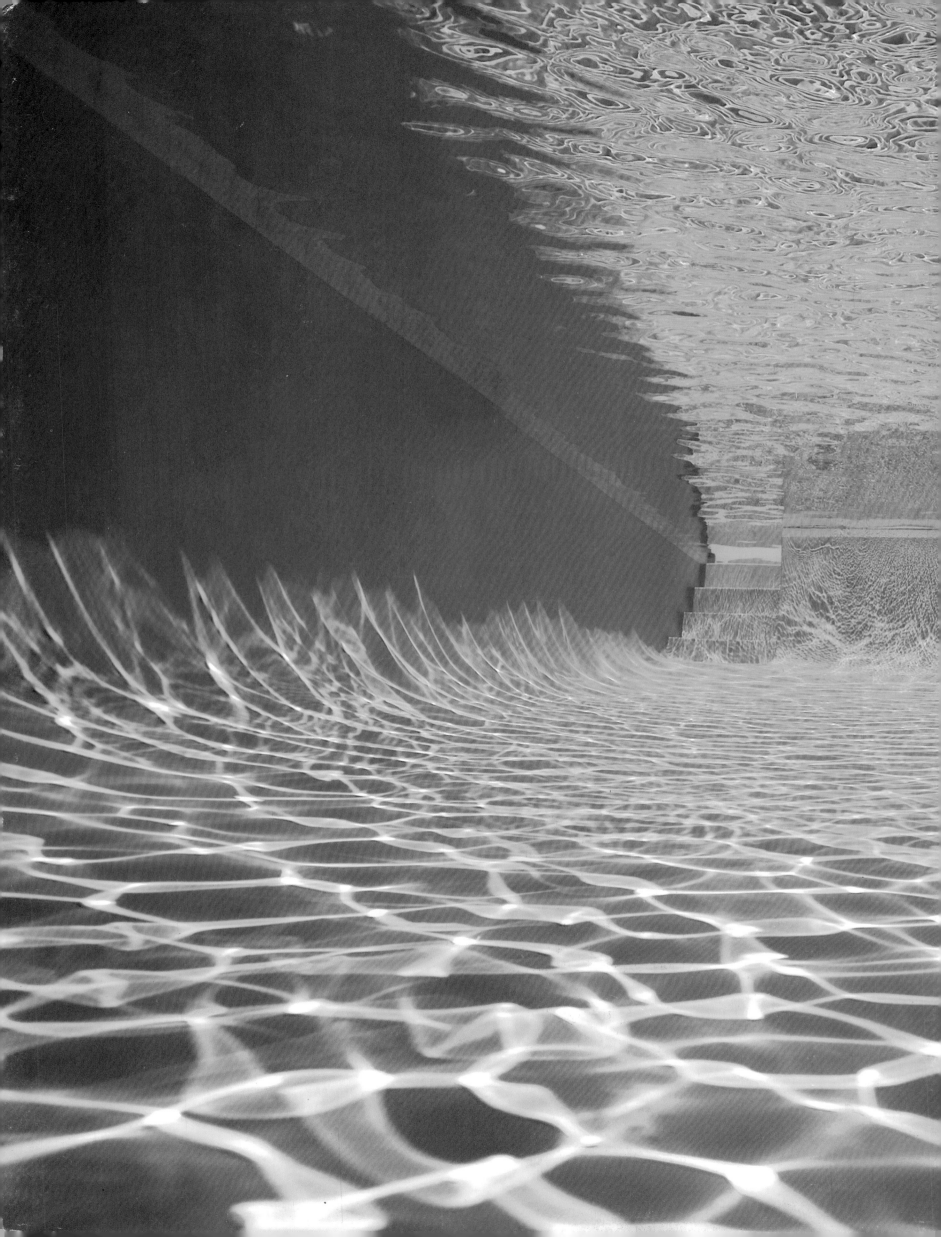